LÉON BAKST

Léon Bakst (1866–1924), a leading Russian artist, was a highly energetic founding member of the *Mir iskusstva* [*World of Art*] association, a group organized in St Petersburg in the late 1890s by artists and art lovers, led by Alexander Benois and Sergei Diaghilev. Its membership included many gifted painters and graphic artists, not only in St Petersburg, but also in Moscow, among them Ivan Bilibin, Alexander Golovin, Igor Grabar, Konstantin Korovin, Boris Kustodiev, Nikolai Roerich and Valentin Serov. Bakst was widely acclaimed as a portraitist, book illustrator and landscape painter, though his style was seen to best advantage in the work he did for the theatre. His designs for stage sets and costumes are conspicuous for their riotous fantasy, astounding beauty and historical authenticity. As the leading designer for the Ballets Russes, which Sergei Diaghilev promoted abroad, Bakst made a unique contribution to the popularization of Russian art in Western Europe.

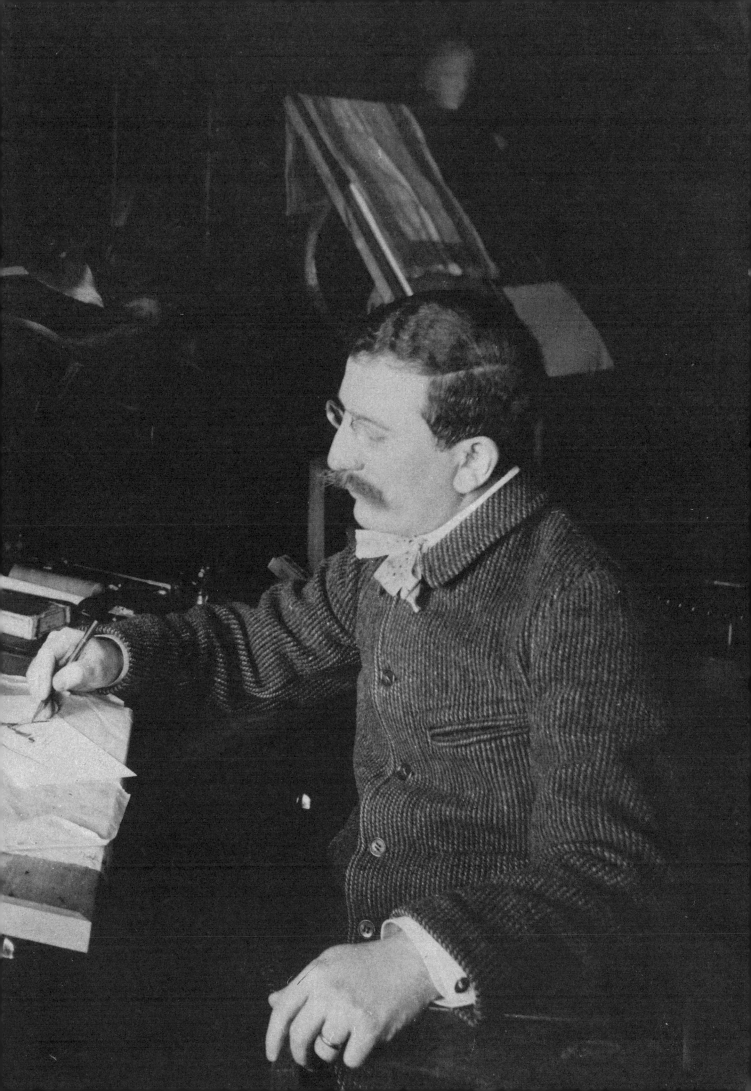

LÉON BAKST

SET AND COSTUME DESIGNS

·

BOOK ILLUSTRATIONS

·

PAINTINGS AND GRAPHIC WORKS

Text and selection by Irina Pruzhan
Designed by Sergei Dyachenko
Translated from the Russian by Arthur Shkarovski-Raffé

PENGUIN BOOKS

Penguin Books Ltd, Harmondsworth, Middlesex, England
Viking Penguin Inc., 40 West 23rd Street, New York, New York 10010, U.S.A.
Penguin Books Australia Ltd, Ringwood, Victoria, Australia
Penguin Books Canada Limited, 2801 John Street, Markham, Ontario, Canada L3R 1B4
Penguin Books (N.Z.) Ltd, 182-190 Wairau Road, Auckland 10, New Zealand

Edited, designed and produced in the U.S.S.R. by
Aurora Art Publishers, Leningrad

First published in English by Viking Books, 1987
Published in Penguin Books, 1988

Printed and bound in Austria

BAKST: HIS LIFE AND WORK

THE SPRING OF 1909 was marked by an event which was destined to play a major role in the art world: Sergei Diaghilev organized the first performances in the west of what was later to become the Ballets Russes. His productions — which brought the best dancers from St Petersburg and Moscow to the Théâtre du Châtelet — were a resounding, unprecedented success. 'The intellectual, artistic and creative elements of Paris... took off their hats to the youthful, colourful, bacchanalian orgy that had come from the north-east,'[1] Anatoly Lunacharsky wrote. Well-known French authors, composers and artists without exception enthused over the impeccable performances, the picturesque profusion of decor and the mastery of the dancers. What particularly amazed the French public was the synthesis of music, choreography and painting. Paris was the first stop on Russian art's triumphal procession across Europe and America.

The Russian 'saisons de danse', which came as a revelation to foreign audiences, had a great impact on the further development of ballet, of stage design and of painting.

Among the many Russian artists involved in Diaghilev's productions — including Alexander Benois, Nikolai Roerich, Alexander Golovin, Ivan Bilibin, Mstislav Dobuzhinsky, Konstantin Korovin, Valentin Serov, Konstantin Yuon, Boris Anisfeld, Fiodor Fedorovsky, Natalia Goncharova, Mikhail Larionov and Sergei Sudeikin — Léon Bakst was undoubtedly in the first rank, as he was the company's leading stage designer, responsible for the sets and costumes of most of its productions. In fact, the Russian seasons in Paris brought him fame that no stage designer had ever before earned. He was a mature master, with years of dogged effort and protracted searching behind him when he became that 'bright star in the theatrical firmament'.[2]

Léon Bakst's creative career started in the late 1880s, after four years — 1883 to 1887 — at the St Petersburg Academy of Arts. Then still in his salad days, he undertook diverse commissions, illustrating books for children and making copies of portraits.

The decisive event in his life came in 1890, when he made the acquaintance of the then young artist Alexander Benois, and his friends Konstantin Somov, Dmitry Filosofov, Walter Nouvel, Sergei Diaghilev and Alfred Nurok. These men shared a characteristic urge to absorb and assimilate the culture, not only of their own country, but of all of Europe. Naturally Bakst's aesthetic horizons were broadened by their discussions on various aspects of literature, music and art, their reading of new books and illustrated foreign magazines and their attendance at theatrical performances and concerts.

Bakst's travels abroad, especially his long stay in Paris, contributed in no small measure to his artistic development. His visits to the Louvre and the Luxembourg Museum, to exhibitions at the Salon, to Versailles and Chantilly, and his travels in Italy, Spain and northern Africa, generated a plethora of new impressions. On the whole he preferred the old masters, such as Velázquez, Rubens and Rembrandt. When he looked at nineteenth-century art his eye was drawn primarily to painters of the Barbizon School, such as Camille Corot, Théodore Rousseau

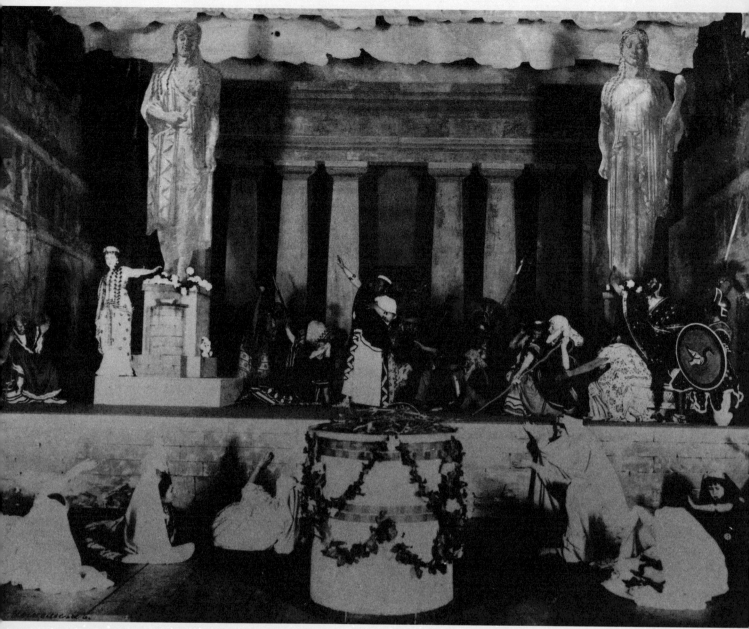

Scene from *Hippolytus*

and especially Jean-François Millet, whose art he regarded as the continuation of the lofty classical tradition he admired.

The more aware Bakst grew of the grandeur of the art of past centuries, the more dissatisfied he was with his own efforts. Realizing that it was vital to polish his skills, he took drawing lessons at the studio run by the veteran Academician, Jean-Léon Gérôme, and also painted from models at the academy maintained by Rodolphe Julian. He derived great benefit from the classes given by Albert Edelfeldt, a Finnish artist then resident in Paris, who helped him master the intricate art of the plein-air school. Finally, he found the several years (1893–1900) he spent working on studies for the painting 'Paris Welcomes Admiral Avelan' (commissioned by the Russian government) to be a good discipline.

The greatest progress he made in those years, however, was in the use of watercolours and pastels. The small studies he exhibited at shows mounted by the Society of Russian Watercolourists earned well-deserved acclaim.

8

Bakst's efforts of the 1890s, efforts that reveal the influences of Konstantin Makovsky, the later Wanderers and also of Adolf von Menzel and Mariano Fortuny, clearly indicate the artist's anguished search for individuality. Though he dreamed of serious, persistent study in order to accomplish the objectives he had set himself, often the vicissitudes of life obliged him to produce sugary, salon-type pictures which he could sell cheaply to art-dealers. The letters he wrote to his friends at the time mirror his mental turmoil:

'I owe this year to myself and to my artistic conscience, against which I have often sinned, to reform and set out on the road pointed out by Millet, Rousseau and Corot... It has cost me much, both morally and physically, to shake off this prettily-smooth, spit-and-polish manner and start searching for, and trying to achieve, that monstrously wonderful and freely sweeping style of Rembrandt, Velázquez, Rubens, Millet, Menzel and others... While working on the picture, I simultaneously daub canvas after canvas, looking within myself for the freedom and daring to express my understanding of art without mean, ulterior motives. But that comes with difficulty and hardship. On the other hand, it is a delight to search within the realm of geniune art, to study and to remember that only the great masters really produced "high art". Damnation! No resources.'[3]

1898 was a milestone in Bakst's creative career. Benois and the other members of his group set up an artistic association which came to be known as Mir iskusstva [The World of Art]. Over the next few years many of the artists of St Petersburg and Moscow joined this association. They included Valentin Serov, Mikhail Vrubel, Konstantin Korovin, Philip Maliavin, Ivan Bilibin, Anna Ostroumova, Yevgeny Lanceray, Mstislav Dobuzhinsky, Alexander Golovin and Nikolai Roerich. They all shared a common refusal to accept either the official academism with its dogmatic, conservative conventions, or the creative efforts of many of the later Wanderers. They advocated inspiration and lyricism in art, and sought novel, more impressive means of visual expression.

Retrospective romanticism constituted a salient trend in *fin-de-siècle* Russian art. Dissatisfaction with reality induced many artists to address themselves to past epochs. But whereas Andrei Riabushkin, Apollinary Vasnetsov, Nikolai Roerich and Ivan Bilibin were primarily interested in the authentically Russian, pre-Petrovian age, its history, mores and folklore, most World of Art artists gravitated towards the eighteenth century and the first half of the following century. Many concentrated on the days of Peter the Great, and the Rococo and Empire architecture of 'old' St Petersburg. Alexander Benois and Konstantin Somov were infatuated with Louis XIV, while Bakst preferred antiquity.

Most World of Art members were influenced by the Art Nouveau style current in western Europe at the turn of the century. The World of Art movement was associated with the crucial artistic phenomena of the day, and it reflected these in diverse activities, incorporating not only the visual arts but also art criticism, the theatre, even music and literature. It set the stage for the flowering of Russian book illustration, and largely contributed to the spectacular world-wide triumph of Russian ballet, Russian music and Russian stage design. Meanwhile, the annual exhibitions mounted by the group, together with the journal it published, introduced the Russian public to the cream of Russian and western European art and served to promote aesthetic tastes and surmount hidebound nationalistic attitudes to visual creativity. At the same time, by arousing an interest in national history, it helped to introduce a new appreciation for the

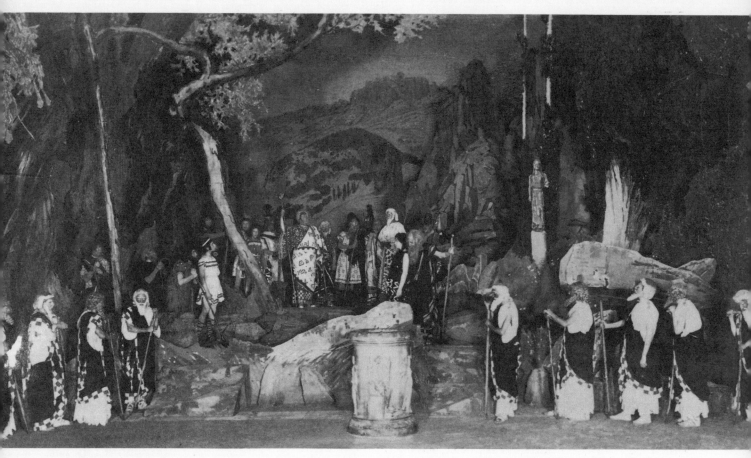

Scene from *Oedipus at Colonus*

grandeur and majesty of Russian culture. Two outstanding personalities in the World of Art group, which was composed of generally well-educated and gifted people, were Sergei Diaghilev, who arranged exhibitions and edited the *World of Art* journal, and Alexander Benois, a superb illustrator of books, a stage designer, art critic and historian, unanimously acknowledged by the group as their chief ideologue.

The *World of Art* journal enriched Bakst's art, infusing it with greater substance and purpose. Book illustration acquired greater prominence. Indeed, the fact that the group had its own periodical enabled its members to translate into reality their view of the printed work as an art form, one whose components should harmoniously blend into one entity. The editors, namely Bakst, Benois, Somov and Lanceray, were able to attain a stylistic integrity and a high professional level of design for their publication. Entranced by this work, Bakst 'spent whole days in inventing elegant titles for the drawings and retouching the photographs, in an attempt to give them a more artistic character'.[4] Meanwhile, his own drawings for the covers, his frontispieces, vignettes, head- and tailpieces done for the *World of Art*, for *Khudozhestvennye sokrovishcha Rossii* [*Art Treasures of Russia*], and for other journals and publications were conspicuous for their rhythmic severity, graceful elegance and expressive play of black and white. In them sinuous lines combined with broken or dotted lines, small dashes, hatching and shading. The overall character and the techniques employed betrayed the influence of western graphic artists, above all of Aubrey Beardsley and Félix Vallotton.

Bakst borrowed decorative elements for his drawings primarily from the classical art of ancient Greece, and now and again one encounters rocaille motifs. This was a singular

10

stylization of antiquity, with the severity and laconic elements of the ancients transmuted into the linear subtlety of Art Nouveau. Later, between 1905 and 1910, Bakst borrowed archaic motifs from Greek mythology. An apposite instance is afforded by his 1909 frontispiece for the *Apollon* [*Apollo*] journal. Now and again the ornamental vignette gives way to a narrative drawing that not infrequently possesses a symbolical tinge. A case in point is the 'Tolling Bells' frontispiece for the *Zolotoye runo* [*The Golden Fleece*] journal (1906, No. 3), intended to accompany the obituary of the artist Victor Borisov-Musatov; it has an associative link with this text, serving subtly to convey the mood.

By contrast, the frontispiece for Alexander Blok's slender volume of verse in 1907, *Snow Mask*, with its allegorical content, play of fantasy, half-hints, linear rhythm and contrasted silhouettes conveys the lyricism of the series of poems, which Blok prefaced with the following epigraph: 'These verses are dedicated to You, tall lady in black with eyes winged and enamoured of the lights and gloom of my snow town.'[5] Alexei Sidorov, a connoisseur of Russian graphic art, thought this drawing 'a model of "synthesized" illustration, characterizing the basic mood and the main image of the book'.[6] The two easel pieces, 'The Downpour' and 'The Vase', which Bakst produced in 1907, both develop from his book illustrations. The latter, also known as 'Self-Portrait', refers in allegorical form to the artist's family life. Meanwhile, 'The Downpour', by virtue of its stylized character and affectionately ironical attitude towards the past, as well as the fineness and accuracy of the drawing, has an affinity with the efforts of other World of Art artists, especially Konstantin Somov.

The technique of lithography, which had its heyday in Russia in the first half of the nineteenth century, had been consigned to oblivion until the World of Art group rediscovered it in the course of their explorations into the various techniques employed in the graphic arts. Here the etcher Vasily Mathé and his pupil Anna Ostroumova-Lebedeva, who was to attain prominence as a master of black-and-white and coloured engravings, played an important role. Perhaps of greatest interest among Bakst's lithographs are his portraits of the artists Isaac Levitan and Philip Maliavin (both dated 1899), which are conspicuous for their keen, lively characterization.

At the time of the first Russian Revolution, in 1905–1907, many of the World of Art artists worked for the satirical journals *Zhupel* [*The Bugaboo*] and *Adskaya pochta* [*Hell's Mail*]. Indeed, the drawings published by Valentin Serov, Yevgeny Lanceray, Mstislav Dobuzhinsky, Ivan Bilibin, Boris Kustodiev, Boris Anisfeld and Dmitry Kardovsky are in the first rank of Russian political satire of the time.

Bakst, like many of Russia's progressive intellectuals, welcomed the Revolution with excited delight. 'Never before has it been so light, bright and springy in Russia as now!'[7] he wrote. Infatuated by the idea of publishing the *Zhupel* journal, he attended conferences of the editorial staff, where the efforts of artists and democratically-minded writers, headed by Maxim Gorky, were pooled.

Later, in 1908, together with Dobuzhinsky, Bilibin, Kustodiev and Anisfeld, Bakst worked for the newly published art and political journal *Satiricon*, closely modelled on the German satirical *Simplicissimus*. This new journal achieved prominence in Russian intellectual life, started as it was in the dark hours of Stolypin's reaction to the revolutionary feelings in the air,

when all progressive thought was suppressed. Bakst did a cover and several illustrations. His cover depicts a monotonous row of barack-like houses, bristling with pointed lightning-conductors. Above, high up in the heavens, sits Zeus, hurling bolts of lightning at the city. The caption on top read: 'Dedicated to Zeuses, great and small.' The allegorical meaning was quite clear: humans were no longer frightened of gods and demigods, as they had found ways and means of repelling their blows. Reactionary ideas could no longer crush the freedom-loving spirit of the populace, with their new-found aspirations. Reflected in this drawing, and others featured in the new journal, was the mood of the progressive intelligentsia, who craved political change and believed in an inevitable revolutionary upsurge in the near future.

Bakst's portraits now underwent a marked evolution. In his early studies of Spaniards, Arabs, Ukrainian peasant women, Roman ladies and French peasants, he had often given priority to national ethnic features, instead of specific characteristics. However, in 1895 he turned towards the more individualized portrait. Though he also produced many superficial, salon-type pieces, these did not convey his complete mastery of the genre. He was happiest depicting people who were kindred spirits. A case in point is the portrait of his friend and colleague Alexander Benois (1898), which radiates a real warmth and evinces a clear insight into the inner man. The sitter's serenity is brought out by the linear smoothness, the restrained colour scheme and the soft texture of the pastel. The quickly sketched background, showing a folder of drawings and a rocaille-framed portrait of the Empress Elizaveta Petrovna, also serves to indicate the mood of an artist attracted to the history and art of eighteenth-century Russia.

Less traditional is the 'Portrait of Sergei Diaghilev and His Nurse' (1906), which follows the flat, silhouetted style of Art Nouveau. In it, Bakst has been able to reveal the complex character of this gifted man, showing us his lively, clever mind, boundless vigour — and his high-society polish and arrogance. Meanwhile, the contrast between the sitter's internally dynamic figure and the elderly nurse, calmly seated in the background with her hands folded in her lap, only amplifies the image's resonance and robust vibrancy. In its singular approach to the sitter, compositional arrangement and colouring, this portrait is linked to some of Valentin Serov's efforts.

In his portraits Bakst preferred to use graphic techniques. Thus, possibly the happiest of the series of drawings done in 1899 is the 'Portrait of the Actress Maria Savina', which is appealing because of the charm of the sitter and the fine elegant line. Undoubtedly of interest are the works produced in 1905 and 1906 in mixed media, notably black and coloured pencil, charcoal, chalk and sanguine. Most follow a similar pattern, with the centrally-positioned face modelled in detail against a blank field where there is a sketchy outline of the figure. The portraits of Konstantin Somov and Andrei Bely, as well as the artist's self-portrait, fall into this group; all were commissioned and produced in 1906 for Nikolai Riabushinsky, the publisher of *Zolotoye runo*, for eventual reproduction in his journal.

Bakst draws closest to western Art Nouveau trends in his 1902 painting 'The Supper'. 'A stylish, *fin-de-siècle*, decadent woman, black-white, lissom as an ermine with a mysterious Gioconda smile'[8]: this is how Vasily Rozanov, aptly and expressively, described the main personage. A concealed apprehension is sensed in the mobile, pale face which the auburn-haired lady turns sharply towards the viewer, in her posture and in the way the fur neckpiece is

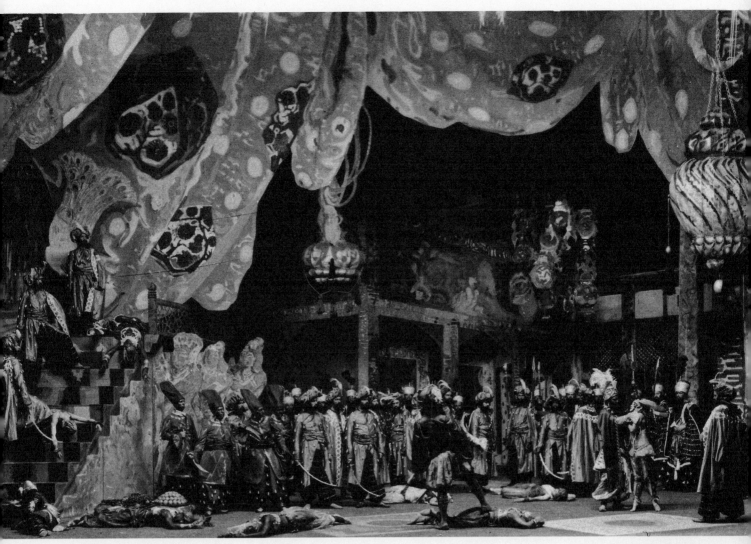

poised to slip off the back of the chair. This feeling is accentuated by the asymmetrical structure, the fragmented composition and the characteristic drawing built on a host of sinuous lines. All this, along with the subtly refined silhouette, the fluidity of form, the flat decorativeness and the touch of poster-like grotesquerie, imparts a particular vigour to the piece. Shown at the 1903 World of Art exhibition, this picture, which did not conform to current aesthetic notions, shocked audiences by its extravagant 'playfulness'. It was far better received in Germany when it was displayed at the Sezession exhibition in Munich.

After his travels in Greece in 1907, made in the company of Serov, graphic principles came to the fore in Bakst's efforts. His mounting interest in archaic art, his fascination with two-dimensional, silhouetted painting, such as is found on classical vases, may account for the gradual increase of linearity in his work. Highly significant in this respect is the preliminary drawing for 'The Sleeper', in which the volume of the prone female figure is conveyed by contour lines alone, with virtually no chiaroscuro modelling. This same preoccupation can also be felt in his graphic portraits. Bakst preferred working in black pencil, almost to the exclusion of all other media; he did not resort to any tinting and he also abandoned thick shading and washes (compare his 1907 portrait of Mily Balakirev with his two 1908 portraits, of Alexander Golovin and Isadora Duncan).

However, by the 1910s, when Bakst was obsessed with the riotous colours of Diaghilev's ballets, his portraits reassumed a painterly character and simultaneously revealed the expressiveness of his stage designs. Cases in point are his portraits of Jean Cocteau (1911), and of the dancers Casati (1912) and Virginia Zucchi (1917).

One of Bakst's more exciting portraits is the somewhat stylized image, in watercolour and gouache, of Ida Rubinstein (1921). Though the dancer, with whom the artist was creatively associated over a long period, is presented offstage, the portrait is highly theatrical. Indeed, the tall figure with the tiny head, sumptuously dressed, holding an enormous muff, seems to be standing in front of footlights. The artistry and refined elegance of the sitter are well conveyed through the finely-etched profile, proud bearing, singular costume and elegant colour scheme. Yet the entire image also reveals those elements of extravagant, decadent weariness that were characteristic of Ida Rubinstein's dancing.

Bakst's portraits, especially those in black and white, are conspicuous for their mastery, their authentic artistry. Their main feature is a fresh immediacy, due in great measure to the brisk manner of execution. To the artist's way of thinking, protracted work on a portrait, coupled with an attempt to convey every detail, inevitably resulted in the loss of inspiration, the portrayal becoming dry and lifeless.[9]

It must be said that Bakst's portraiture has not been properly appreciated in the extensive literature published about him; his landscapes, too, are rarely mentioned, though the artist, who loved the countryside and had a genuine feeling for nature, time and again took up landscape painting. In his younger years he produced rapid impressionistic studies in oils and watercolours that depicted nature's changing condition. His 'Evening in the Neighbourhood of Aïn-Zaïnfour, Sfax' (1897) and 'In the Vicinity of Nice' (1899) are pieces that appeal by virtue of their lyrical perception of the natural world.

The artist produced most of his landscape pieces in 1903 and 1904 when in France, Finland and outside Moscow. Among these are his 'Olive Grove', 'Landscape' and 'Village Church'. More generalized from the angle of form and colour, these landscapes conform to a somewhat monotonous greenish-grey colour sheme. Whereas before Bakst was chiefly interested in the state of nature as evinced by a sunset or by rain, he now sought to convey the overall character, influenced in no mean measure by his contacts with Serov and such Moscow painters as Abram Arkhipov, Konstantin Korovin and Sergei Vinogradov. In 1903, these men founded the Union of Russian Artists at whose shows Bakst exhibited after the disintegration of the World of Art group.

Later on we can observe a certain decorative conventionality in the artist's landscapes. This is well illustrated by his 1906 watercolour 'Sunflowers Beneath the Window', in which the ornamental and two-dimensional interpretation of form is clear. One of Bakst's best landscapes is his 1908 'Acacia Branch Above the Sea', astonishing in its unexpected compositional arrangement and colour scheme. The vivid colouring, a blend of full-blown blues, greens, yellows and pinks, anticipates the vibrant splashes of colour which were to emerge two years later in the decor for the ballet *Schéhérazade*.

The trend the artist followed in this genre dovetailed with the mainstream development of Russian turn-of-the-century landscape painting.

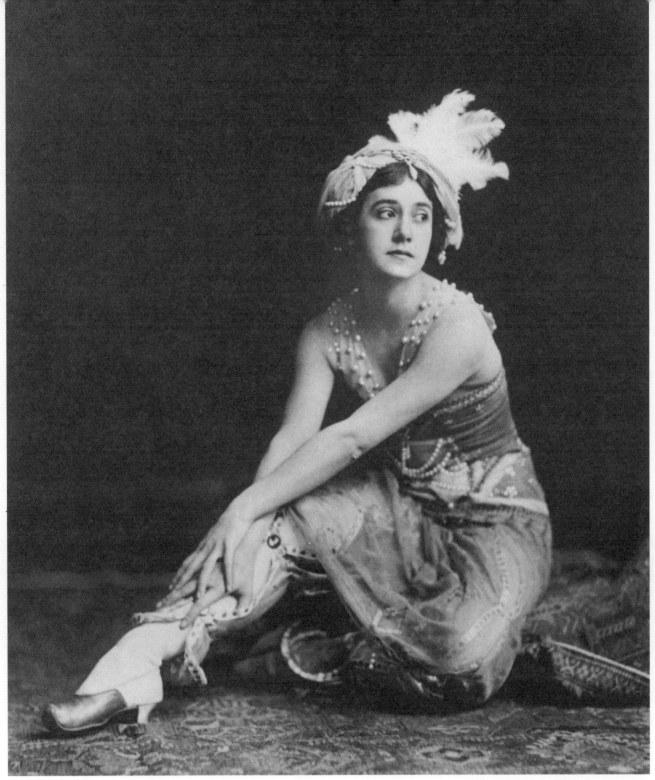

Tamara Karsavina in *Schéhérazade*

In Bakst's mind nature was invariably associated with music. Music lent him inspiration and evoked flights of fantasy. 'Without flowers and music half of happiness is lost!' he said.[10]

Best known of Bakst's easel-work is his 1908 painting 'Terror Antiquus', which evoked a diverse range of opinions in the press. Some critics thought it 'merely an airplane view of a geographical map in relief'.[11] Others considered it 'a work stemming from complex and significant intellectual efforts'.[12] This large canvas, the subject of which derives from the legend of the sunken city of Atlantis, is a bird's-eye view of a landscape, illuminated by huge flashes of lightning. The sea rushing inland inundates a craggy coast. We see buildings rocking and panic-

stricken inhabitants scurrying to and fro. Frothing waves, about to engulf ships, dash against the walls of stone fortresses. Above it all towers the archaic statue of the goddess Aphrodite; she is calm, imperturbable, a frozen smile on her lips. This statue is the incarnation of the feminine ideal, with love and art triumphing over everything mundane and transient, and it imparts an enigmatic, symbolic meaning to the picture.

In the painting the abstract symbol does not exclude historical verisimilitude. Thus the dark blue sea, studded with isles that seem to glow with a phosphorescent light, is actually the view one sees opening up before one when looking from the Acropolis; the brownish, ash-grey mountains rising up on the right are the same 'epically gigantic mountain ranges and bare cliffs — savage and classical...'[13] which Bakst so enthusiastically describes in his travel notes from Greece. Also discernible are the Lion Gates of Mycenae, the ruins of the palace in Tiryns and the Acropolis of Athens, while the statue of the goddess is reminiscent of the archaic korai that lent inspiration to Valentin Serov in his painting 'The Rape of Europa'.

'Terror Antiquus' translated into reality the artist's long-cherished dream of producing a work with a profound philosophical meaning. However, the end result of his three years' endeavour gave Bakst no satisfaction. The elements of theoretical contemplation and delibera-tion that he introduced interfered with his aim of arresting the viewer's attention; the picture was rather like an academic treatise. Nonetheless the painting was largely consonant with the work of other Russian painters between 1905 and 1915. The interest evinced in the latest scientific discoveries, the peculiar romantic aura imparted by the archaic elements and the use of a decorative panel centring on an intricate symbolic image make 'Terror Antiquus' akin to some of the efforts of Nikolai Roerich, Konstantin Bogaevsky, Kuzma Petrov-Vodkin and Mikalojus Čiurlionis. 'Terror Antiquus' mirrors its author's tendency towards monumentality and archaism. 'The dream of the archaic is the last and most cherished dream of the art of our age,' Maximilian Voloshin observed in 1909.[14]

After his travels in Greece his interest in antiquity became all-absorbing and Bakst began to lecture and publish articles on classical culture. His ideas are set out most fully in the article 'Classical Trends in Art', which he published in *Apollon* (1909, Nos. 2/3). Repudiating subjectiv-ity and aestheticism, he advocated the art of large forms, the continuity of tradition and the need for thorough professional schooling. He believed that recourse to archaism, to a 'crude, lapidary style'[15] and to children's drawings, with their spontaneity of perception and bright, pure colours, would infuse art with fresh vigour. Amongst contemporary painters he singled out the trio of Paul Gauguin, Henri Matisse and Maurice Denis, who had chosen the same road, which Bakst contended was the one and only road. Naturally, views like this were to bring him to Fauvism, whose echoes were manifest not only in his painting and drawing, but also in his method of teaching at Elizaveta Zvantseva's art school. The basic demand that he put to his students was 'the ability to arrange contrasting colours, to balance their reciprocal influences and to translate this into the simplest of forms'.[16] However, Bakst taught, although successfully, for only four years. After 1910 he settled in Paris for good, dedicating himself entirely to his job as stage designer for Diaghilev's Ballets Russes.

Bakst had conceived an interest in the theatre in his boyhood. He often recalled how he used to entertain his sisters by putting on toy shows, with paper figures cut out of books and

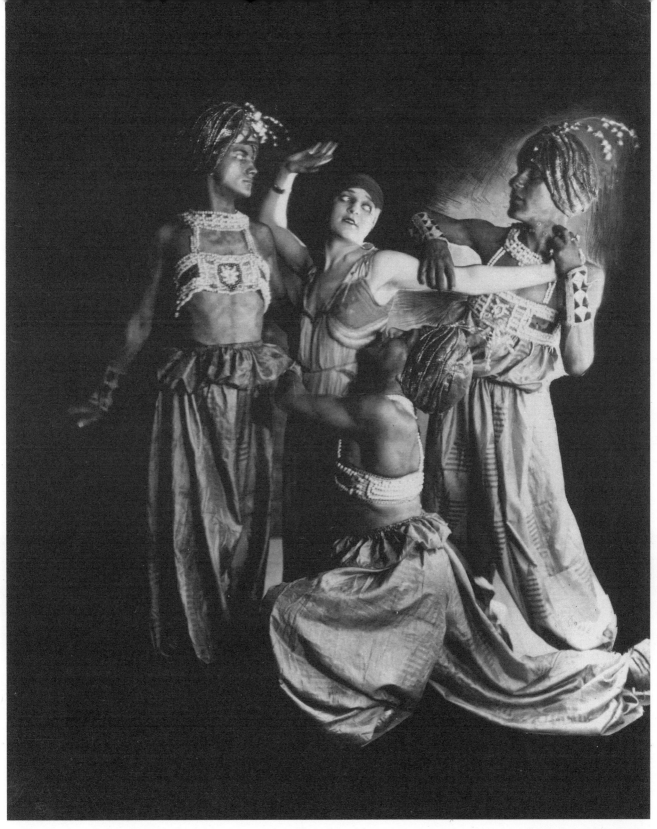

Scene from *Schéhérazade*

magazines. But the decisive moment in his choice of the theatre as a career was when he established a close relationship with Benois and his group, all of whom were great enthusiasts of music and theatre. Indeed, the theatre was an integral component of the intellectual and creative activities of the World of Art members. The demands they made in the visual arts regarding an artistic and stylistic integrity were extended to the theatre. This happened to coincide with other efforts to reform stage design, especially scenic painting. Here the way was

paved by the Private Russian Opera of Moscow. Its patron, Savva Mamontov, invited to design sets, not the art staff of the Imperial Theatres, who adhered to rigid stereotypes, but such highly talented easel-painters as Vasily Polenov, Victor Vasnetsov, Mikhail Vrubel, Konstantin Korovin, Valentin Serov and Isaac Levitan. The overall reform of the stage by Konstantin Stanislavsky and Vladimir Nemirovich-Danchenko at the Moscow Art Theatre — founded in 1899 — naturally served to renovate stage design. In this field Konstantin Korovin and Alexander Golovin were most closely connected with the World of Art. In the early 1900s they designed several productions at the Bolshoi Theatre in Moscow and at the Maryinsky Theatre in St Petersburg.

In 1902 Bakst first tried his hand at stage design with a production of the French pantomime *Le Cœur de la Marquise* [*The Heart of the Marchioness*] at the Hermitage Theatre of the Imperial Court in St Petersburg. Though his sketches still had vestiges of his training in book illustration, they were conspicuous for their Empire-style elegance and their refined colour scheme. These traits asserted themselves in his decor for Josef Bayer's *Die Puppenfee* [*The Fairy Doll*], produced at the Hermitage and Maryinsky Theatres in the following year.

Indeed, this ballet, which had little to recommend it, was completely transformed into a festive, poetic spectacle, thanks to the stage designer's talent and aesthetic sensibility. In his presentation of the two worlds, one of everyday happenings, the other where the toys are brought to life, Bakst displayed a remarkable ability for conveying the cheerful, bright fantasy of the fairy-tale and its traditional romantic dichotomy.

Bakst's sketches of the real-life personages of this ballet vividly reproduced the St Petersburg social life of the 1850s. Most exciting, though, were the figures of the dolls, which were astonishing in their refined draughtsmanship and meticulous presentation of faces, hairstyles and detailing of the garments. What was apparent here was the inherent affection of a World of Art artist for expressive details and 'charming trifles'. 'One simply cannot tear one's eyes away from these admirable costumes, in which each dot, each splash, each bow, each curl, gloves and even beauty spots are so precisely conceived and so indispensable from the point of view of colour,'[17] one reviewer commented.

It was *Die Puppenfee* that made Bakst's name in the world of the musical theatre. His reputation was further established by the sets he designed for two classical tragedies: Euripides' *Hippolytus* and Sophocles' *Oedipus at Colonus*, in 1902 and 1904 respectively, at the Alexandrinsky Theatre in St Petersburg. Thus far antiquity had been represented on the stages of the Imperial Theatres in what one might term its classical version; that is, in the form of a Greece of white marble, populated by men and women of ideal proportions garbed in snow-white robes, who spoke only with 'rounded gestures'. However, the action in these two tragedies was set in a far earlier period, in the archaic chapter of Greek history. With this in mind Bakst turned to the ancient myths and epics and studied the artifacts excavated by Schliemann and Evans at Troy, Tiryns, Mycenae and Crete. Fascinated by the simplicity and perfection of archaic elements, he decided to introduce them into his scenery and costumes.

His setting for *Hippolytus* was both simple and dynamic. One sees a square in the Peloponnesian town of Troezen, with the palace of King Theseus in the background. In front of the palace are the huge, archaic statues of Aphrodite and Artemis, the two goddesses whose

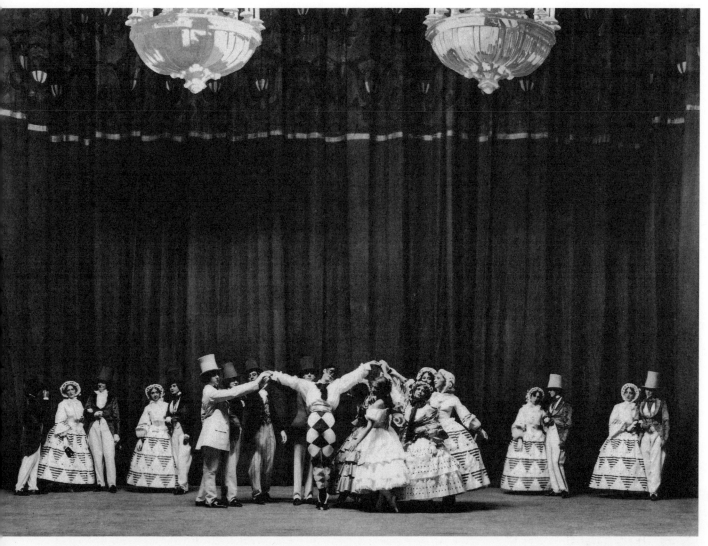

rivalry provoked the tragedy. The artist had conceived their hieratic, static oppressiveness as symbolic of the tragedy's basic message. In their desire to create an effect reminiscent of the ancient theatre, the two directors, Yuri Ozarovsky and Dmitry Merezhkovsky, introduced a chorus that Bakst placed on the lower proscenium, around the sacrificial altar whence fumes of incense curled upwards. The grim-visaged courtiers, with their pointed beards, wearing flowing cloaks and chitons, the warriors in their tall helmets, holding large round shields, the women with their curling locks, dressed in long pleated tunics, and the mute dark-skinned slaves, all served to create a living picture conjured up from the days of the ancient Greeks. The many-coloured costumes, the angularity of the silhouettes and the somewhat jerky, sharp movements were in marked contrast to the hitherto current notions of 'ancient' Greece. The costumes were abundantly embellished with the type of ornaments encountered on ancient Greek pottery and in ancient Egyptian art. With the meticulous attention he paid to every detail, Bakst sketched all the props, and used make-up on the actors' bodies as well as on their faces, to create greater verisimilitude. The costumes designed for the two productions, though historically authentic, nevertheless possessed a precisely measured dose of scenic convention and artistic generali-zation. In short, this was no superficial stylization, but a talented reinterpretation of the very spirit

of ancient times. 'The severe and noble colouring of Bakst's costumes and his highly intelligent interpretation of classical dress were unique; nothing of the sort had been seen either in the Russian theatre or in any other theatre in the world,' Benois wrote.[18]

Even more than in *Die Puppenfee*, the productions of these two Greek tragedies revealed the singular features of Bakst as a stage designer. These were his ability to offer an independent, original and bold interpretation, the richness of his imagination, and, chiefly, his fundamentally novel understanding of the role played by costume on stage. His most meticulously executed costume sketches were undoubtedly works of art in their own right. They were more than simple sketches of garments. They were actual portraits of the people in their characteristic attitudes. At the same time, the sharply delineated contours, the clear-cut drawing, the precise use of colour and the detailed directions as to cut, colour and material to be used, made these sketches totally comprehensible to the costumier. Bakst indeed went further than simply providing the sketch; not infrequently he himself chose the necessary fabrics, supervised the making of the costumes and was present at the fittings.

Bakst's talents were not appreciated by the management of the Imperial Theatres. On the other hand, they were readily acknowledged by the dancers, singers and actors who began to ply him with commissions. What brought about the great change in his destiny was the collaboration between the World of Art artists, especially Bakst and Benois, and the budding choreographer, Michel Fokine. Indeed, Bakst was, in the late 1900s, associated with Fokine's debut.

Also in line with Bakst's interests at this period was his involvement with Vera Komissarzhevskaya's drama company. With her sensibility attuned to new trends in art and her desire to keep abreast of the times, she became close friends with a group of Symbolist writers and invited Vsevolod Meyerhold to direct at her new theatre. At this time not only theatre people, but also poets, novelists and artists energetically debated the theatre's destiny, producing an intensive search for new theatrical forms. The then young actor and director Meyerhold, noted for his ventures into the theory and practice of the conventional stage, advocated the repudiation of naturalism and verisimilitude in favour of symbolic conventions, emphasizing theatricality. He attached great significance to decor, which he viewed as crucial for conveying the basic message of the play. The repertory billed for the opening season of the Komissarzhevskaya company consisted of plays by Henrik Ibsen, Hugo von Hofmannsthal, Maurice Maeterlinck, Leonid Andreyev and Alexander Blok, and showed clearly a move towards Symbolism.

The Elysium that Bakst depicted on the Komissarzhevskaya theatre curtain was in its way 'a flight into a dream'. By enticing the viewer into a phantom world, where figures in white and blue garments flitted among flowering groves and classical temples, the artist created a mood that was in harmony with the spirit of the Komissarzhevskaya company. Incidentally, the artist's well-known 'Elysium' panel of 1906 is a later version of this curtain.

Bakst first collaborated with Meyerhold in 1908, in a joint effort to produce Oscar Wilde's *Salomé* at the Mikhailovsky Theatre in St Petersburg, with Ida Rubinstein in the title role. The highlight was to have been the 'Dance of the Seven Veils', which Fokine choreographed to the music of Alexander Glazunov. Bakst had enthusiastically agreed to design the sets and

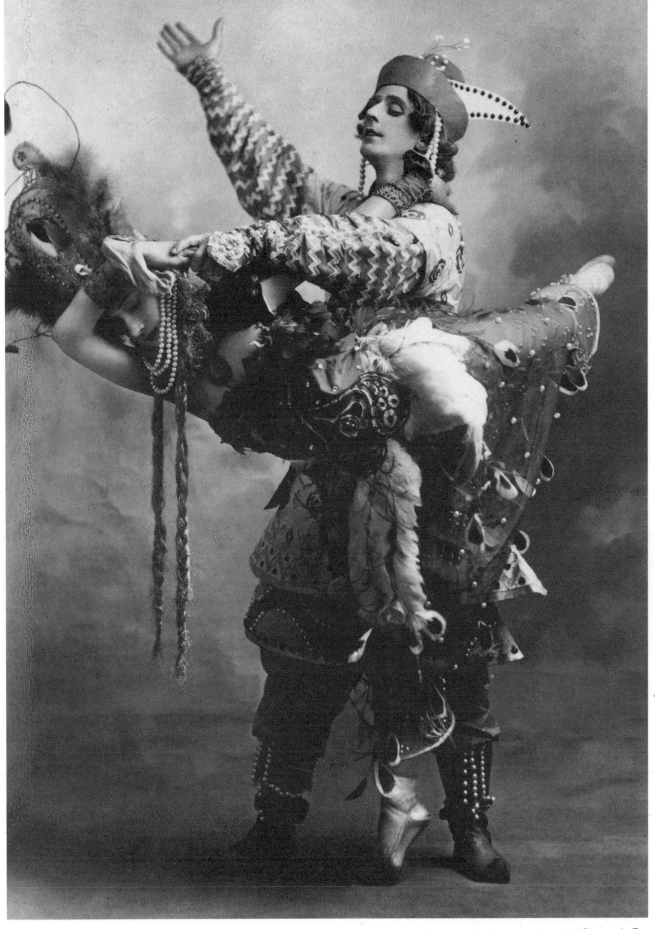

Tamara Karsavina as the Firebird and Michel Fokine as the Tsarevich Ivan in *L'Oiseau de Feu*

costumes. He was attracted to the biblical Orient's colourful, monumental character. However, *Salomé* was banned by the Imperial censors a few days before the first night, as the Russian clergy suspected an affront to Orthodoxy. Still, the inspired labours of Bakst, Meyerhold and Fokine were not completely wasted. Some six weeks later Ida Rubinstein performed the 'Dance of the Seven Veils' at a recital at the St Petersburg Conservatoire; she wore the costume Bakst had designed and danced in front of his set. She later repeated this performance abroad.

The *Salomé* costume sketch is in fact a portrayal of Rubinstein performing the 'Dance of the Seven Veils'. In it a transparent scarf of a cerulean blue flutters behind her back. The strings of pearls winding around her body seem to follow the overall rhythm of her movement. The pale face, the elegant arms and legs, the flowing lines and the colour scheme of soft pale-blue and greyish tones produced an unconventional image of the Judaean princess that was largely consonant with the lyrical nature of the image created by Oscar Wilde. Though Bakst was subsequently to return to this subject, he never had so complete a success. His sketches for later productions of *Salomé* in Paris betray an Art Nouveau pretentiousness; we no longer feel the poetic grace of the image; instead it has become cruder, more corporeal.

Bakst's stage designs for the two Greek tragedies and *Die Puppenfee* reveal two basic aspects of his work which are, as a rule, tentatively designated the Oriental and the Romantic. We can see these trends develop in his work for the Ballets Russes.

Bakst's creative efforts cannot truly be separated from Sergei Diaghilev's initiatives and ventures. The World of Art exhibitions, which ended in 1903, left Diaghilev's tremendous vitality far from exhausted. In 1905 he mounted (at the Tauride Palace in St Petersburg) a stupendous exhibition of Russian portraits. Next came the 1906 retrospective show of Russian art. Visitors to this were astounded not only by the abundance of remarkable Russian works of art, ranging from icons to modern pieces, but also by Bakst's interior decoration. He repeated it for the Russian art show that Diaghilev organized at the Salon d'Automne in Paris in that same year. 'The decoration of the exhibition,' Alexander Shervashidze commented, 'its cosiness, the restrained luxury of the first three rooms, lined with a faintly glittering brocade, the elegant mini-garden with a very good bust of Paul I in the middle and with greenery and flowers up above and down below (which amazed the French visitors) is superb. The other rooms were decorated with printed stuff, accentuated by a fine frieze of thin wooden boards tinted to match. The mini-garden and friezes were designed by Bakst, truly one of the cleverest and most gifted decorators of the day, who naturally enjoys well-deserved success.'[19]

This exhibition, which translated into reality Diaghilev's long-cherished wish to 'exalt' Russian painting in the western world, demonstrated the high standard of Russian art and signally contributed to the popularity of Russian culture in Europe. In 1907 Diaghilev arranged five recitals of Russian music at the Paris Grand Opéra. In 1908 he produced Modest Mussorgsky's opera *Boris Godunov*, with the bass Fiodor Chaliapin in the title role. This was a sensation; Parisian opera lovers were profoundly moved both by the music and by this singer's powerful and original talent.

When Alexander Benois first suggested taking Russian ballet abroad Diaghilev responded enthusiastically, and engaged Anna Pavlova, Mathilda Kshessinska, Tamara Karsavina, Vera Fokine, Vaslav Nijinsky, Vera Karalli, Mikhail Mordkin, Adolf Bolm, Sofia Fedorova and

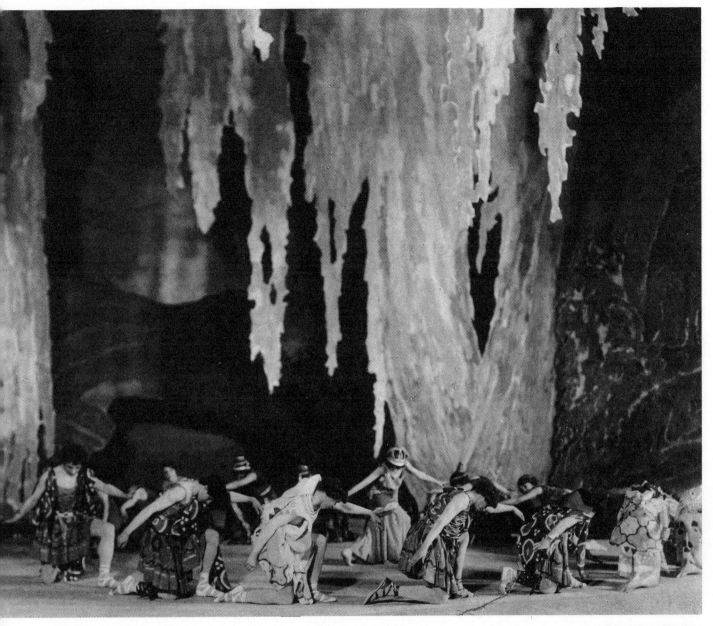

Ekaterina Geltzer, star dancers of the Maryinsky Theatre in St Petersburg and the Bolshoi Theatre in Moscow. He also invited, as choreographer, the young and gifted Michel Fokine, who sought to revitalize ballet by making it more modern, more striking and closer to the mainstream of art in general. Fokine saw painting as crucial to ballet productions, and this led him to seek contacts with the World of Art artists, who became co-directors of his ballets. He maintained that costume innovation could not be separated from dance innovation, and in the ballets he choreographed dance is most intimately associated with the decor, the painterly, plastic elements almost coming to dominate.

Diaghilev's company had its debut in the spring of 1909 at the Théâtre du Châtelet in Paris. The designs that Bakst produced for the ballet *Cléopâtre*, which was presented during the first Russian season, earned him unprecedented success. The setting of an Egyptian temple was conspicuous for its clarity and conciseness. Without attempting to reproduce faithfully Egyptian architecture, the designer summarized his conception of this architectural style by emphasizing

its solemn and austere monumentality. Here again, as in some of his previous work, the historical material served only as a point of departure for his stylization. He said: 'I always sought to convey the music of the image, shaking off the shackles of archaeology, chronology and mores.'[20]

The decoration, in which orange-gold blended with azure-blue, produced the sensation of blazing heat that excellently conveyed the stern spirit of the play, with its rituals, sacred rites and tragic dénouement; it was a fitting frame for the action. The costume sketches for *Cléopâtre* disclosed the artist's immeasurably increased mastery, with the line now more sinuous, the silhouette more expressive, the form more plastic and the colour far richer.

Still more sensational was the éclat with which his production of the ballet *Schéhérazade* was received when it opened at the Paris Opéra the following season. When the curtain rose, the audience was dazzled with the sight of the sumptuous, fabulously rich apartments of the Khan's harem. The walls and ceiling were resplendent with mosaics and paintings; the floor was covered with a red carpet on which scarlet rugs stood out as dark splashes of colour; gold and silver lamps were suspended from above. Spectators were greatly impressed by the emerald-green silk curtains, lavishly ornamented with pink and gold. One sensed in their colouring, texture and ornamental design the Oriental languor and lyricism characteristic of the entire production. The freely organized setting produced the illusion of a real-life interior, while the undulating and mingling contours of the objects introduced a dynamic element.

The colouring dominated the sets. The vivid greens, blues, reds and pinks created a sense of Oriental opulence and luxury. It was the colouring which produced a definite emotional response, an appropriate mood in the audience, the moment it was revealed. The intensity of the colour scheme, dominated by reds and greens, already introduced something mysteriously ominous, a mood that expressed the gist of the sensual poetry of the *Arabian Nights* and emphasized the moving drama of Rimsky-Korsakov's music. As he worked on the decor for *Schéhérazade*, Bakst drew mainly upon Persian miniatures, to which he added motifs from Turkish and Chinese ornaments, thus synthesizing his conceptions of Oriental art.

The costumes were in perfect harmony with the scenery. They echoed the basic colours of the sets and thus served to promote and complement the main colour scheme. In his costume designs Bakst used pure, primary colours, contrasted in a daring, at times sharply accentuated, manner. Yet, despite the vivid chromatic character of the decor and the abundance of movement, full harmony reigned on the stage. This was attained by an unerring choice of tones and a strict adherence to the rhythm of the colour scheme. Everything was attuned to one basic key, with even the smallest details geared to the overall concept.

Schéhérazade disclosed for the first time Bakst's full coloristic potential. In this production, colour engendered an exceptionally great emotional impact. One notes that Bakst was able to adapt the colour scheme to the music and by means of the various nuances of colour, enhance the feelings produced by the music. To convey the mood generated by the music through colour, to interpret in a painterly way the emotional sensuality inherent in the music — this was the most significant innovation to occur in theatre design for many years.

Bakst possessed an unerring sense of colour. He displayed a capability for both blending and contrasting his colours, discovering unprecedented combinations which served to create a

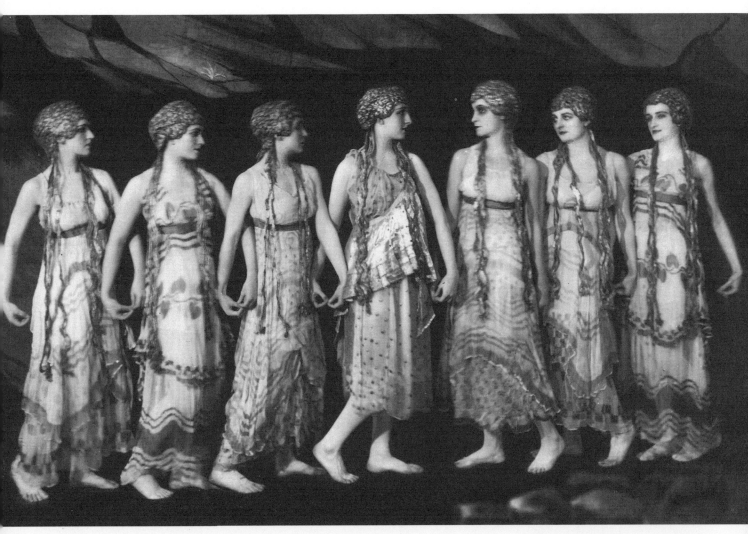

Scene from *L'Après-midi d'un Faune*

new resonance and produce unexpected effects. In his careful study of the mise-en-scène he traced the movements of every single person in order to correlate the design and colour of his or her costume with those of the other people on stage. 'My mise-en-scènes,' he said, 'are the products of a deliberately designed arrangement of splashes of colour against the background of the sets... The costumes of the leading players dominate and blossom within the bouquet of the other costumes.'[21]

Schéhérazade made a sensational impression. 'Paris is enchanted by this creative effort of Bakst's, as spicy, sensuous and vivid as Oriental fabrics and semi-precious stones, impregnated with the aroma of the Orient,' Yakov Tugendhold, the St Petersburg correspondent of the *Apollon* journal, wrote.[22]

The production had a marked influence on French theatre and on the efforts of easel-painters. Oriental-style furniture, rugs, carpets, coloured cushions, vivid textiles with Oriental ornamental designs, headdresses in the form of turbans and sundry other 'exotic' items came into fashion. The top Paris couturiers — Worth, Paquin, Poiret — based their dresses on Bakst's costumes. Bakst unexpectedly found himself an arbiter of Parisian fashion. Maximilian Voloshin wrote: 'Bakst... has been able to find that elusive nerve that rules fashion, and currently his influence is felt everywhere in Paris, both in ladies' frocks... and at picture

shows.'[23] The desire to introduce a note of beauty and aesthetic taste into everyday life induced him to design textiles and ladies' clothes.

The Orient was brilliantly interpreted once again, this time in Bakst's decor for Gabriele d'Annunzio's mystery play, *La Pisanella*, which Ida Rubinstein's company performed at the Théâtre du Châtelet in 1913. The action is set in the kingdom of Cyprus in the thirteenth century. 'The time is a most curious one, a time I know well; one which has yet to see itself presented on stage,' he wrote to the producer, Vsevolod Meyerhold. 'The overall character is languorously magnificent and blazingly mad. A whole heap of colours, and... contrasts.'[24] The artist's enthusiastic approach to the material was manifested in his four sets and myriad costumes, as well as different, richly ornamented curtains for each act. The show was seen as a brilliant carnival of stylization and symbolism, which both artist and director held close to their hearts. *La Pisanella* was an intricate, opulent production that could be compared only to *Schéhérazade* in its breadth of approach, scale of artistic imagination and power of painterly temperament.

Though Bakst was entranced by the Orient, he was also eager to present Greece on the stage. In 1911 and 1912 he produced stage designs for four productions based on ancient myths: *Narcisse*, *Daphnis and Chloë*, *L'Après-midi d'un Faune* and *Helen of Sparta*, the last for Ida Rubinstein's company. These were markedly different from the productions he had done a decade earlier for the Alexandrinsky Theatre in St Petersburg. In these four Bakst scaled the heights of artistic expression. His concept of ancient times had broadened and his approach was likewise modified. In addition to studying ancient art, literature and archaeology, he also drew on the personal impressions he had gained from his travels in Greece. Thus the olive grove in *Narcisse*, the austere, rusty-red cliffs in *Daphnis and Chloë* and the wild, rocky landscape in *Helen of Sparta* are all echoes of what he had seen on first setting foot in Greece. But his impressions of contemporary Greece were not enough, and he introduced a note of archaic austerity which he modified by filtering it through the prism of twentieth-century aesthetic concepts and his own *Weltanschauung*. Thus what Alexander Blok said about the writer Viacheslav Ivanov is equally valid of Bakst: he 'construed the ancient symbols in conformity with the logic of his own modern heart and mind'.[25]

Among Bakst's masterpieces may be ranked the costume sketches for the Boeotians and Bacchantes in the 1911 ballet *Narcisse*. Their robust figures, presented in highly dynamic motion from complex angles, and their dances, permeated with healthy sensuality, are frankly reminiscent of the peasant women of Delphi with their 'muscular sun-bronzed legs',[26] whose crude perfection of form had struck the artist during his travels in Greece. Movement constitutes a salient feature of his costume sketches. With his sensitive ear for music and a fine understanding of the specific features of choreography, he conveyed through his sketches movements that were archetypal. Together with the body, the garments 'spring to life', in tune with an overall dynamic rhythm, and they serve to accentuate the position of the arms, legs and torso. Compositional balance was also attained with the help of long scarves which enveloped the figures of the dancers. The colours employed in the *Narcisse* sketches are vibrant and full-bodied; combinations of two colours, in the fabric and the ornamental designs, are seen in most of the costumes: green and blue, orange and pink, yellow and orange or red and violet; and when Bakst brings various costumes together in the dance, he seeks to counterbalance

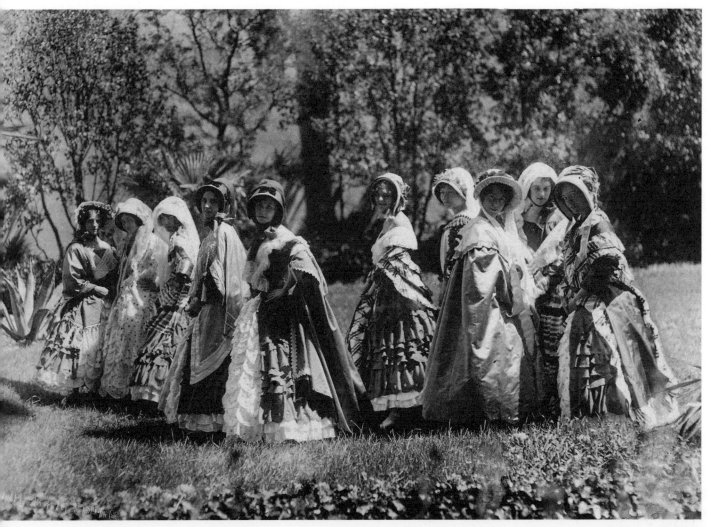

Scene from *Papillons*

contrasting colours. Most vividly manifest in his *Narcisse* sketches are his characteristic feelings for colour, line and plasticity. Noting that these sketches were executed 'with a calligraphically sure hand in marvellous, vibrant colours', Benois compares them to the 'drawings of Eisen, Toyokuni and other charming Japanese connoisseurs of costume and ornament'.[27] Their expressiveness, their intricate angles and a certain preciousness cause these sketches to show a particular affinity with Art Nouveau graphic works.

Another major success for Bakst was the costume and make-up he designed for the Faun in the ballet *L'Après-midi d'un Faune* to the music of Claude Debussy (1912). The brown leotard with its large, dark splotches was highly reminiscent of the hide of an animal. The abbreviated wig and golden horns narrowed the forehead, while the make-up emphasized the elongated eyes and the skull and also made the mouth larger, the lips thicker and the nose fleshier, thus giving the face a naive, infantile expression. Igor Stravinsky recollected that 'in the production of this ballet Bakst played possibly the main role, doing the sets, marvellous costumes and even furnishing tiny movements in the choreography.'[28] Yet Bakst's designs for the backdrop and the costumes, which conformed to his usual style of painterly illusion, jarred with the Constructivist principle that Nijinsky employed in the choreography. The tendencies that Nijinsky introduced in his production of *L'Après-midi d'un Faune* were further elaborated by him in his ballet to

27

Stravinsky's music, *Le Sacre du Printemps*, which was produced in 1913, with designs by Nikolai Roerich, and, in a lighter mood, in a ballet originally planned as a divertissement, *Jeux*, to the music of Claude Debussy, with designs again by Bakst. In this second production, also in 1913, Nijinsky intended to show athletic movements expressed lyrically — his aim was to convey the dynamic spirit of the day. The setting of the story was a garden party, and the subject was love, revealed through a tennis game. For the first time a choreographer introduced the theme of sport, and dancers — a boy and two girls — in sports clothes. The plasticity of their dance, their simplified angular gestures and movements, unbending knees and sharply bent elbows had an affinity with Cubism, which had by now established itself in the visual arts. The stage design and decor accentuated the choreographer's concept; one saw a lawn, framed by bright green trees and flowerbeds that were somewhat geometrical. In the background were yellow rectangles, representing buildings.

L'Après-midi d'un Faune, *Jeux* and also the later (1917) production of the ballet *Les Femmes de Bonne Humeur*, in the first version of which Bakst introduced Constructivist elements, displayed his attempts to conform to the latest trends in art. However, he was unable to renege on his own creative credo. While accepting Cubism in easel-painting, he believed it to be unacceptable for the musical theatre, and he completely repudiated Constructivism on the stage. On the other hand, Diaghilev, who gravitated to everything fashionable and acutely contemporary, eagerly turned to this newest trend in western art. Characterizing the evolution of the Ballets Russes, Anatoly Lunacharsky noted: 'From Bakst, Benois and Fedorovsky via Goncharova to Picasso and Braque.'[29]

As Diaghilev grew increasingly dissatisfied with Bakst's creative tendencies, he twice asked avant-garde artists to do productions that he had originally commissioned from Bakst. André Derain designed the ballet *La Boutique Fantasque* in 1919 and Léopold Survage designed the opera *Mavra* in 1922. In the early 1920s Bakst and Diaghilev broke off relations. The last designs Bakst produced for Diaghilev were for *The Sleeping Beauty* in 1921.

Due to his amazingly multi-faceted gift for stage design, Bakst was able to create, in addition to the colourful, dynamic decor for productions on Oriental and Greek themes, highly lyrical settings for Romantic ballets. Thus, billed at the Grand Opéra in Paris in 1910, at the same time as *Schéhérazade*, was the ballet *Le Carnaval*. His costumes for this piece were refined, elegant and delicately coloured in pastel tints, expressing a light, bubbling humour which magnificently corresponded to the character of the music and the choreography. In his comments on the ballet Michel Fokine noted: 'Bakst transports the spectator into the age of Schumann, a time of German Romanticism, with its conventionally studied grace and heightened sensuality, an age of melancholic daydreaming.'[30] Again, his inspired Romantic decor for the ballet *Le Spectre de la Rose*, to the music of Carl Maria von Weber, which was produced in 1911, cannot truly be separated from the choreography and the music. The artist designed the set, a girl's bedroom, in the German Biedermeier style of the 1830s and 1840s. The young man's costume, a leotard dappled with pieces of fabric cut to resemble rose petals of different reds and pinks, evokes immediate associations with the graceful, tender blossom.

For Bakst the peak of his Romantic period was his decor for Tchaikovsky's *The Sleeping Beauty*, which Diaghilev presented at the Alhambra Theatre in London in 1921, under the title

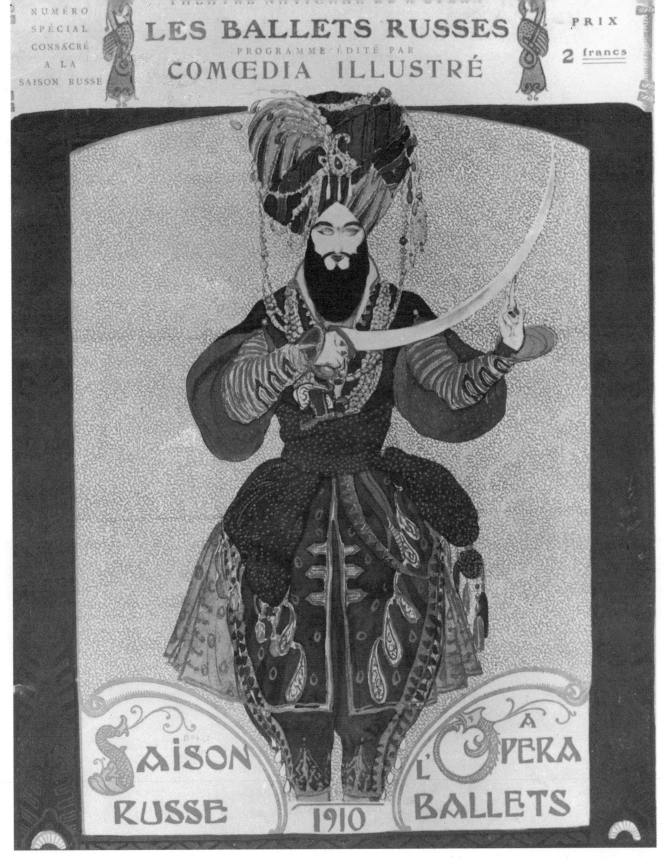

NUMÉRO SPÉCIAL CONSACRÉ A LA SAISON RUSSE

LES BALLETS RUSSES
PROGRAMME ÉDITÉ PAR
COMŒDIA ILLUSTRÉ

PRIX
2 francs

SAISON RUSSE — 1910 — A L'OPERA BALLETS

Cover for *Comoedia Illustré*, 1910

The Sleeping Princess. This time Bakst was faced with a particularly heavy responsibility. This popular ballet, which had first been produced by Marius Petipa, and which already had a thirty-year history on the Russian stage, had its own established traditions. Nonetheless, Bakst did not copy either the first Maryinsky Theatre production of 1890 — which had required a team of five designers — or the second, 1914, production, when that master of theatrical painting,

Konstantin Korovin, had done the designs. Bakst chose his own approach, which brimmed over with innovation.

The settings for the Prologue, based on a blend of white, red and gold, were solemnly festive. The capacious hall was flanked on either side by slender columns. The colourful backdrop created an illusion of a broad flight of stairs with another hall opening to the left, beyond the landing. Bakst's perfect command of linear and aerial perspective, and his use of the achievements of the eighteenth-century Italian monumentalists enabled him to transform the limited area of the stage into two magnificent halls by trompe l'œil alone. The sumptuous Baroque elements were in perfect keeping with the resonant intensity of colour that was characteristic of Bakst's Post-Impressionist style.

The scene of the festivities held in honour of Aurora's coming-of-age was a grassy lawn in a park, set against the background of an elegant, sparkling-white double colonnade. Beautifully conspicuous amidst the greens and whites were the crimson splashes of the dancing peasants' costumes and the differently coloured courtiers' dresses. The end of this scene was conceived in a most effective manner, one that was uncommon at the time. After the princess fell asleep, two rows of lilac-bushes gradually hid the now slumbering kingdom, the Lilac Fairy appearing in a gap between the shrubs, lit only by the glow of the rising moon.

In the hunting scene, autumn (in the first production the action took place in summer) engendered a nostalgic sadness, in keeping with the prince's mood. The landscape's brown and grey colour scheme served as a fine foil for the golden-chestnut, olive, light-green and muted-blue splashes of the costumes of the hunters. The somewhat subdued and restrained colour scheme reminded one of a medieval French tapestry.

For a ballet in the early 1920s, when 'chamber theatre' was prevalent in the west, so impressive a production, with six different sets and about 300 costumes, appeared stupendous. Turning again to the tradition of illusory scenic design, Bakst challenged contemporary art with its urge for simplification and stereotype.

Bakst spent the twilight of his life working primarily for the Paris Opéra. He not only designed the sets but also wrote the books for some of the pieces he produced. At the same time, he painted portraits, gave lectures on theatrical art and modern-dress fashions and wrote articles and essays.

As a world-famous master, an arbiter of elegance and good taste, Bakst was elected to membership of multitudes of art, theatrical and music societies and associations in France and elsewhere. Exhibitions of his work were mounted in various cities of Europe and America. However, in the hurly-burly of life he felt lonely, and at times was obsessed by deep nostalgia. 'His fame was his tragedy. I well remember my last meeting with him and what he said about having no time to do what he really wanted,'[31] Dobuzhinsky wrote about his mood at the time.

A man of brilliant original gifts, Bakst also possessed great charm which appealed to everyone he met. His manner was both natural and simple. 'To work with Bakst,' Valerian Svetlov said, 'was a real delight; he was a delicate, well-bred man; even when he did not agree with somebody, he used to defend his own opinions but hesitatingly and he was liable to yield the ground as soon as he met with a weighty argument. Alien both to self-esteem and to blind obstinacy, he was a very sincere and simple man.'[32]

Bakst's creative œuvre, which is diverse, complex and at times contradictory, largely reflects the specific features of the ideological and artistic life of both Russia and western Europe towards the close of the nineteenth century and throughout the first quarter of the following century. His bold search, his romantic fervour and his perfect grasp of the salient features of contemporary culture, were all geared to one objective: attaining beauty and harmony in art and in life.

Léon Bakst is one of those Russian artists whose creative efforts are held in high esteem throughout the world. Though more than sixty years have passed since his death, time has not diminished the regard in which he is held. To this day exhibitions of his work are mounted and articles and monographs are still devoted to him. It is true that in the literature published in western Europe and America, Bakst is seen almost exclusively as a stage designer who was affiliated with Diaghilev's Ballets Russes. Though stage designs unquestionably constitute the most valuable part of his legacy, Bakst, as a true World of Art artist, succeeded in many fields. He was an excellent portrait painter, a clever book illustrator and a fine dress designer and interior decorator.

Speaking of the important role played by early twentieth-century Russian stage designers and more specifically of Bakst, Anatoly Lunacharsky wrote, '...in the realm of theatre art, especially set and costume design... such eminent Russian artists as Roerich, Benois, to some extent Yuon and Dobuzhinsky and, above all, Bakst, created a real revolution. True, not everyone accepts the superfluous extravagance and brilliance of the Russian decorative palette, the overly independent, at times even dominant, role of the stage designer. Yet the influence Bakst exerted, which is reflected in many theatrical productions, transcended the limits of the theatre and modified the style of ladies' fashions and interior decoration. The names of Bakst and his fellow artists whose talents were devoted to the service of the theatre shall remain in the history of Europe's artistic culture.'[33]

[1] A. Lunacharsky, 'A Russian and an American at the Paris Season', in *On Music and the Musical Theatre*, vol. 1, p. 178, Moscow, 1981 (in Russian)

[2] *Alexander Golovin: Encounters and Impressions, Letters, Reminiscences about the Artist*, p. 68, Leningrad and Moscow, 1960 (in Russian)

[3] Letter from Bakst to A. Benois dated 15 August 1893, Paris (MSS department of the Russian Museum, Leningrad, fund 137, storage unit 666, sheets 12–13) (in Russian)

[4] A. Benois, *Reminiscences of the Russian Ballet*, p. 188, London, 1947 (in English)

[5] A. Blok, *Snow Mask*, St Petersburg, 1907 (in Russian)

[6] A. Sidorov, 'Russian Illustrative Art', in *The Russian Nineteenth-Century Book*, vol. 2, p. 314, Moscow, 1924 (in Russian)

[7] Letter from Bakst to L. Gritsenko-Bakst dated 19 October 1905, St Petersburg (MSS department of the Tretyakov Gallery, Moscow, 111/194) (in Russian)

[8] V. Rozanov, *Among Artists*, p. 102, St Petersburg, 1914 (in Russian)

[9] 'Portrait Group by Leon Bakst, Noted Russian Artist, Exhibited', *The Baltimore Sun*, 26 March 1924 (in English)

[10] Letter from Bakst to L. Gritsenko-Bakst dated 26 July 1903, St Petersburg (MSS department of the Tretyakov Gallery, Moscow, 111/104) (in Russian)

[11] S. Mamontov, 'Exhibition of the Union of Russian Artists', *Russkoye slovo* [*The Russian Word*], 29 December 1909 (in Russian)

[12] A. Benois, 'Letters on Art: The Salon Once Again', *Rech* [*Speech*], 10 February 1909 (in Russian)

[13] L. Bakst, *With Serov in Greece: Travel Notes*, p. 9, Berlin, 1923 (in Russian)

[14] M. Voloshin, 'Archaic Features in Russian Painting: Roerich, Bogaevsky and Bakst', *Apollon* [*Apollo*], No. 1, p. 43, 1909 (in Russian)

[15] L. Bakst, 'Classical Trends in Art', *Apollon* [*Apollo*], No. 3, p. 61, 1909 (in Russian)

[16] Y. Obolenskaya, 'At Zvantseva's School, under the Guidance of L. Bakst and M. Dobuzhinsky, 1906–1910' (MSS department of the Tretyakov Gallery, Moscow, fund 5, storage unit 75, sheet 15) (in Russian)

[17] N. O⟨ttoka⟩r, 'Theatre and Music. The Ballet', *Rech* [*Speech*], 10 November 1909 (in Russian)

[18] A. Benois, *Reminiscences of the Russian Ballet*, p. 228, London, 1947 (in English)

[19] A. Shervashidze, 'Russian Art Exhibition in Paris', *Zolotoye runo* [*The Golden Fleece*], Nos. 11/12, p. 131, 1906 (in Russian)

[20] Y. Tugendhold, 'Marc Chagall', *Apollon* [*Apollo*], No. 2, p. 14, 1916 (in Russian)

[21] Letter from Bakst to S. Diaghilev dated 28 April 1911, Paris [?] (MSS department of the Russian Museum, Leningrad, fund 137, storage unit 2631, sheets 3–5) (in Russian)

[22] 'Art News from the West: France', *Apollon* [*Apollo*], No. 6, p. 78, 1911 (in Russian)

[23] M. Voloshin, 'Parisian Art Shows', *Moskovskaya gazeta* [*The Moscow Daily*], 28 September 1911 (in Russian)

[24] Letter from Bakst to V. Meyerhold dated 10 August 1912, Paris (Central Archives of Art and Literature, Moscow, fund 998, storage unit 997, sheets 2–3) (in Russian)

[25] A. Blok, 'The Work of Viacheslav Ivanov' in *Collected Works*, vol. 5, p. 12, Moscow, 1962 (in Russian)

[26] L. Bakst, *op. cit.*, p. 16

[27] A. Benois, 'New Ballets: *Narcisse*', *Rech* [*Speech*], 22 July 1911 (in Russian)

[28] *Igor Strawinsky: Leben und Werk*, p. 41, Zurich, 1957 (in German)

[29] A. Lunacharsky, 'The Entertainer of the Gilded Crowd: News from Diaghilev's Season', in *On Theatre and Play-writing*, vol. 2, p. 341, Moscow, 1958 (in Russian)

[30] Copy of Michel Fokine's notes concerning the production of *Le Carnaval*, p. 7 (M. Fokine Archives in the Leningrad Museum of Theatre and Music) (in Russian)

[31] M. Dobuzhinsky, 'Bakst as I Remember Him', *Segodnia* [*Today*], 6 January 1925 (in Russian)

[32] V. Svetlov, 'Reminiscences', in *Unedited Works of Bakst*, p. 116, New York, 1927 (in English)

[33] A. Lunacharsky, 'Russian Performances in Paris', *Sovremennik* [*The Contemporary*], Nos. 14/15, p. 257, 1914 (in Russian)

THEATRICAL DESIGNS

Bakst was among the first artists who, in collaboration with Benois, sought to create a new Russian ballet. He devoted himself to the ballet for many years, almost to the exclusion of everything else. He gave the ballet a great deal; a richness of colour, a feeling for the times, and costumes unlike the old ballet costumes...

Michel Fokine

He was exotic, fantastic — reaching from one pole to the other. The spice and sombreness of the east, the serene aloofness of classical antiquity were his.

Tamara Karsavina

As for the costumes, they are beyond compare. In this field Bakst, from the outset (while still in Russia working on *Le Cœur de la Marquise* and *Die Puppenfee*), took a dominant position and has remained unique and unexcelled ever since... Admiration is evoked both by the artist's boundless fantasy and by his amazing discoveries regarding the blend and very *quality* of colours. What also arouses admiration is the mastery with which this is all done... It is no wonder that his costumes, which in their day served to create enchanting theatrical effects, today remain precious works of art.

Alexander Benois

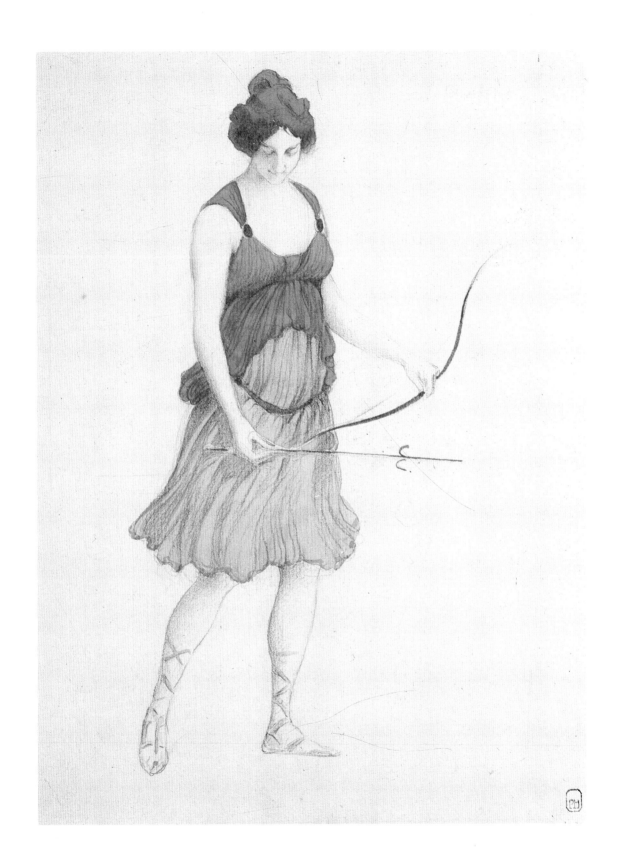

1 NYMPH HUNTRESS

Costume design for Léo Delibes' ballet *Sylvia*. 1901

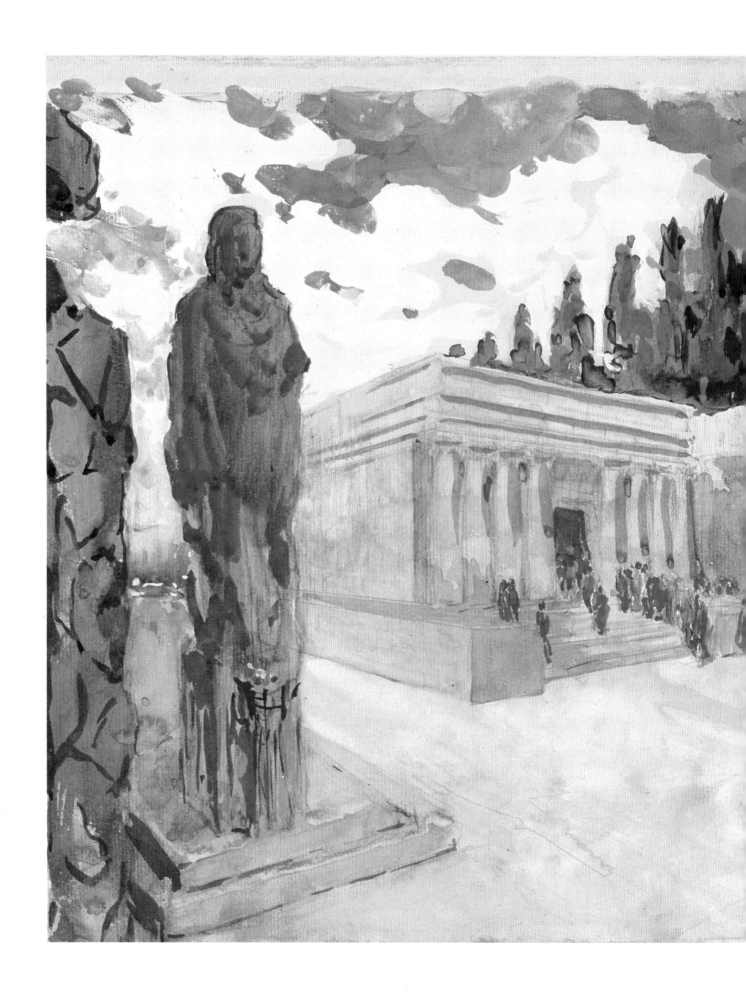

2 Set design for Euripides' tragedy *Hippolytus*. 1902

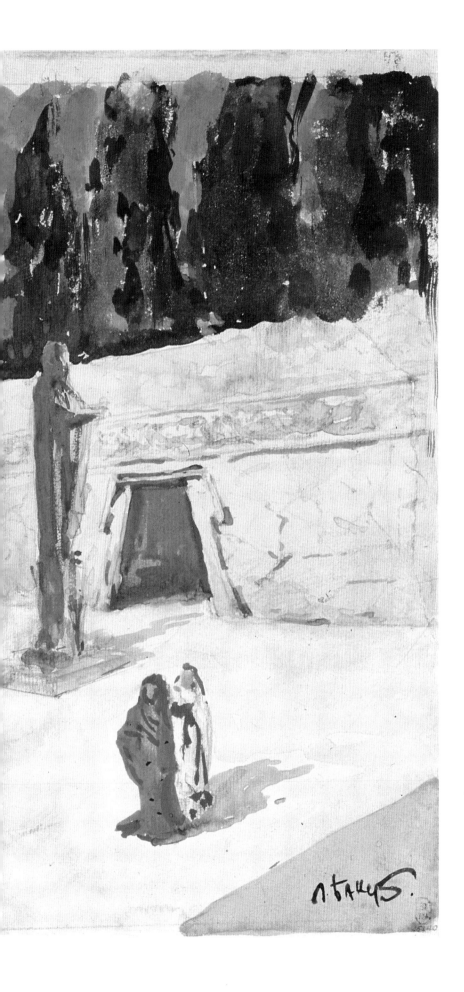

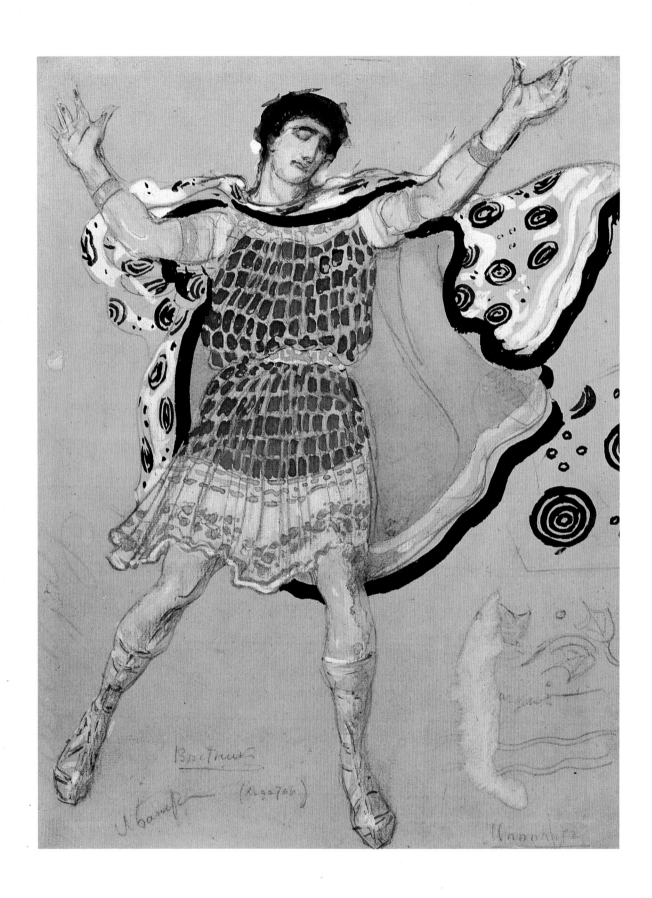

3 HERALD

Costume design for Euripides'
tragedy *Hippolytus*. 1902

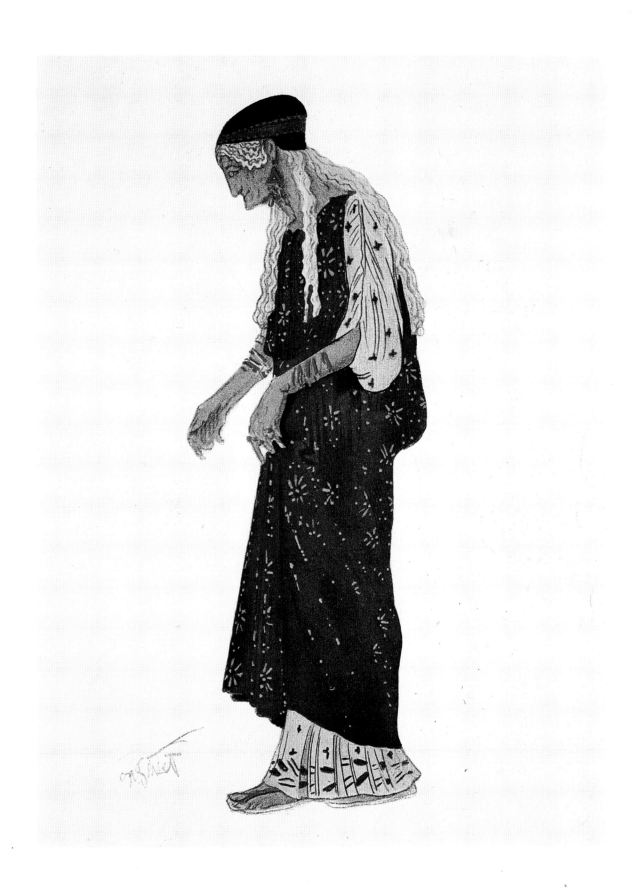

4 NURSE

Costume design for Euripides'
tragedy *Hippolytus*. 1902

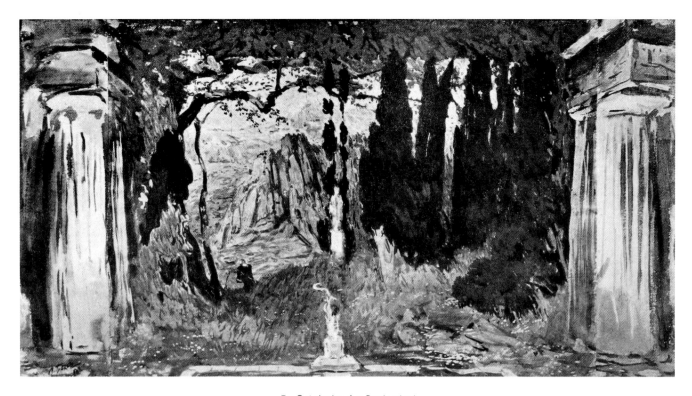

5 Set design for Sophocles'
tragedy *Oedipus at Colonus*. 1904

6 Set design for Josef Bayer's
ballet *Die Puppenfee*. 1903

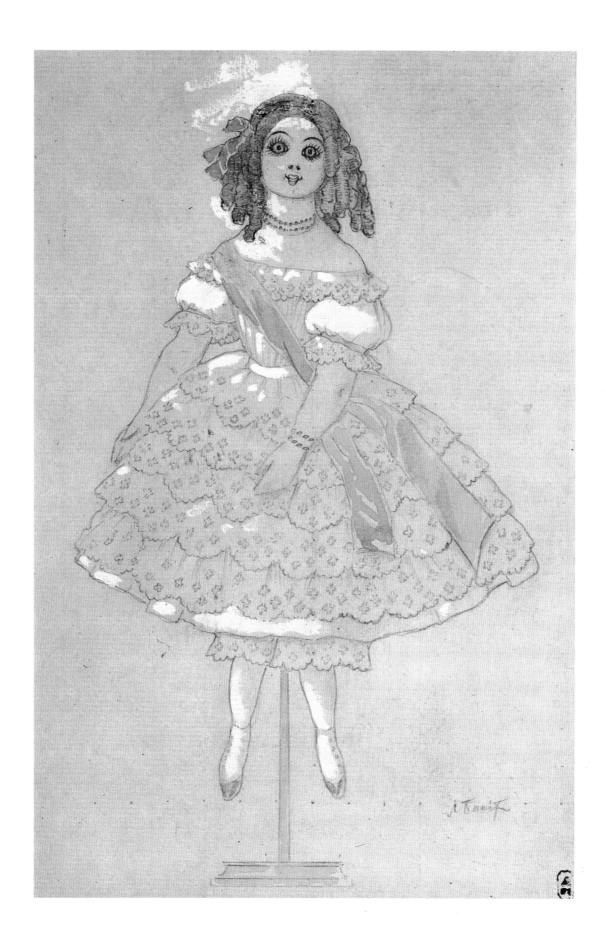

7 CHINA DOLL

Costume design for Josef Bayer's
ballet *Die Puppenfee*. 1903

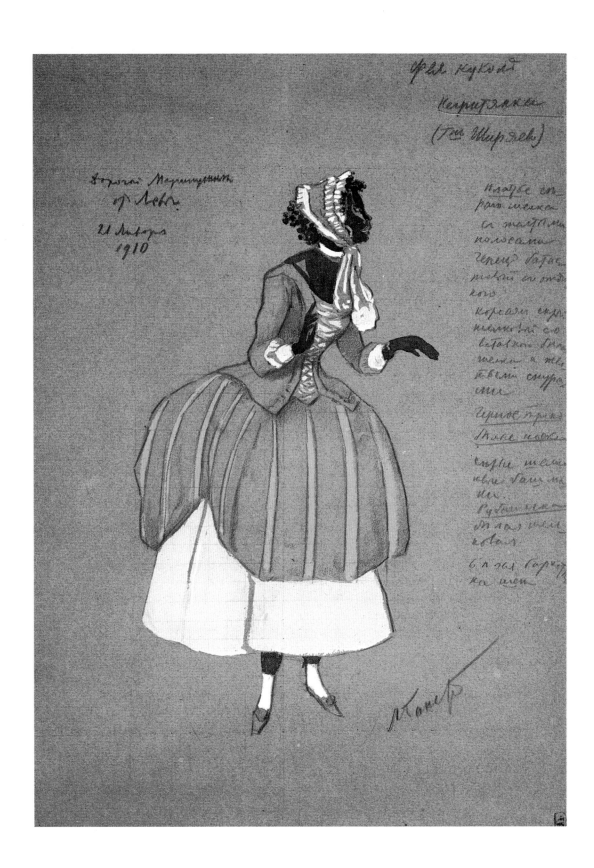

8 NEGRO DOLL

Costume design for Josef Bayer's
ballet *Die Puppenfee*. 1903

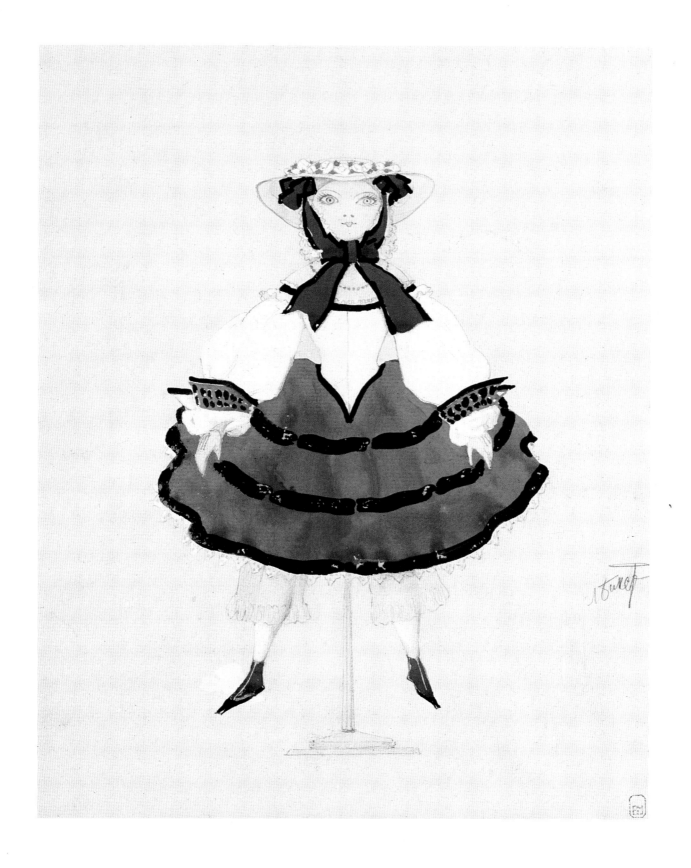

9 FRENCH DOLL

Costume design for Josef Bayer's
ballet *Die Puppenfee*. 1903

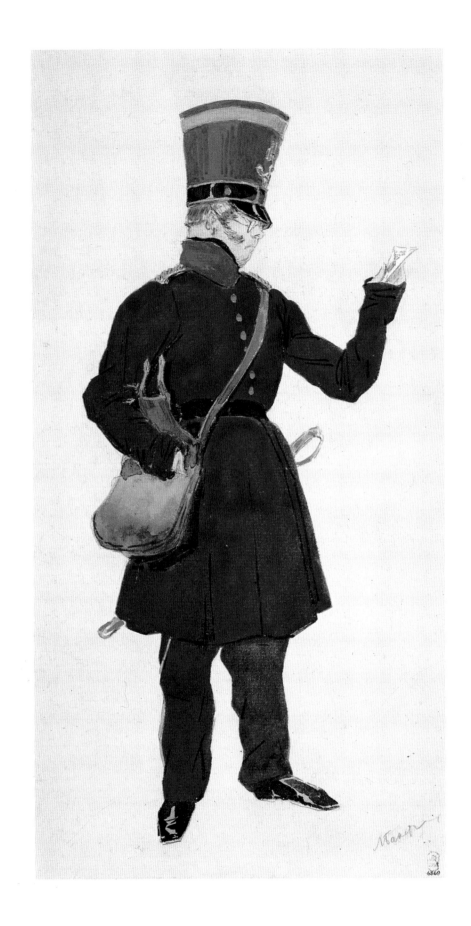

10 POSTMAN

Costume design for Joseph Bayer's
ballet *Die Puppenfee*. 1903

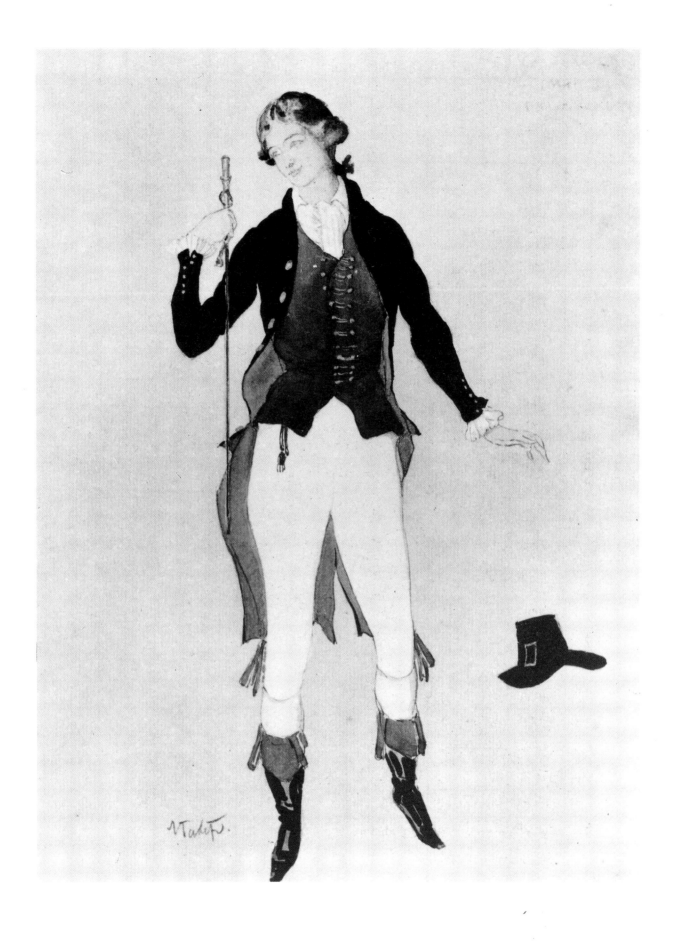

11 WILHELM MEISTER

Costume design for Leonid Sobinov
in Ambroise Thomas' opera *Mignon*. 1903

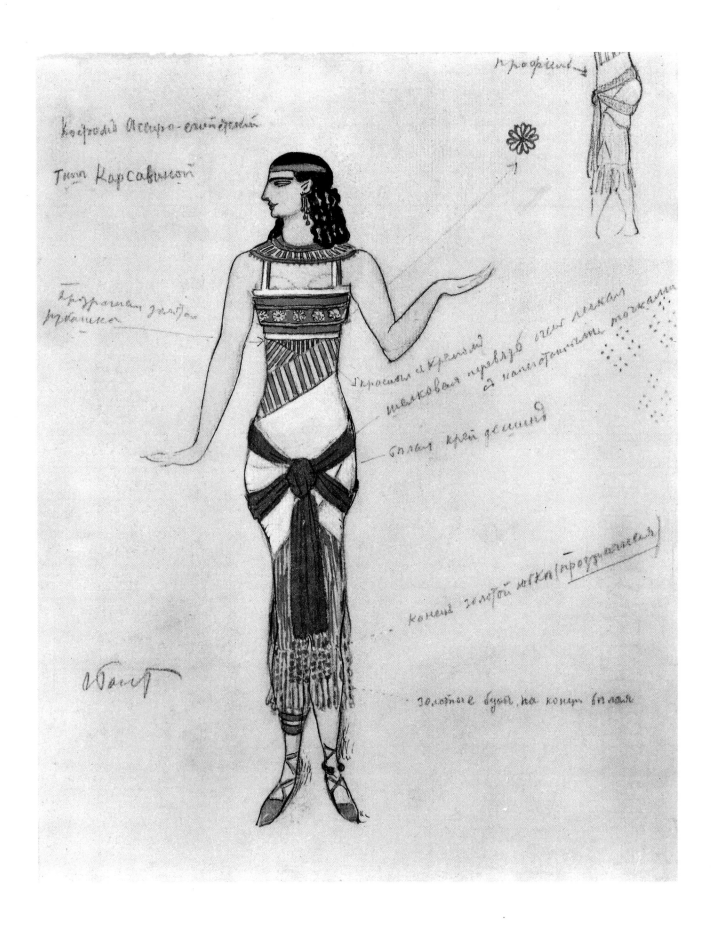

12 TORCH DANCE

Costume design for Tamara Karsavina. 1907

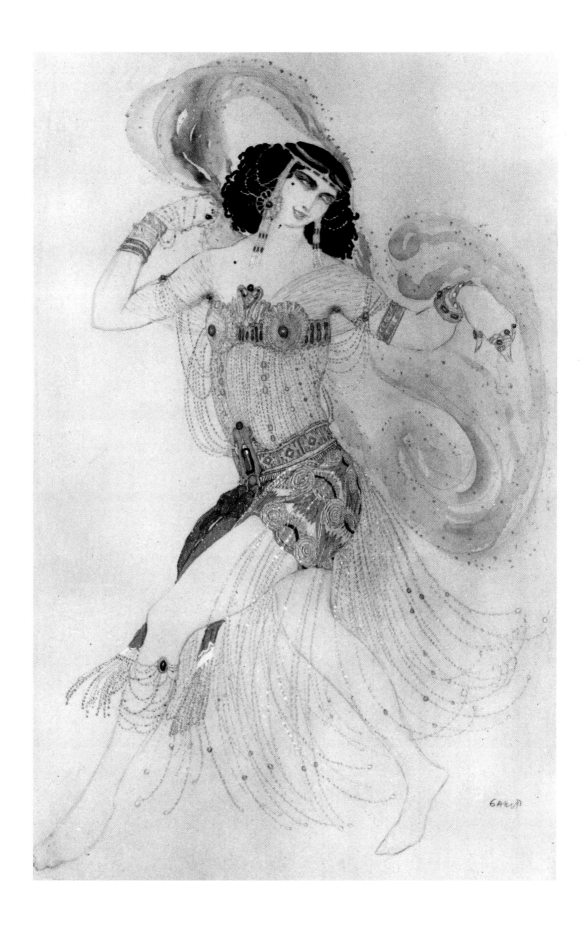

13 SALOMÉ

Costume design for Oscar Wilde's play of the same name. 1908

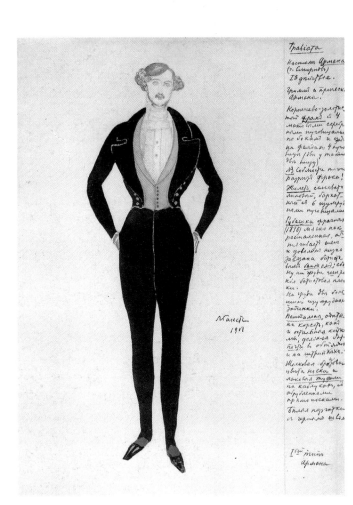

14 ARMAND

Costume design for Giuseppe Verdi's
opera *La Traviata*. 1908

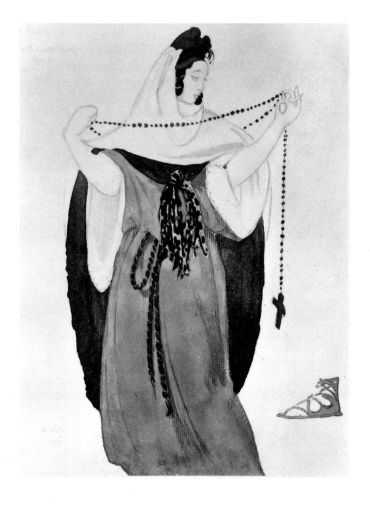

15 THAÏS

Costume design for Maria Kuznetsova in Jules Massenet's
opera of the same name. 1910

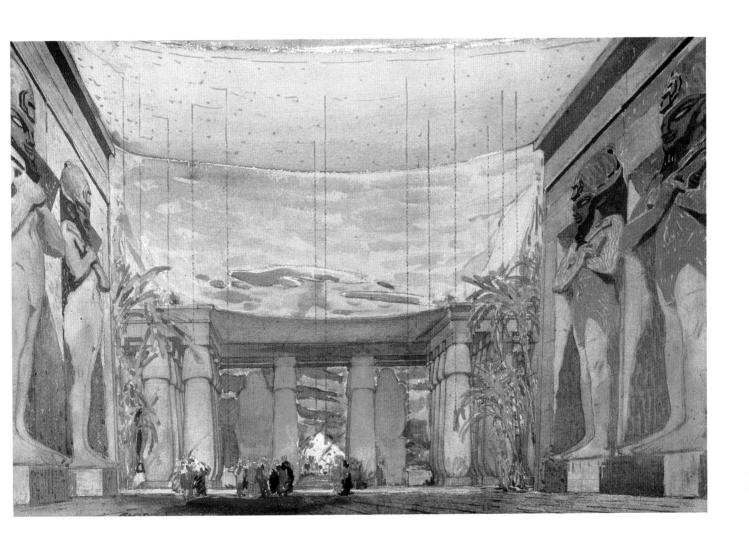

16 Set design for the ballet *Cléopâtre* to the music of Anton Arensky
and other Russian composers. 1909

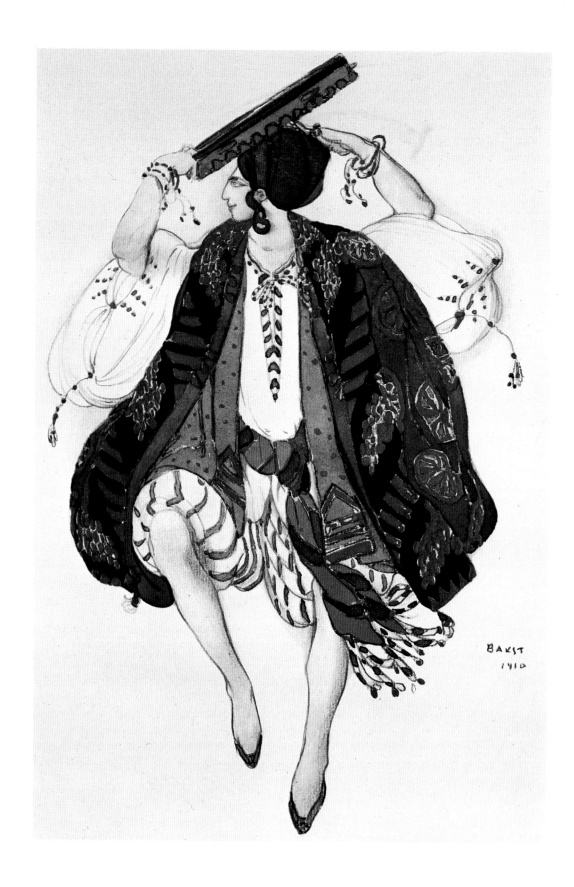

17 JEWISH DANCE

Costume design for the ballet *Cléopâtre* to the music of
Anton Arensky and other Russian composers. 1910

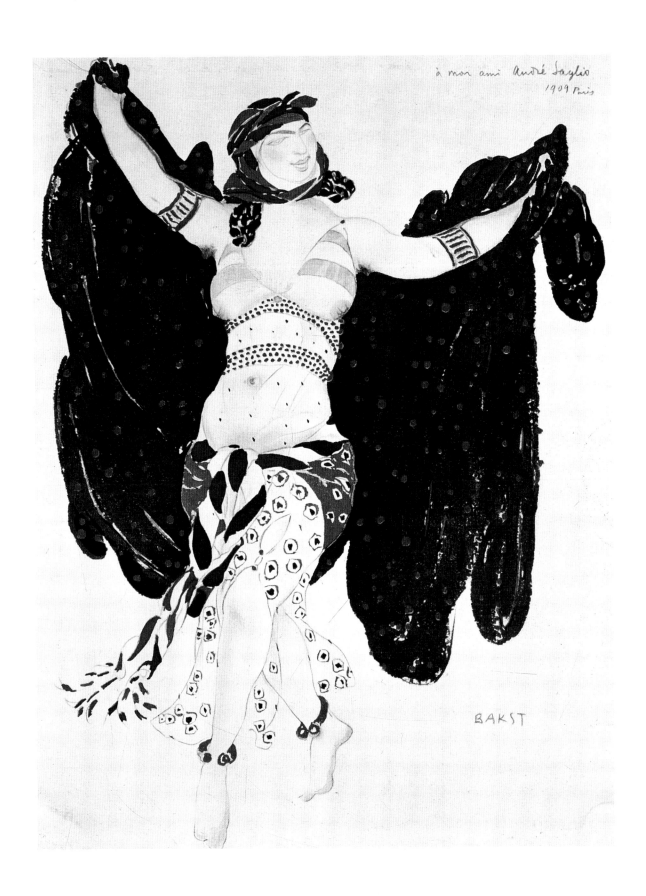

à mon ami André Saglio
1909 Paris

BAKST

18 SYRIAN DANCE

Costume design for the ballet *Cléopâtre* to the music of
Anton Arensky and other Russian composers. 1909

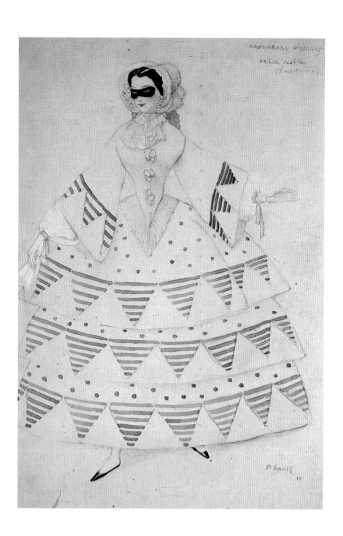

19 VALSE NOBLE

Costume design for the ballet *Le Carnaval*
to the music of Robert Schumann. 1910

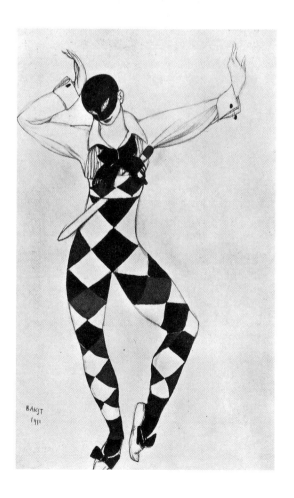

20 HARLEQUIN

Costume design for the ballet *Le Carnaval*
to the music of Robert Schumann. 1910

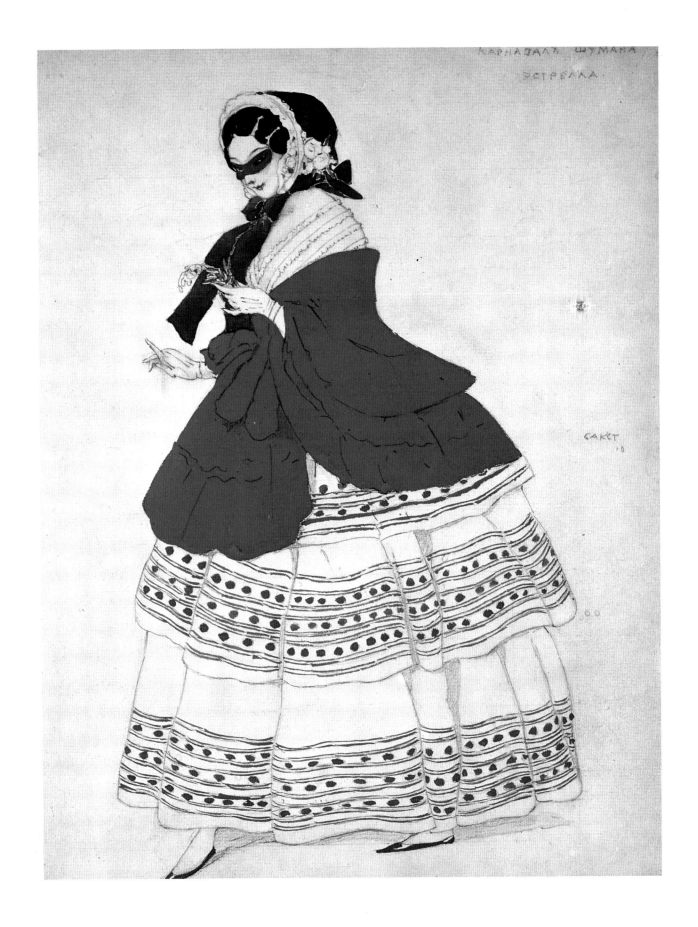

21 ESTRELLA

Costume design for the ballet *Le Carnaval*
to the music of Robert Schumann. 1910

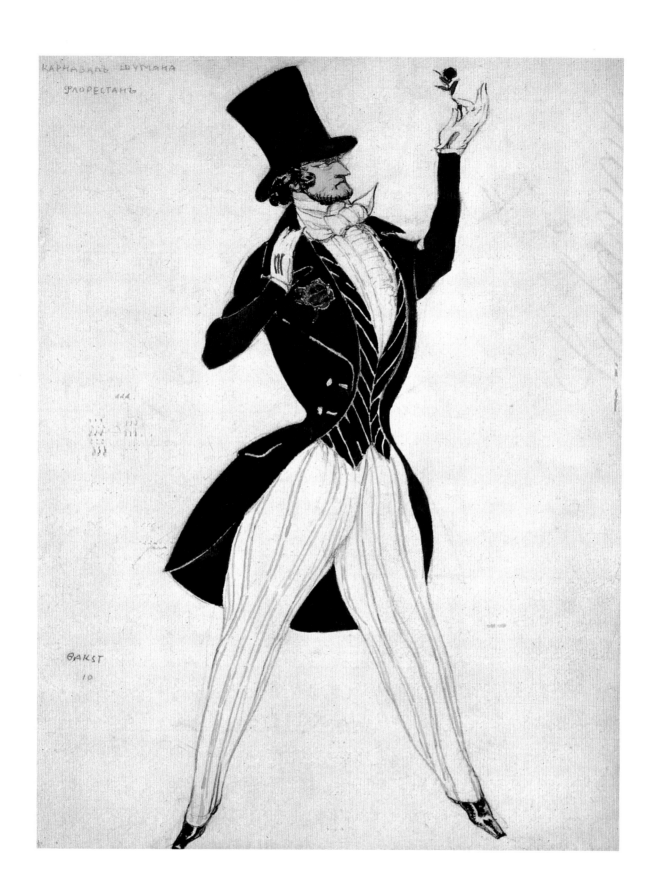

22 FLORESTAN

Costume design for the ballet *Le Carnaval*
to the music of Robert Schumann. 1910

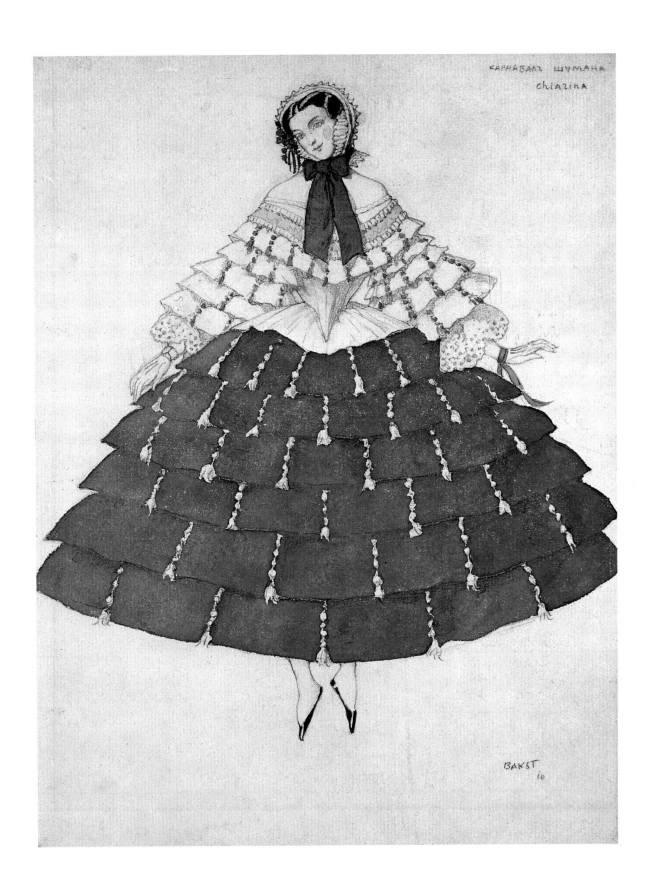

КАРНАВАЛ ШУМАНА
chiarina

BAKST
10

23 CHIARINA

Costume design for the ballet *Le Carnaval*
to the music of Robert Schumann. 1910

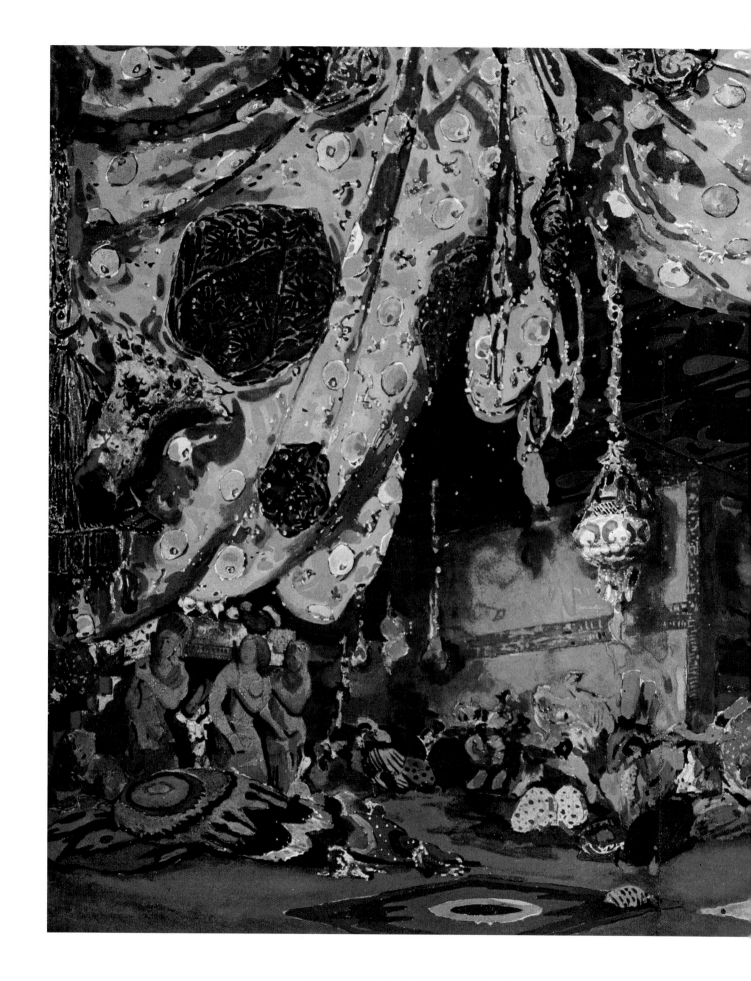

24 Set design for the ballet *Schéhérazade*
to the music of Nikolai Rimsky-Korsakov. 1910

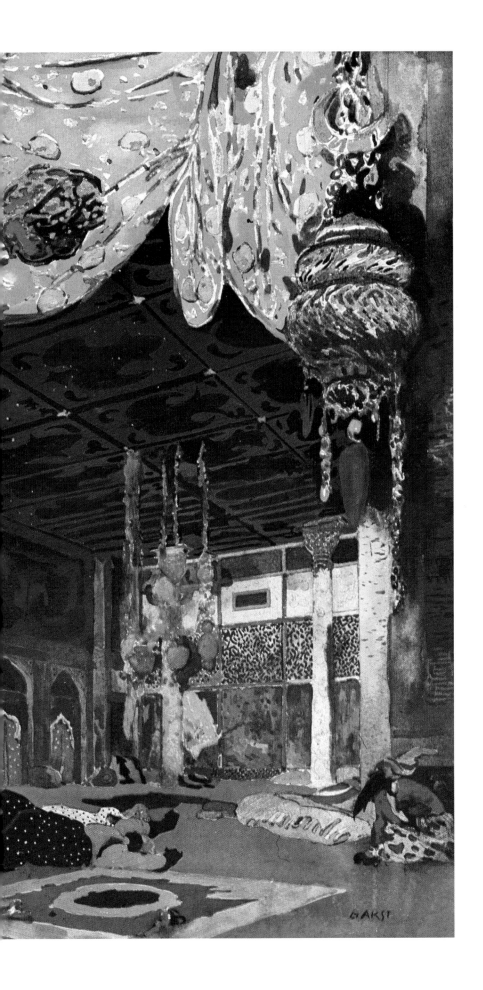

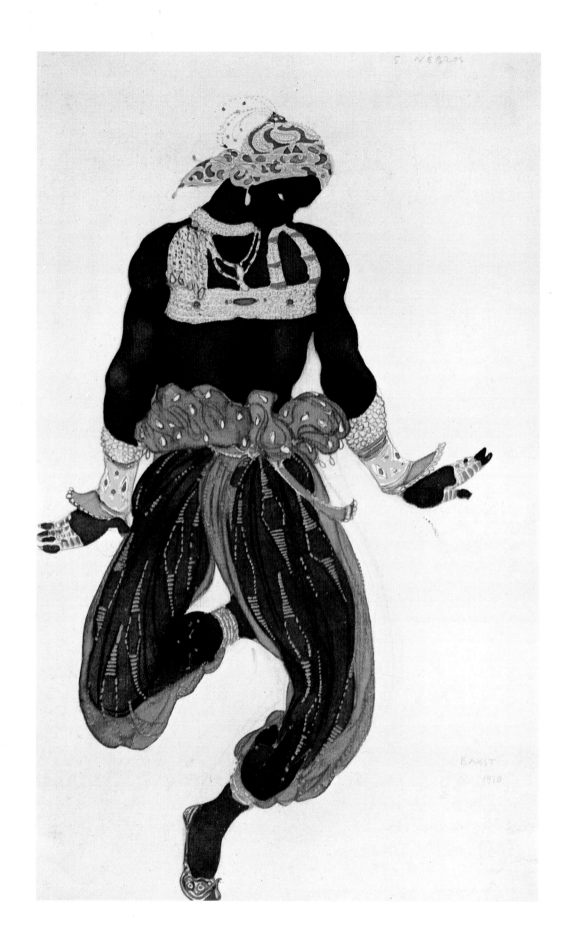

25 SILVER NEGRO

Costume design for the ballet *Schéhérazade*
to the music of Nikolai Rimsky-Korsakov. 1910

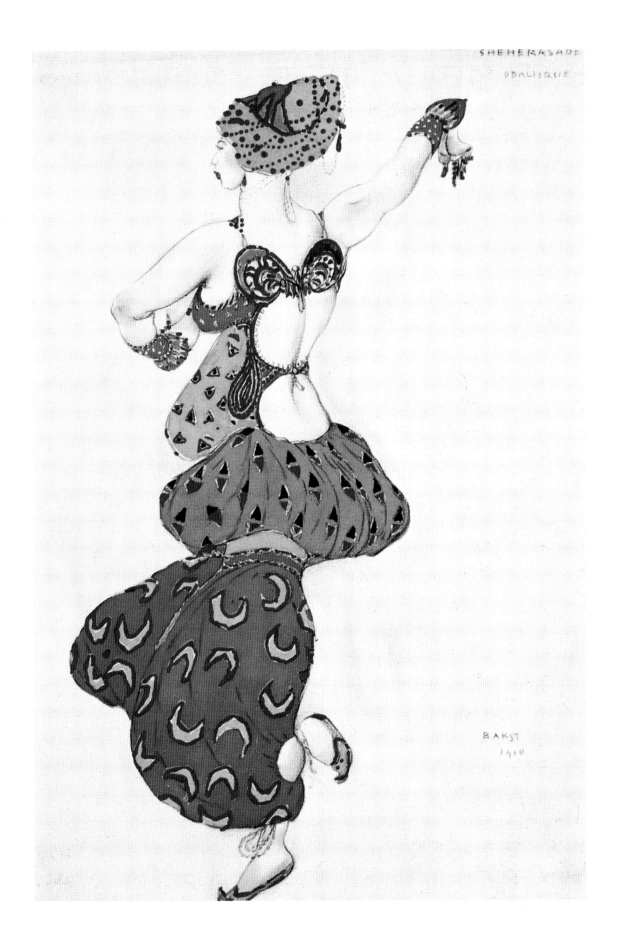

BAKST
1910

26 ODALISQUE

Costume design for the ballet *Schéhérazade*
to the music of Nikolai Rimsky-Korsakov. 1910

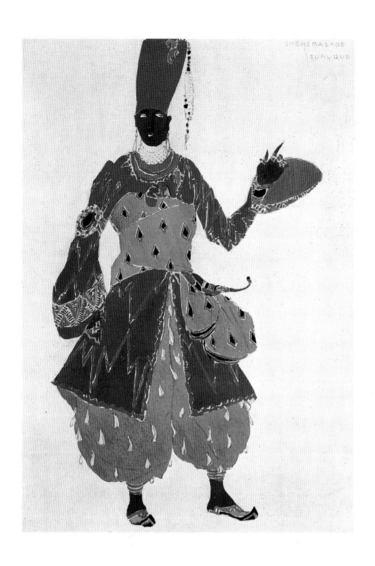

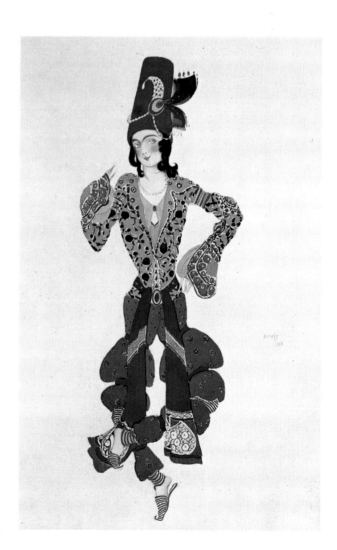

27 EUNUCH

Costume design for the ballet *Schéhérazade*
to the music of Nikolai Rimsky-Korsakov. 1910

28 YOUNG INDIAN

Costume design for the ballet *Schéhérazade*
to the music of Nikolai Rimsky-Korsakov. 1910

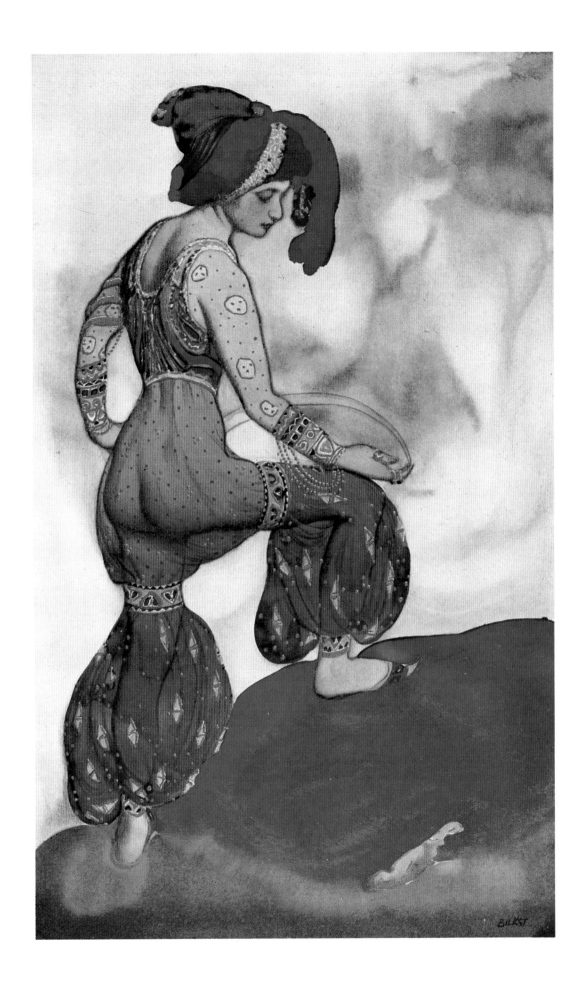

29 THE RED SULTANA. 1910

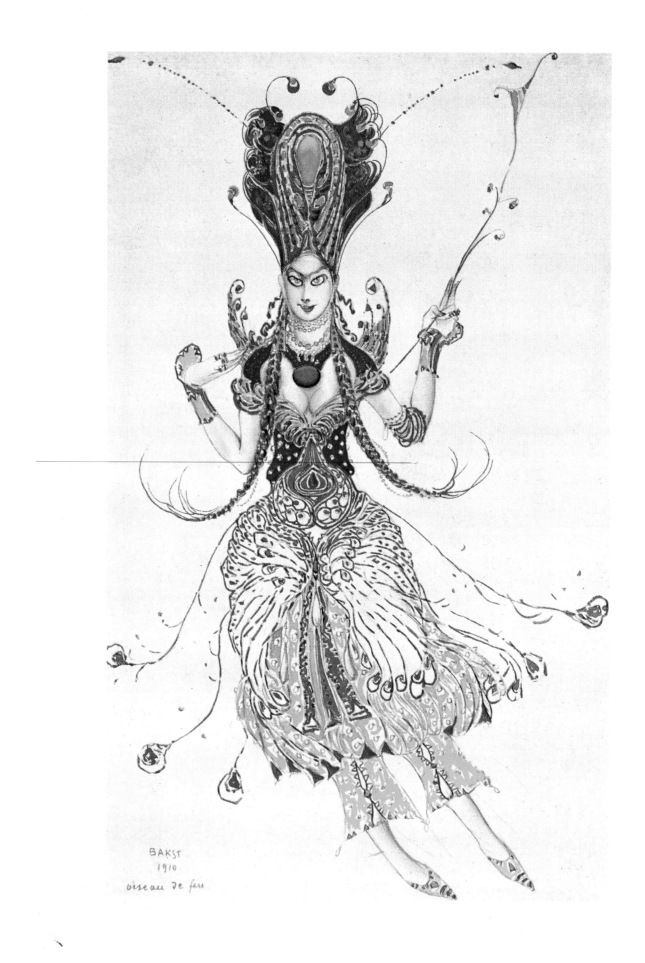

30 THE FIREBIRD

Costume design for Igor Stravinsky's
ballet *L'Oiseau de Feu*. 1910

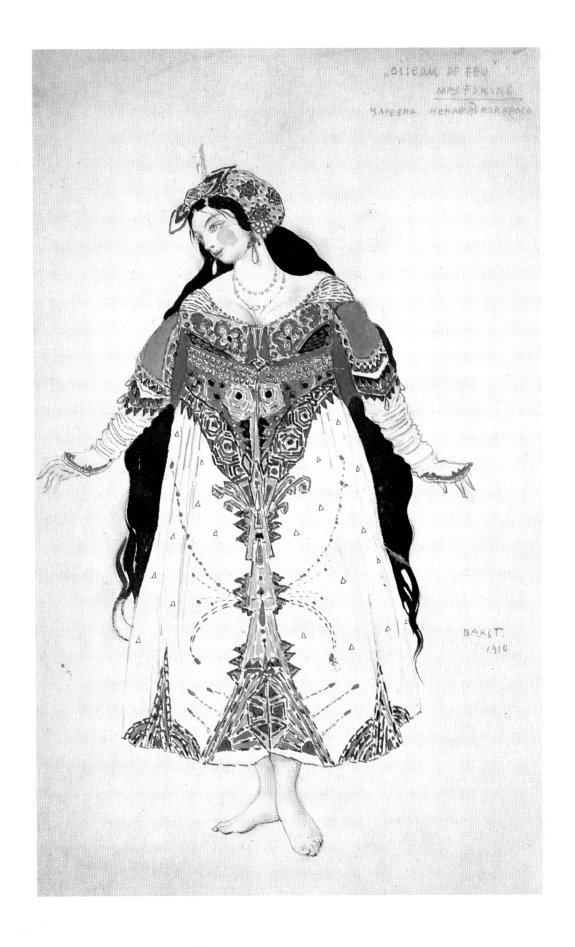

31 THE TSAREVNA

Costume design for Igor Stravinsky's
ballet *L'Oiseau de Feu*. 1910

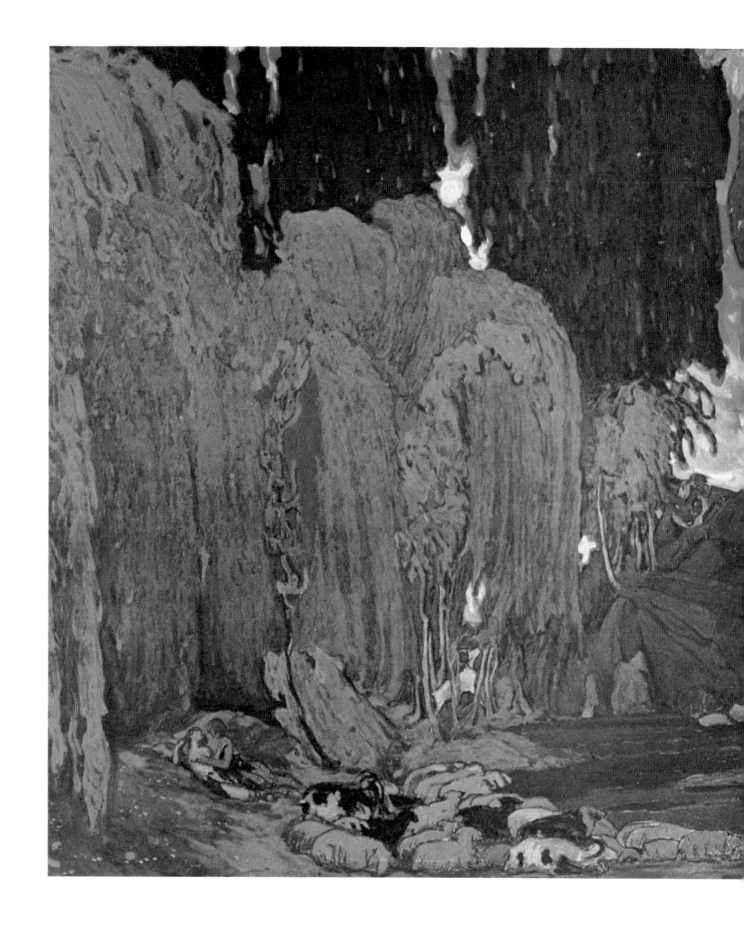

32 Set design for Nikolai Cherepnin's
ballet *Narcisse*. 1911

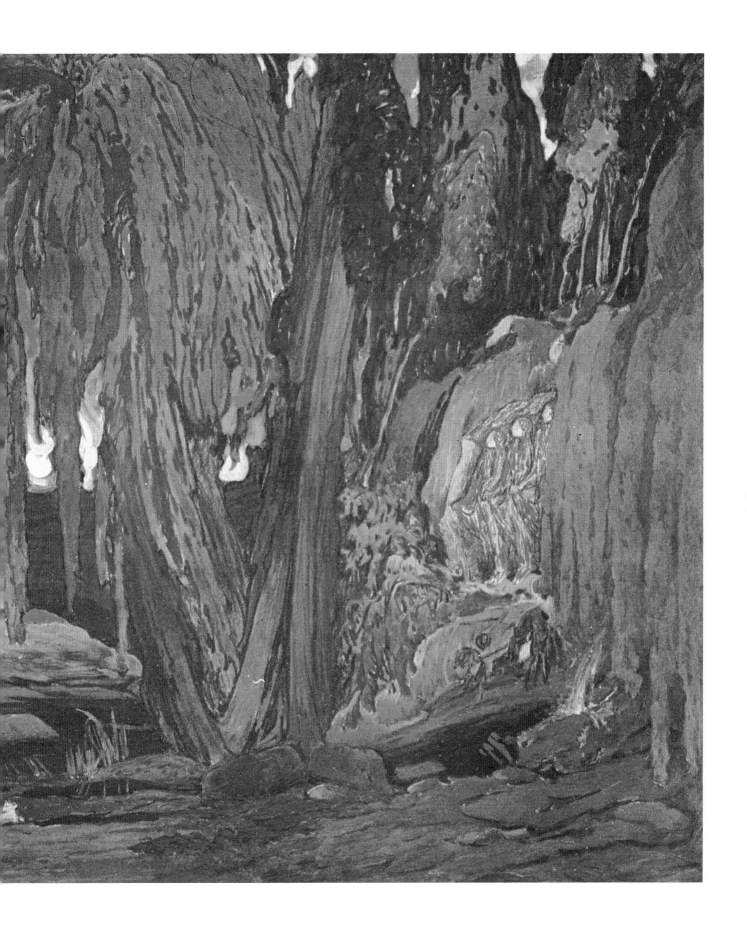

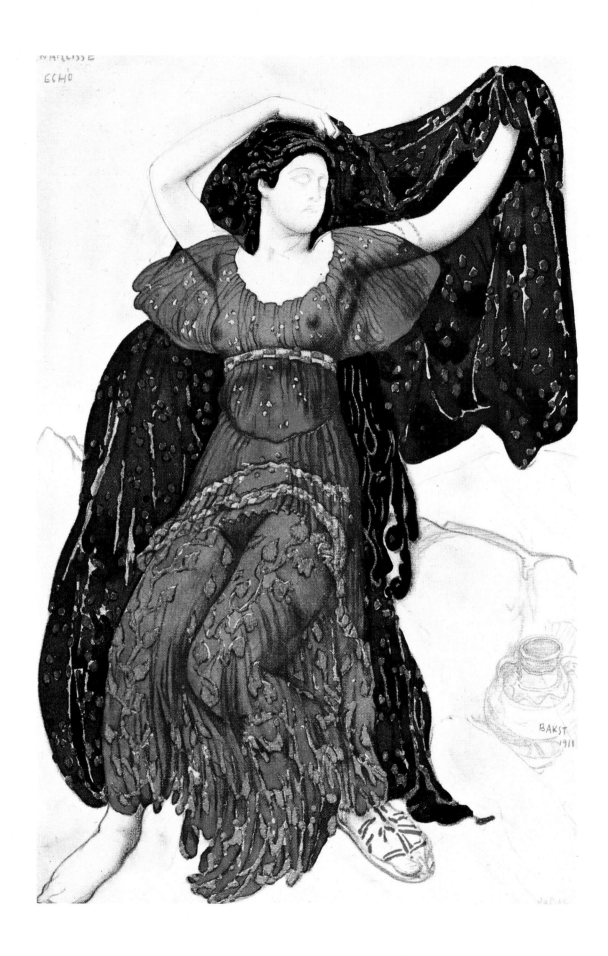

33 THE NYMPH ECHO

Costume design for Nikolai Cherepnin's
ballet *Narcisse*. 1911

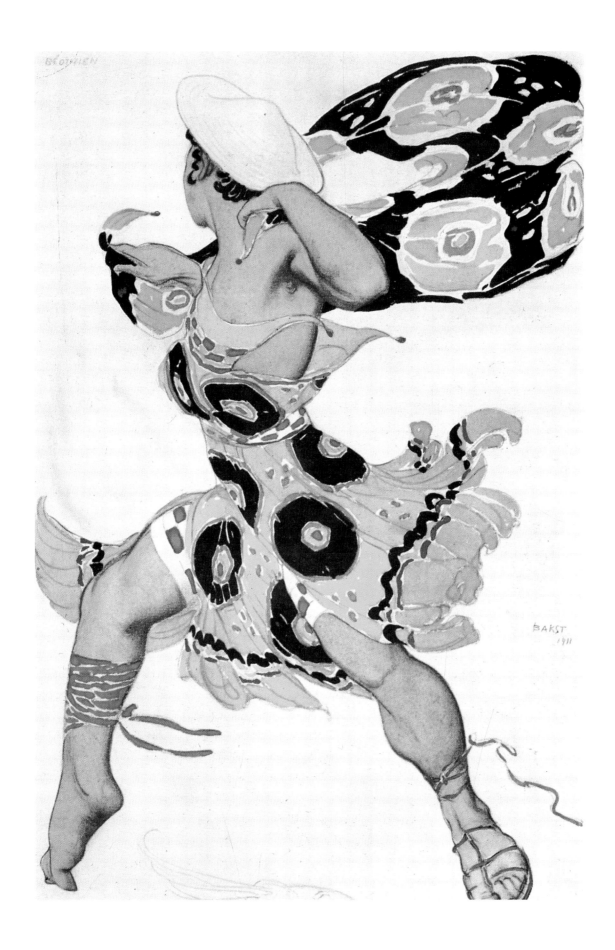

34 EPHEBUS

Costume design for Nikolai Cherepnin's
ballet *Narcisse*. 1911

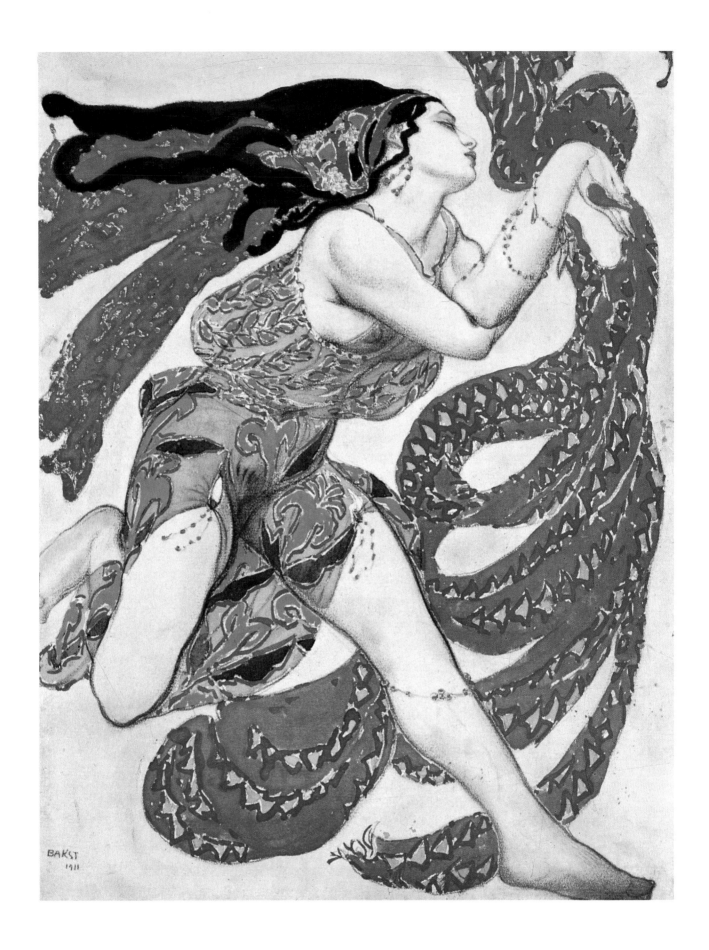

35 BOEOTIAN GIRL

Costume design for Nikolai Cherepnin's
ballet *Narcisse*. 1911

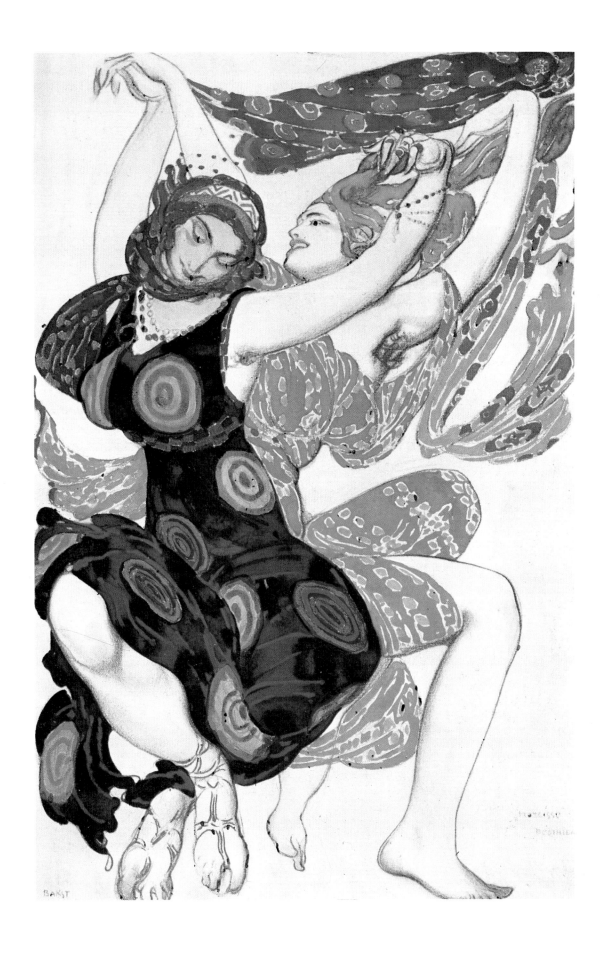

36 TWO BOEOTIAN GIRLS

Costume designs for Nikolai Cherepnin's
ballet *Narcisse*. 1911

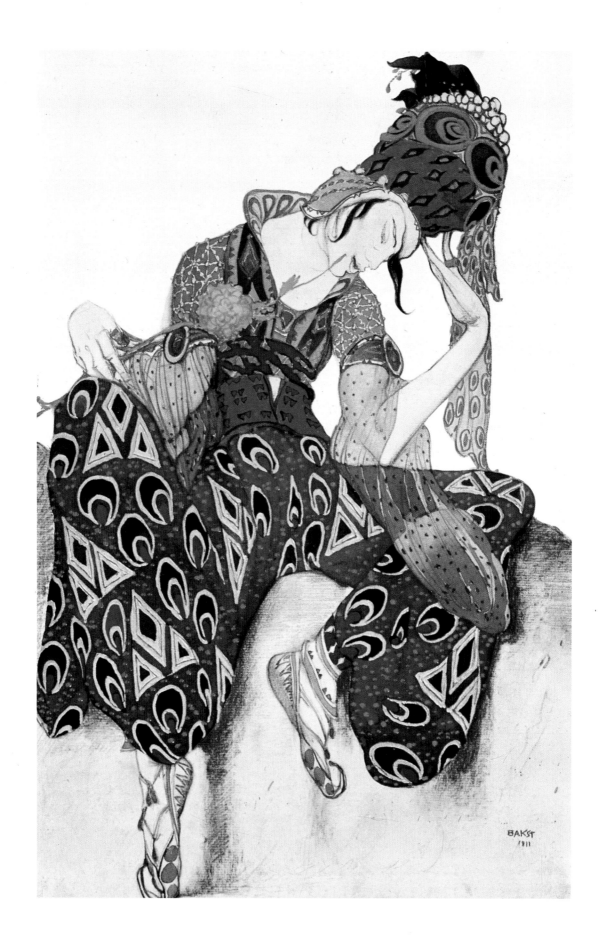

37 ISKANDER

Costume design for Paul Dukas'
ballet *La Péri*. 1911

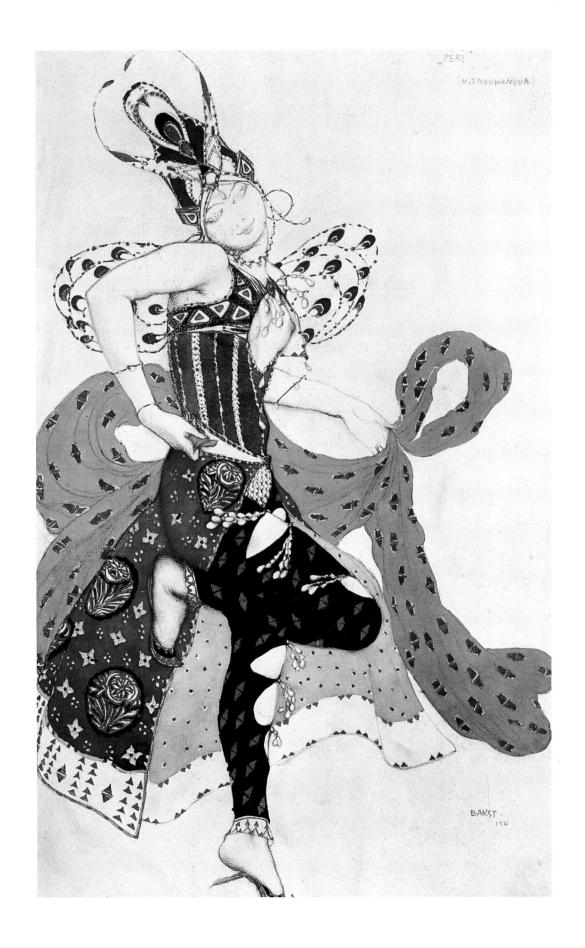

38 THE PERI

Costume design for Paul Dukas'
ballet *La Péri*. 1911

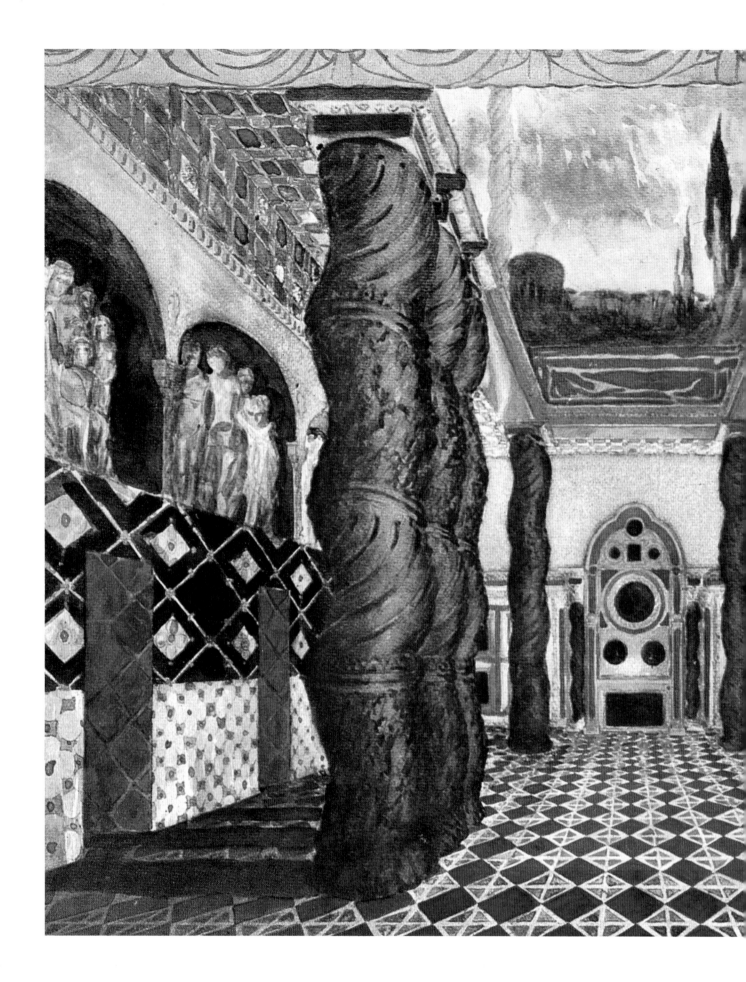

39 Set design for Act III of Gabriele d'Annunzio's
mystery play *Le Martyre de St Sébastien*. 1911

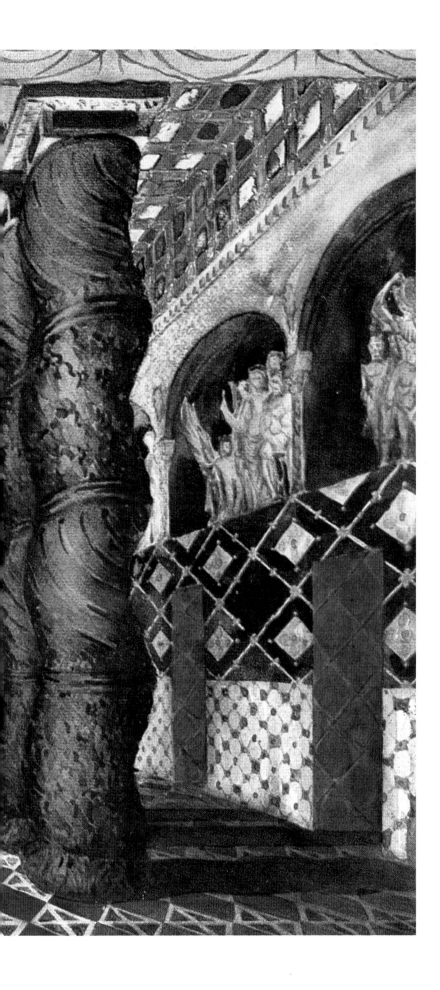

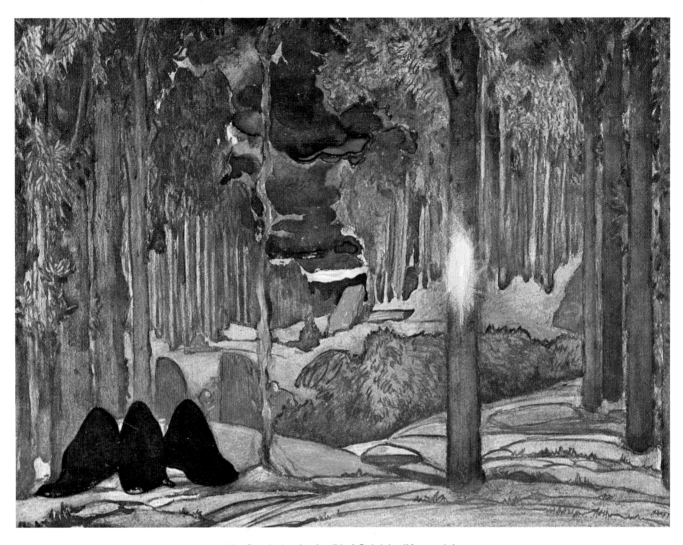

40 Set design for Act IV of Gabriele d'Annunzio's
mystery play *Le Martyre de St Sébastien*. 1911

41 HERALDS

Costume designs for Gabriele d'Annunzio's
mystery play *Le Martyre de St Sébastien*. 1911

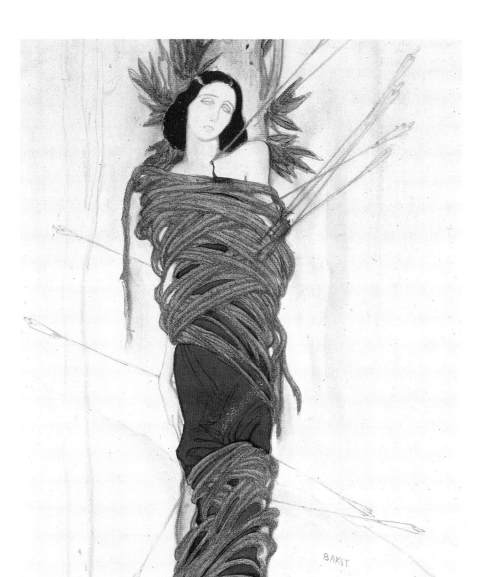

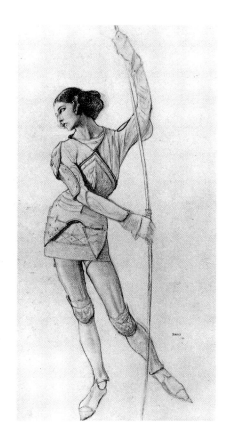

42 ST SEBASTIAN

Costume design for Gabriele d'Annunzio's
mystery play *Le Martyre de St Sébastien*. 1911

43 ST SEBASTIAN

Costume design for Gabriele d'Annunzio's
mystery play *Le Martyre de St Sébastien*. 1911

44 Set design for Reynaldo Hahn's
ballet *Le Dieu Bleu*. 1912

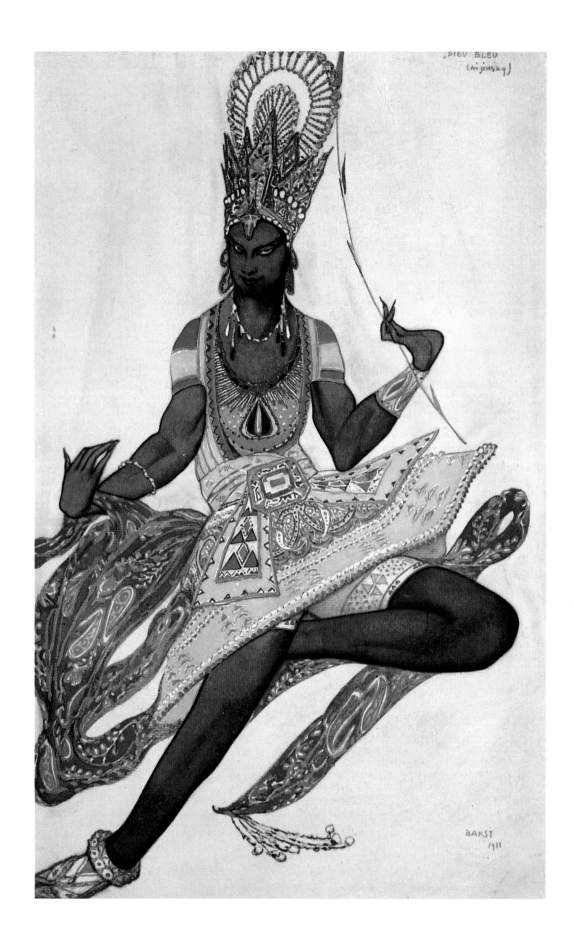

BAKST
1911

45 THE BLUE GOD

Costume design for Reynaldo Hahn's
ballet *Le Dieu Bleu*. 1912

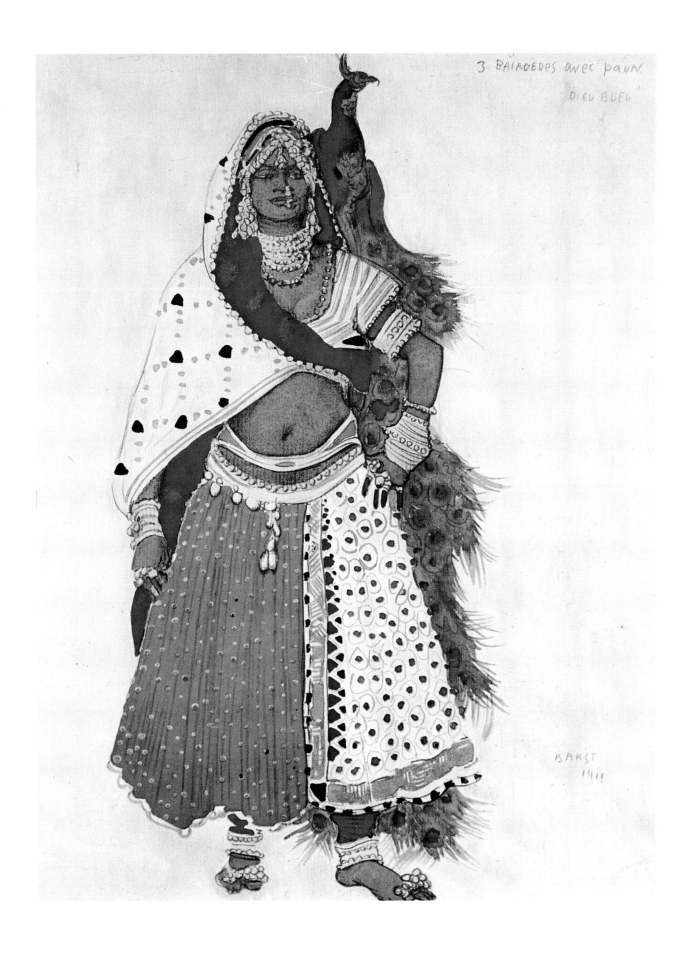

46 BAYADÈRE WITH PEACOCK

Costume design for Reynaldo Hahn's
ballet *Le Dieu Bleu*. 1912

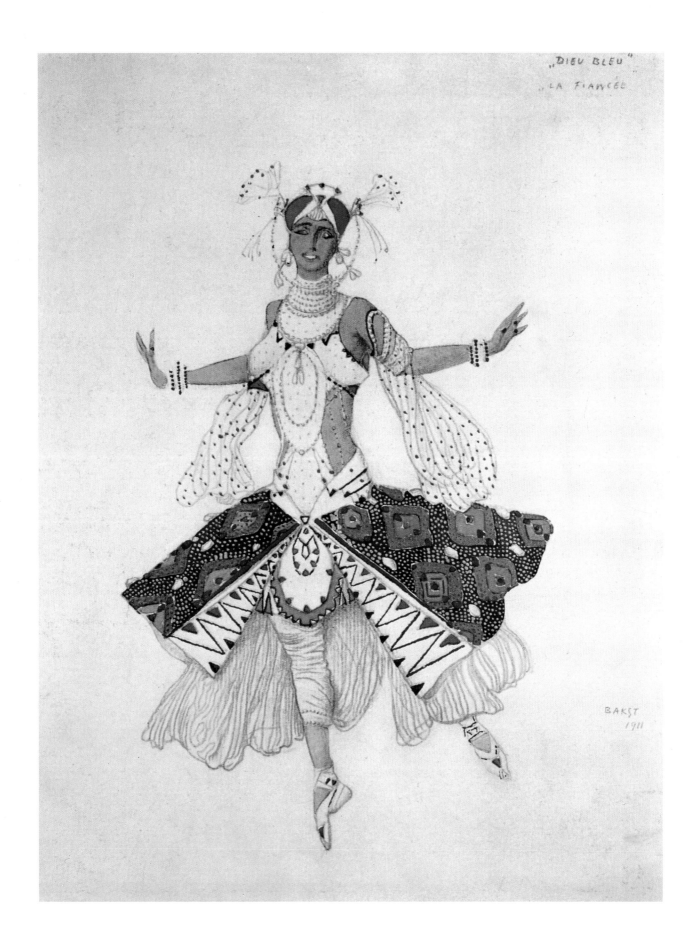

"DIEU BLEU"
"LA FIANCÉE

BAKST
1911

47 BRIDE

Costume design for Reynaldo Hahn's
ballet *Le Dieu Bleu*. 1912

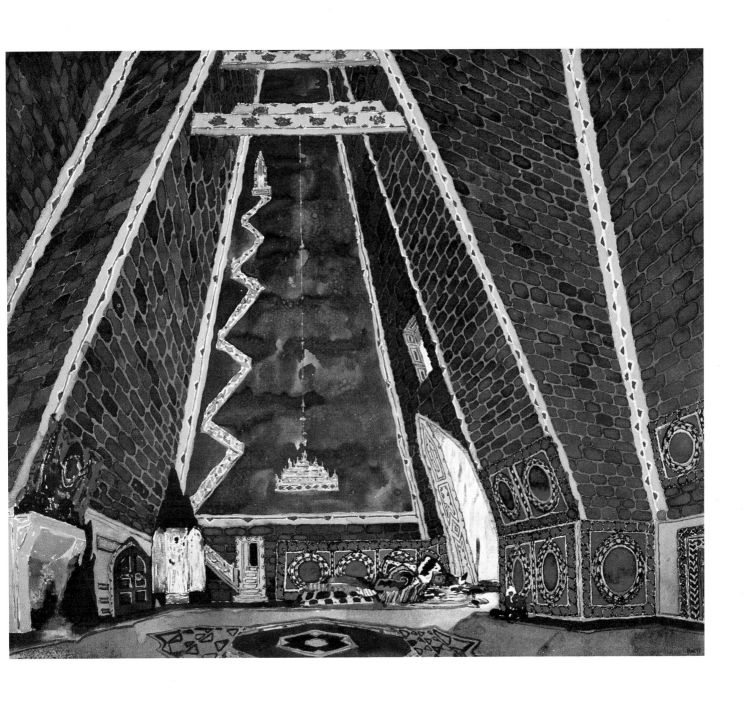

48 Set design for the ballet *Thamar* to the
music of Mily Balakirev. 1912

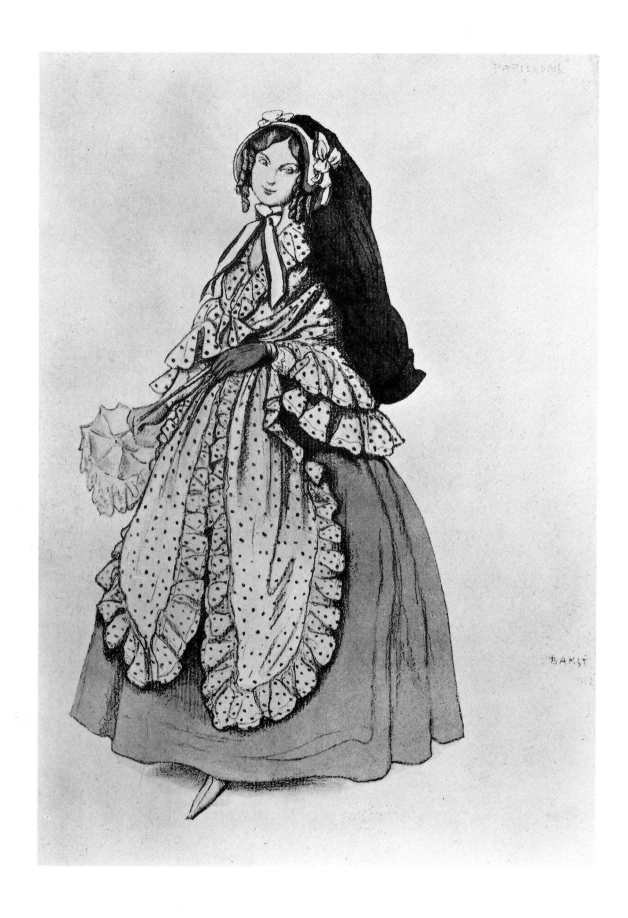

BAKST

49 BUTTERFLY

Costume design for the ballet *Papillons*
to the music of Robert Schumann. 1912

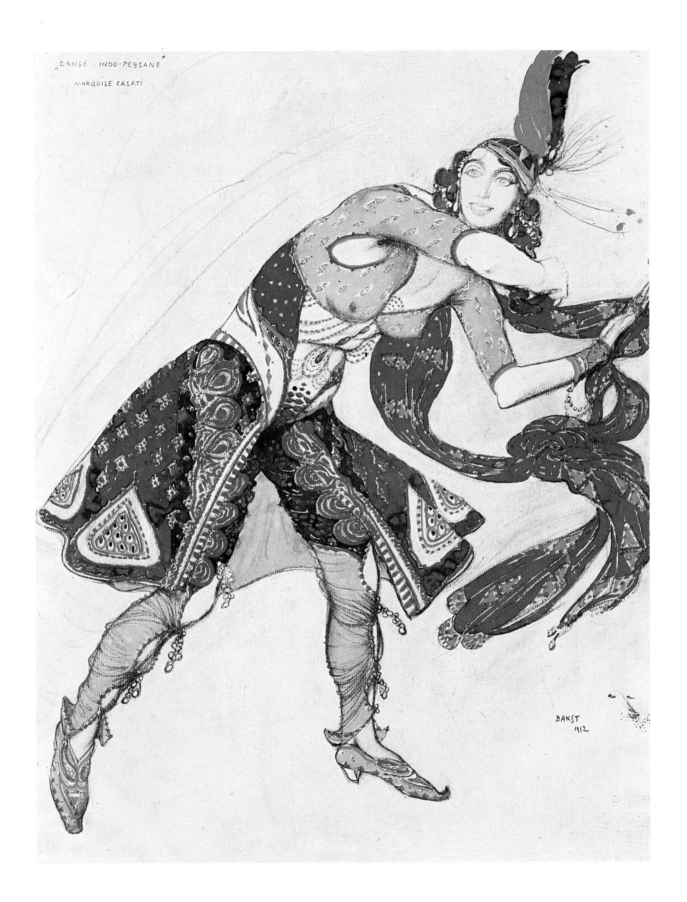

"DANSE INDO-PERSANE"
MARQUISE CASATI

BAKST
1912

50 INDIAN DANCE
Costume design for Marchesa Casati. 1912

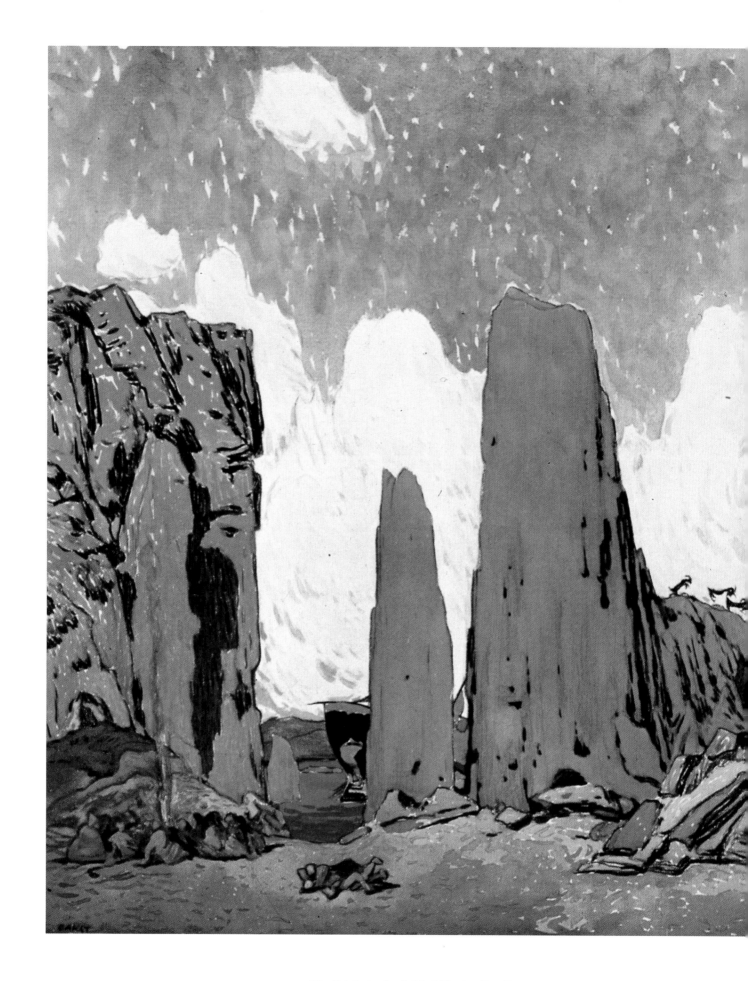

51 Set design for Act II of Maurice Ravel's
ballet *Daphnis and Chloë*. 1912

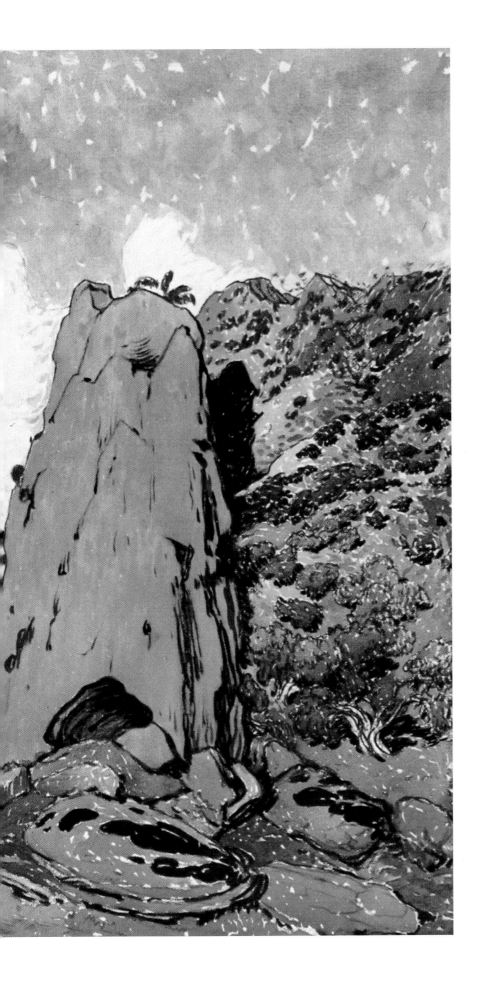

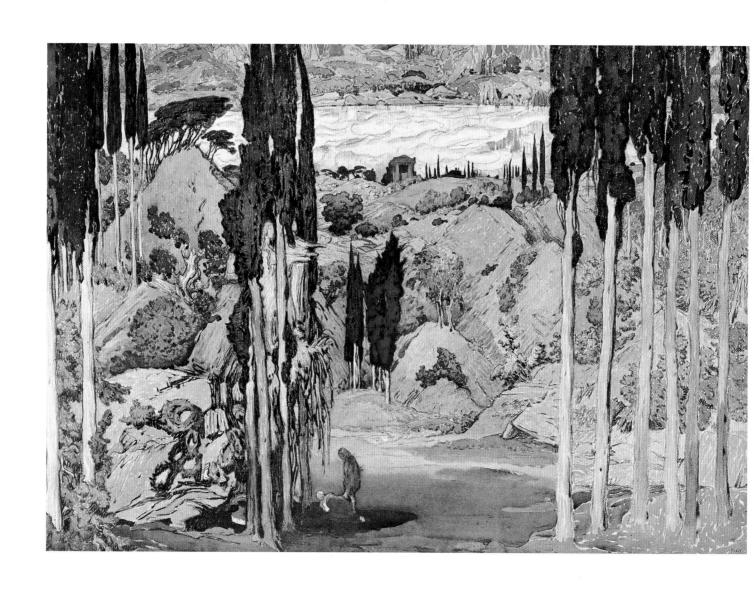

52 Set design for Act II of Maurice Ravel's
ballet *Daphnis and Chloë*. 1912

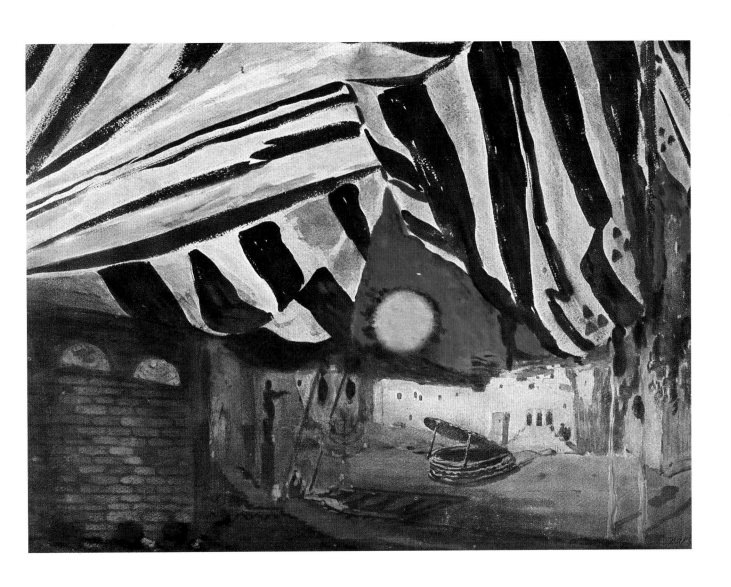

53 Set design for Oscar Wilde's play *Salomé*. 1912

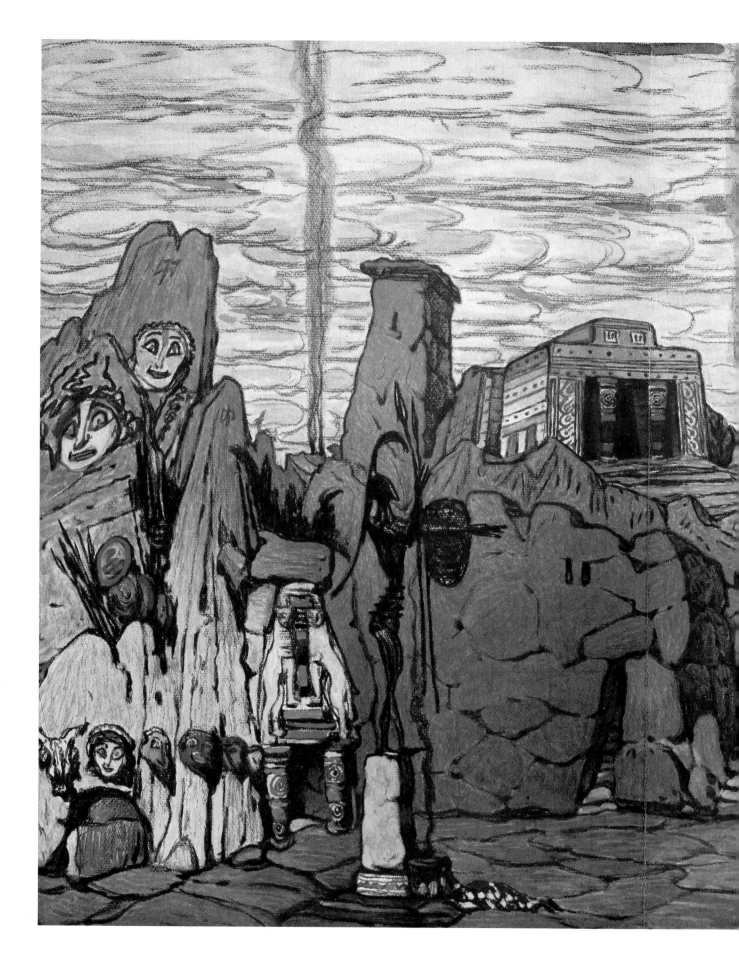

54 Set design for Act II of Emile Verhaeren's
play *Helen of Sparta*. 1912

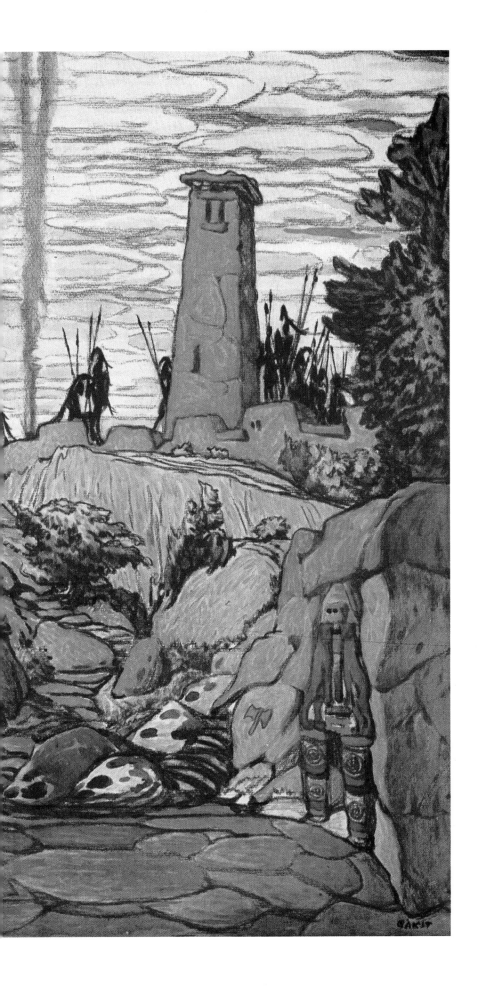

55 Set design for Acts I and III of Emile Verhaeren's
play *Helen of Sparta*. 1912

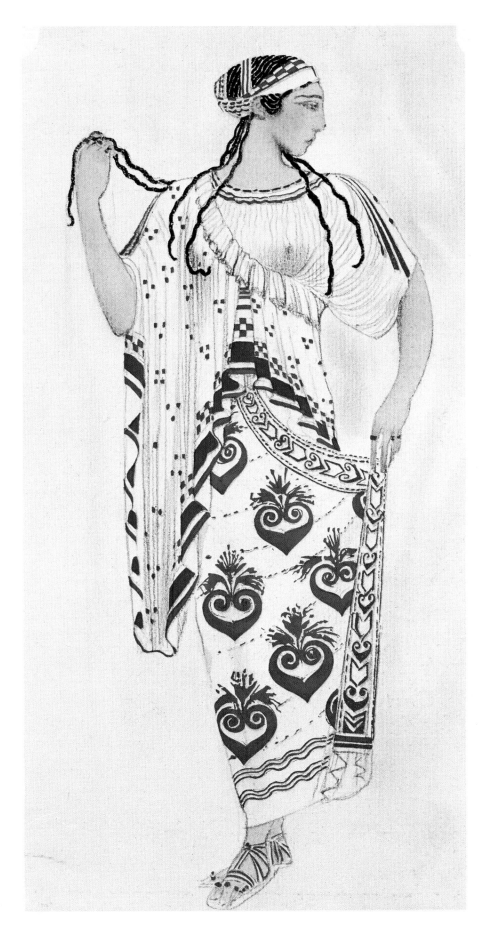

56 HELEN

Costume design for Emile Verhaeren's
play *Helen of Sparta*. 1912

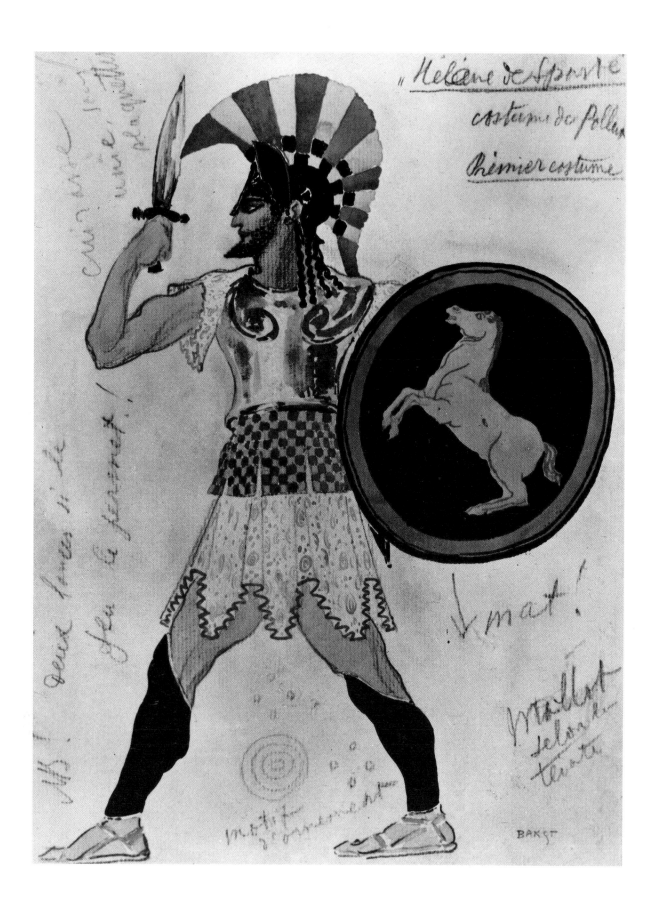

57 POLLUX

Costume design for Emile Verhaeren's
play *Helen of Sparta*. 1912

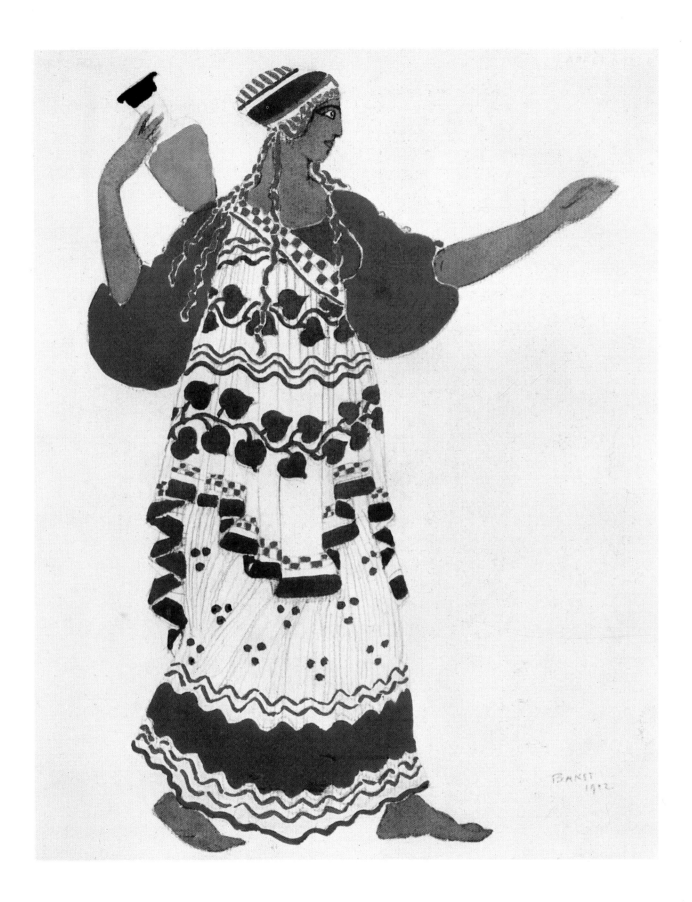

58 NYMPH

Costume design for Claude Debussy's
ballet *L'Après-midi d'un Faune*. 1912

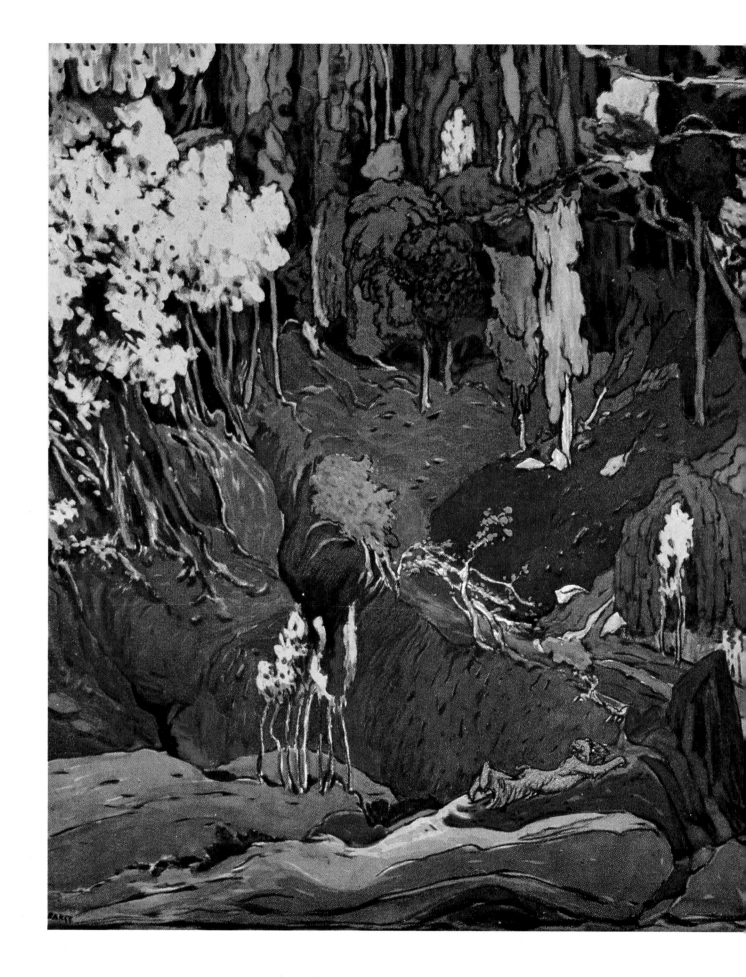

59 Set design for Claude Debussy's ballet
L'Après-midi d'un Faune. 1912

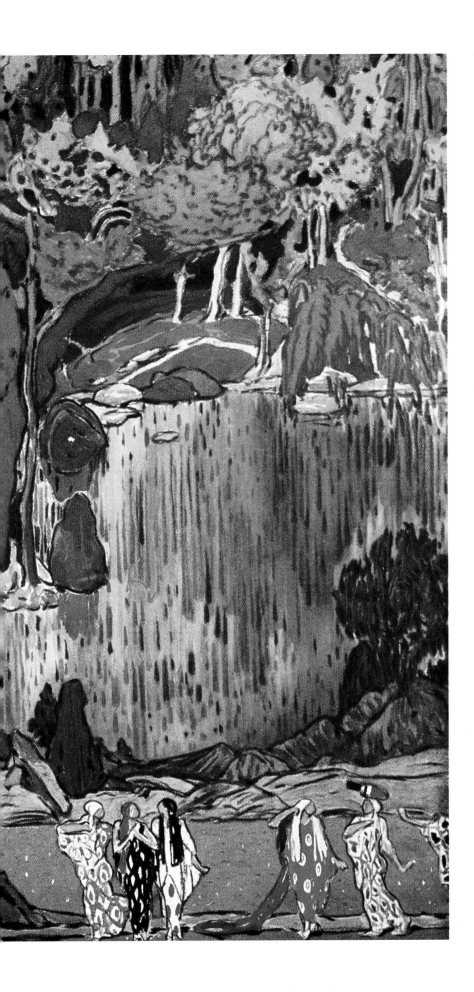

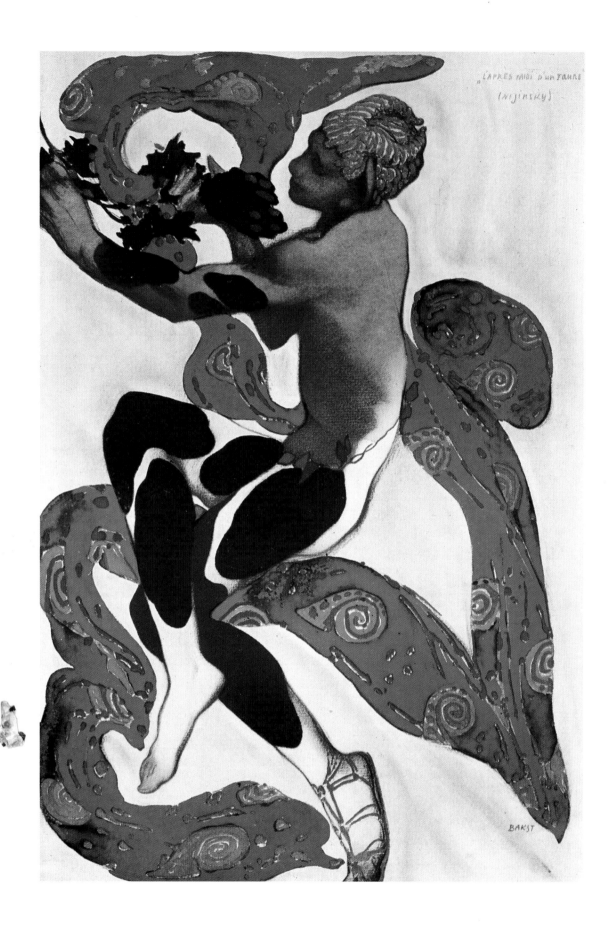

60 FAUN

Costume design for Claude Debussy's
ballet L'Après-midi d'un Faune. 1912

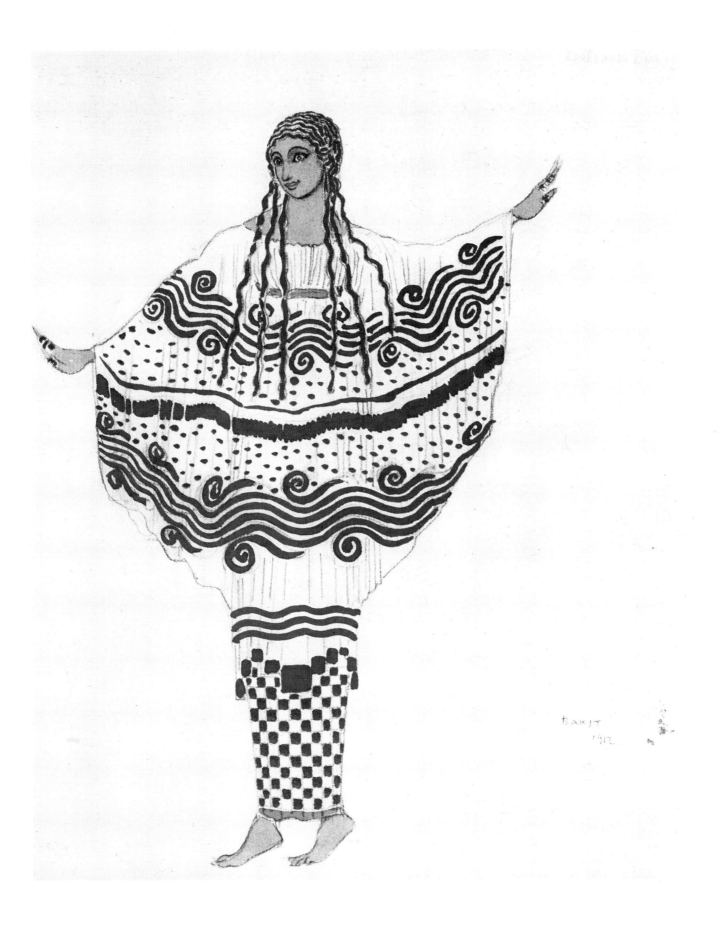

61 NYMPH

Costume design for Claude Debussy's
ballet *L'Après-midi d'un Faune*. 1912

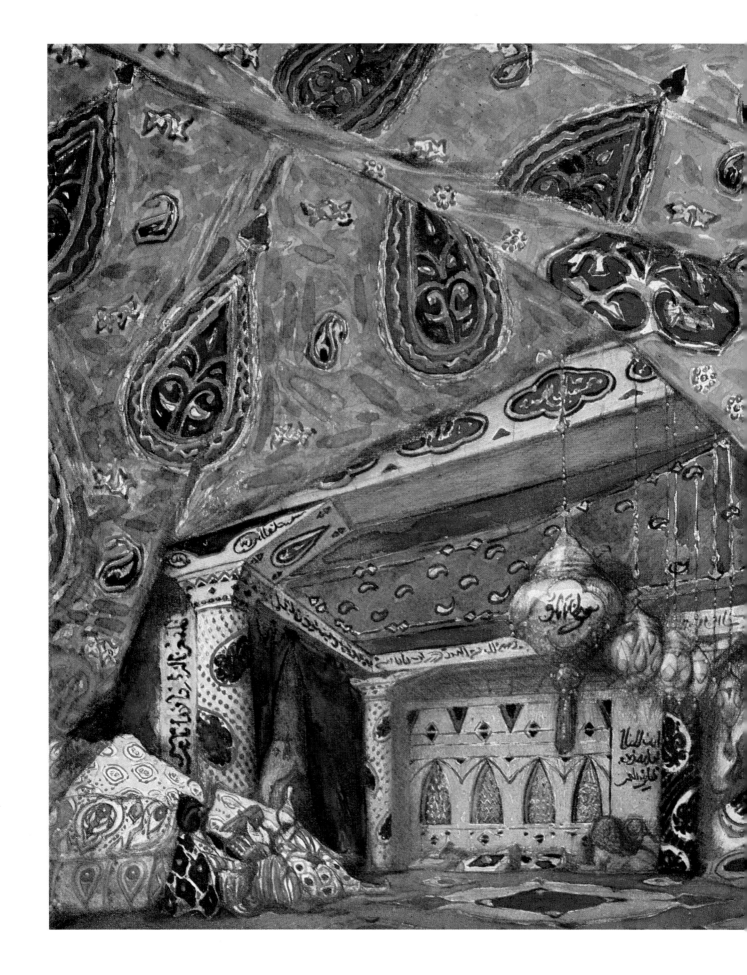

62 Set design for the ballet *Les Orientales* to the music of
Mikhail Ippolitov-Ivanov and Modest Mussorgsky. 1913

63 Set design for Act I of Gabriele d'Annunzio's
 mystery play *La Pisanella*. 1913

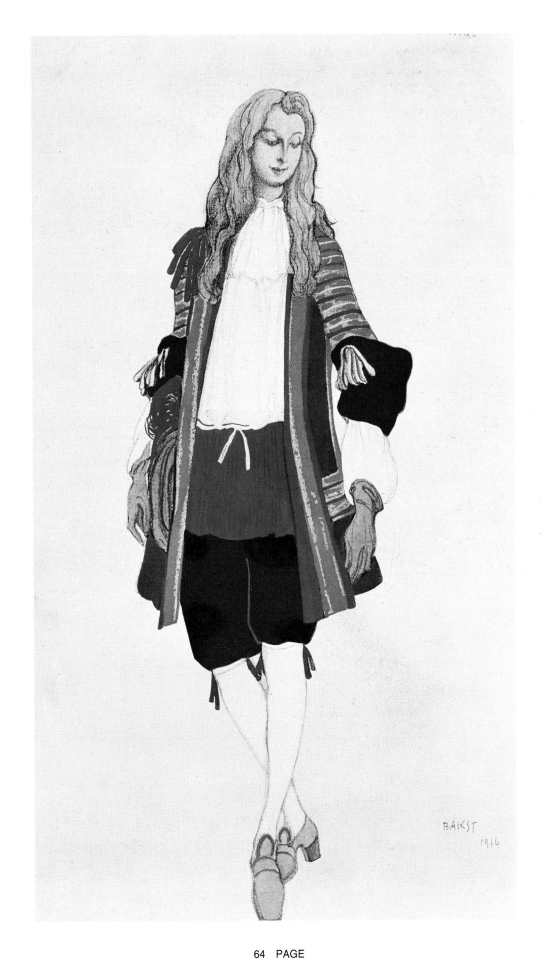

64 PAGE

Costume design for the 'Aladdin' divertissement (part of the
ballet *The Sleeping Beauty* produced by Anna Pavlova's company). 1916

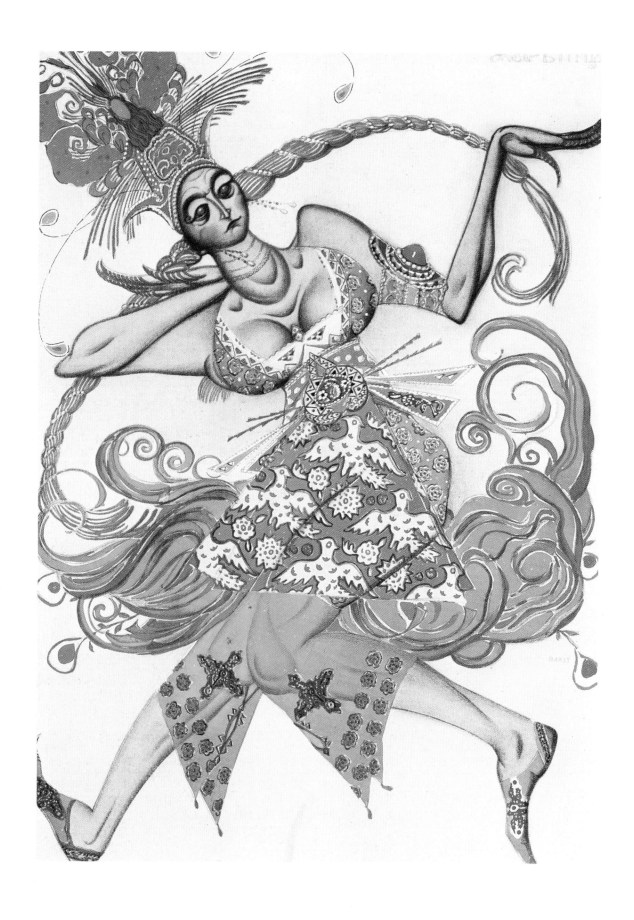

65 THE FIREBIRD

Costume design for Igor Stravinsky's
ballet *L'Oiseau de Feu*. 1913

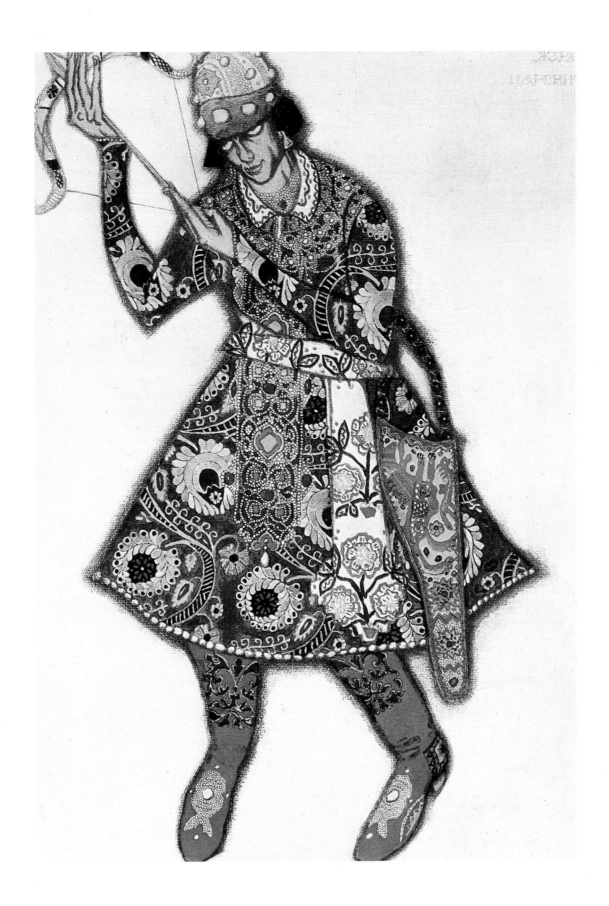

66 THE TSAREVICH IVAN

Costume design for Igor Stravinsky's
ballet *L'Oiseau de Feu*. 1913

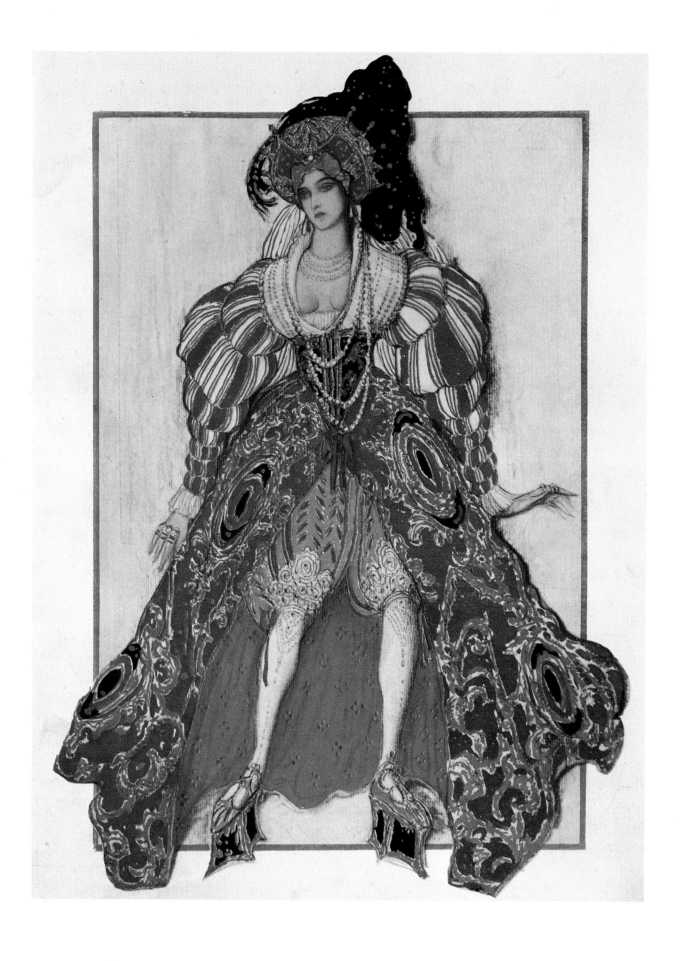

67 POTIPHAR'S WIFE

Costume design for Richard Strauss'
mime-drama *La Légende de Joseph*. 1914

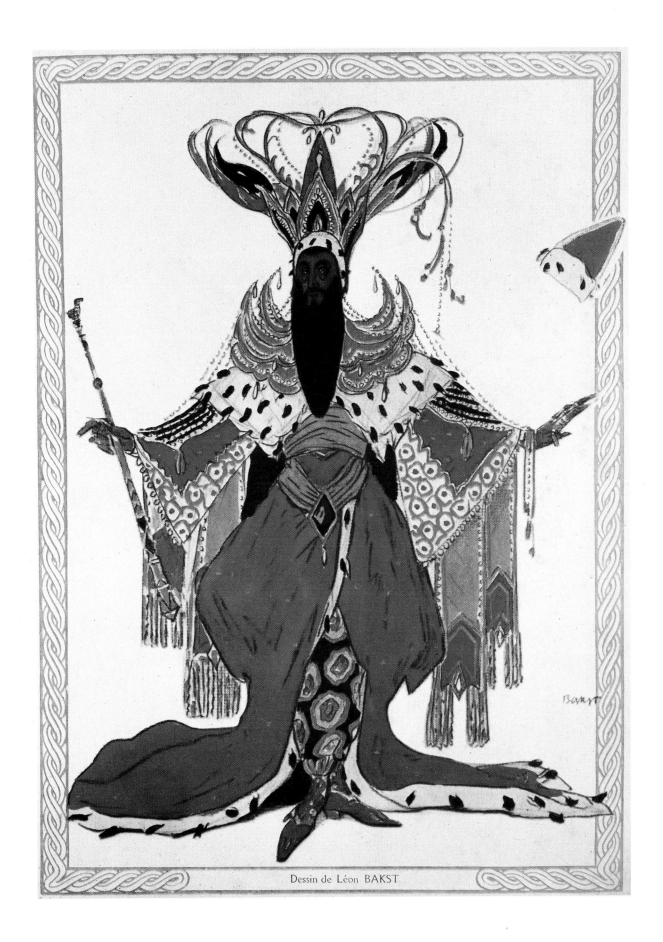

Dessin de Léon BAKST

68 POTIPHAR

Costume design for Richard Strauss'
mime-drama *La Légende de Joseph*. 1914

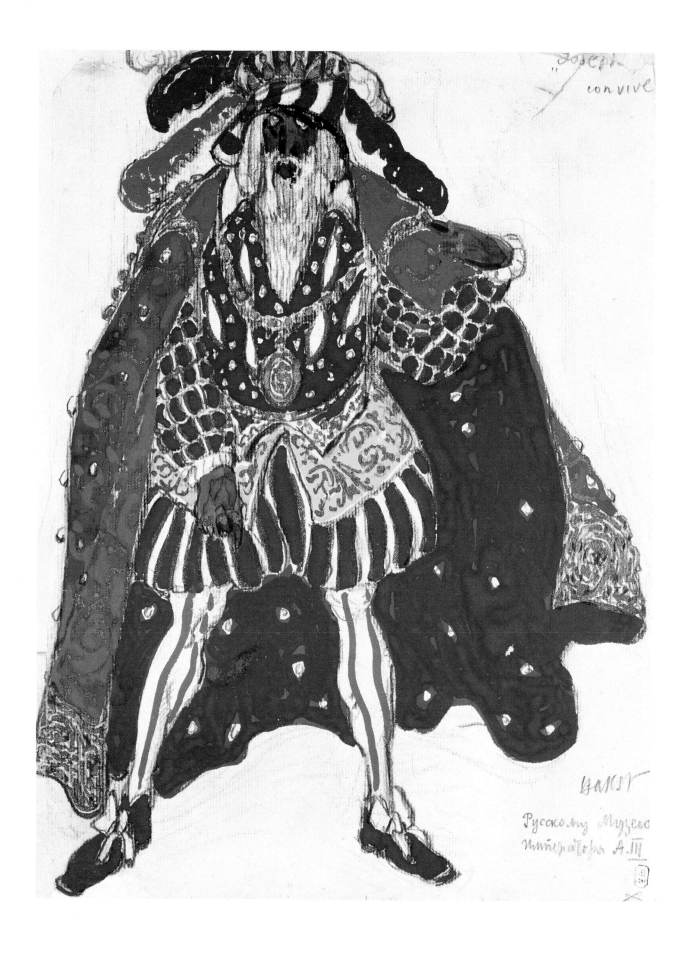

69 GUEST

Costume design for Richard Strauss'
mime-drama *La Légende de Joseph*. 1914

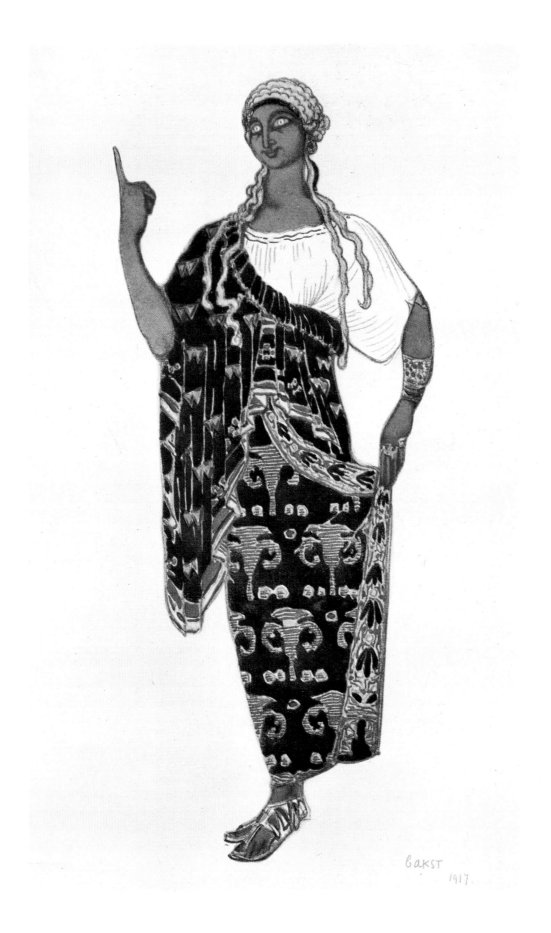

70 NURSE

Costume design for Gabriele d'Annunzio's
tragedy *Phèdre*. 1917

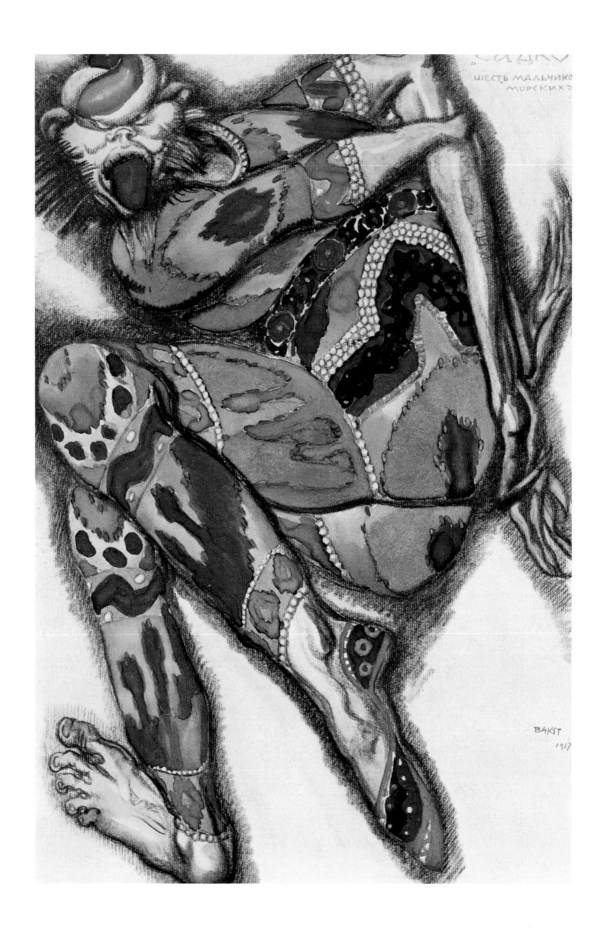

71 THE GREEN DEVIL

Costume design for Nikolai Rimsky-Korsakov's opera *Sadko*. 1917

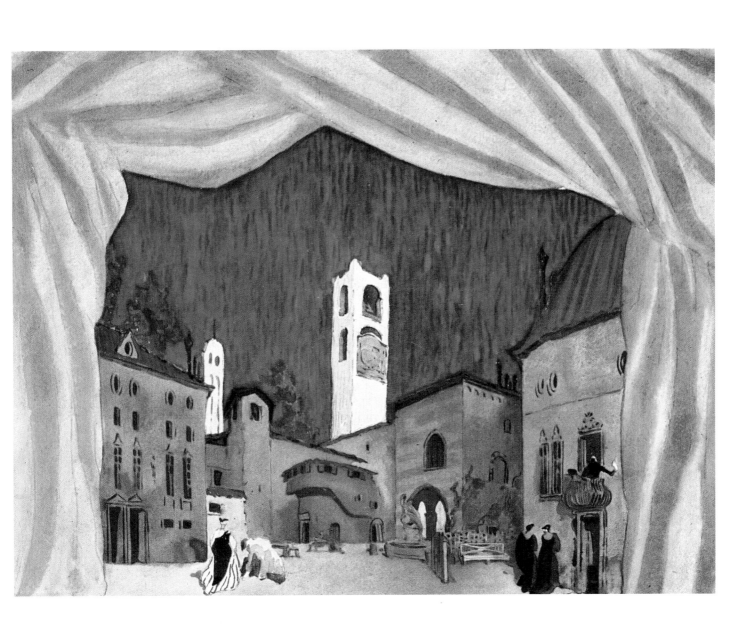

72 Set design for the mime performance *Les Femmes de Bonne Humeur*
after Carlo Goldoni's comedy. 1917

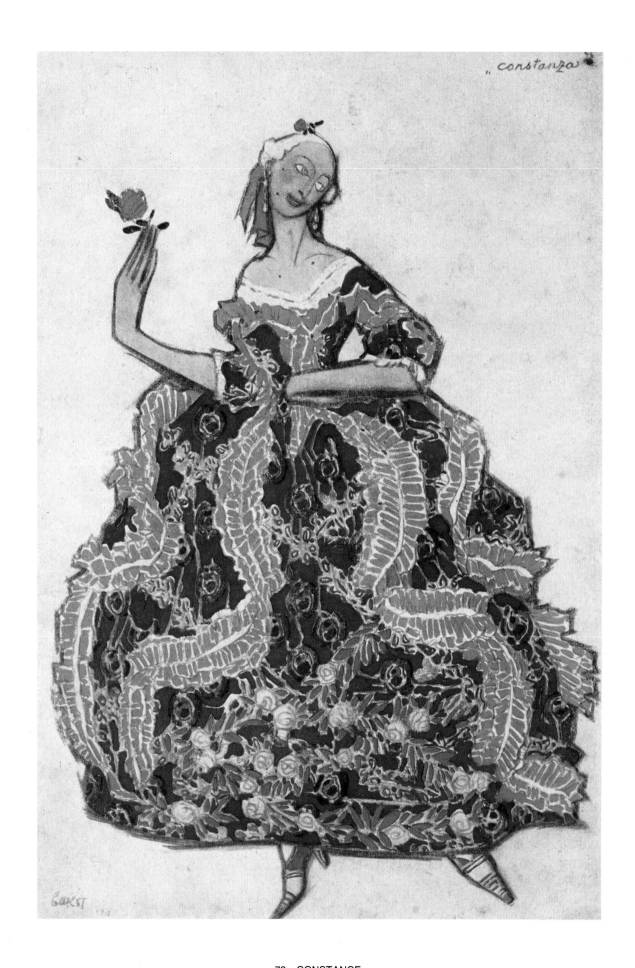

„constanza"

73 CONSTANCE

Costume design for the mime performance *Les Femmes de Bonne Humeur*
after Carlo Goldoni's comedy. 1917

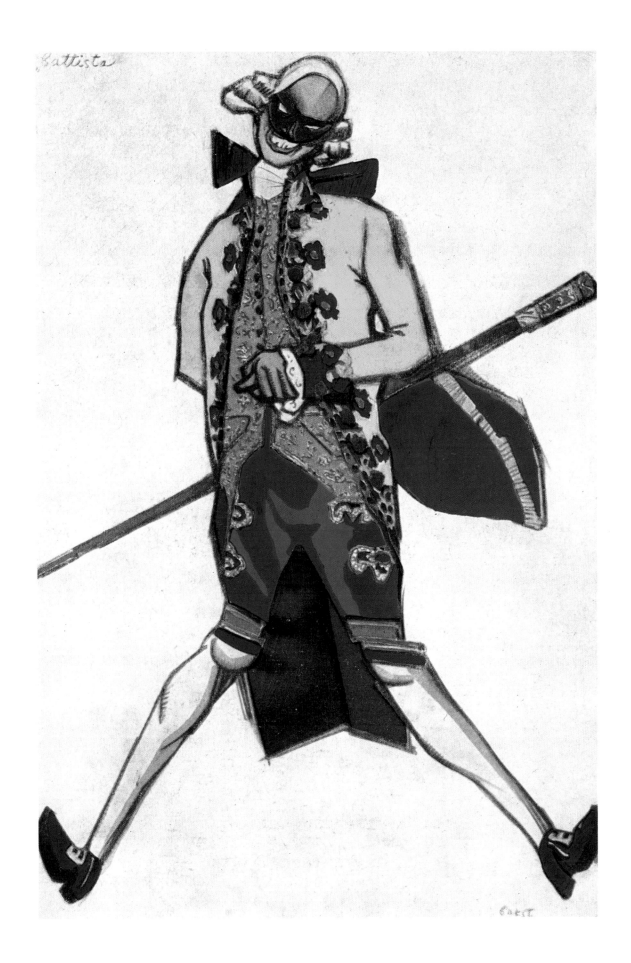

74 BATTISTA

Costume design for the mime performance *Les Femmes de Bonne Humeur*
after Carlo Goldoni's comedy. 1917

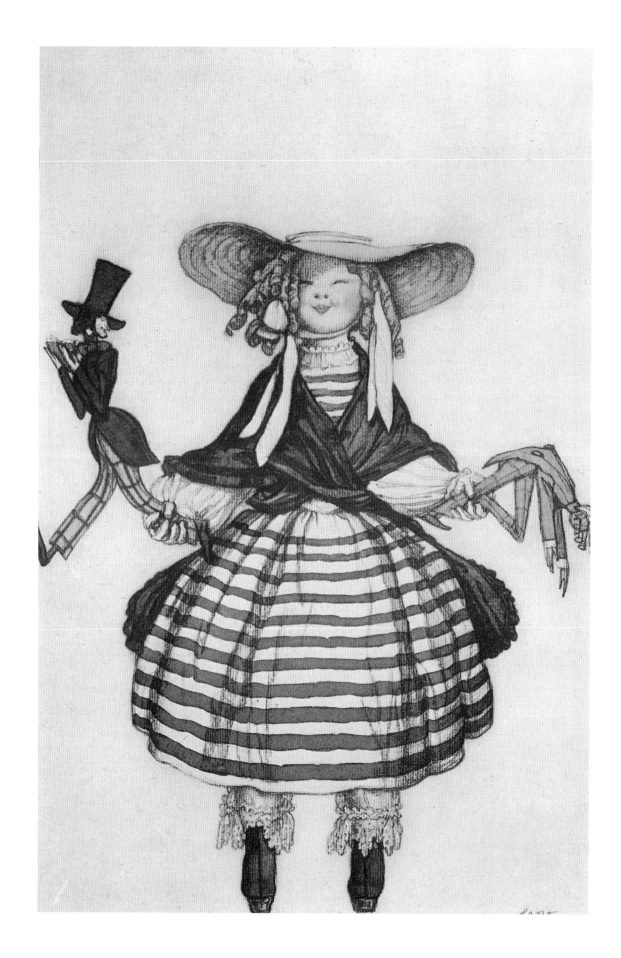

75 DOLL

Costume design for the ballet *La Boutique Fantasque*
to the music of Gioacchino Rossini. 1919

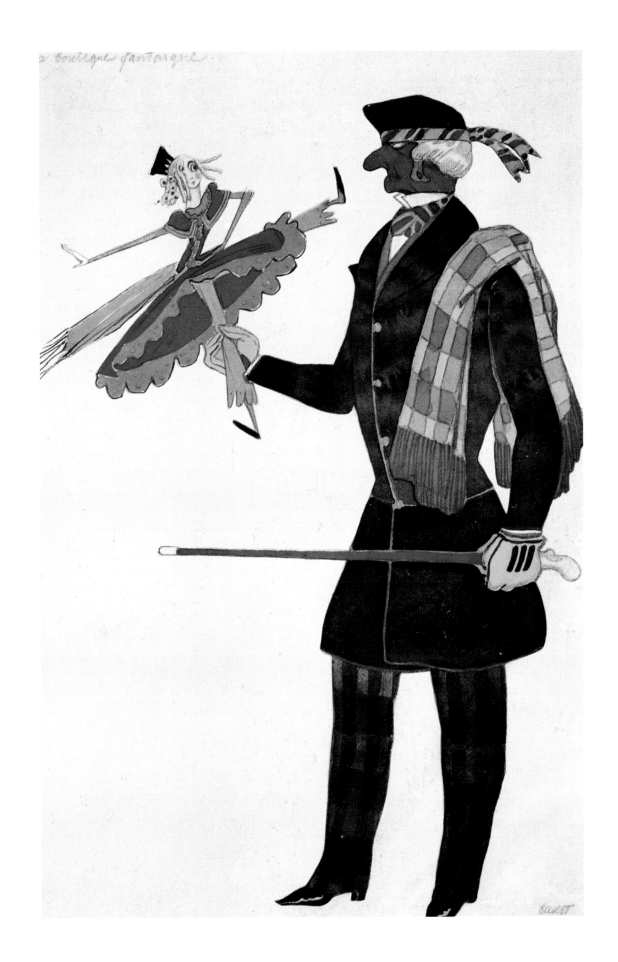

76 ENGLISHMAN

Costume design for the ballet *La Boutique Fantasque*
to the music of Gioacchino Rossini. 1919

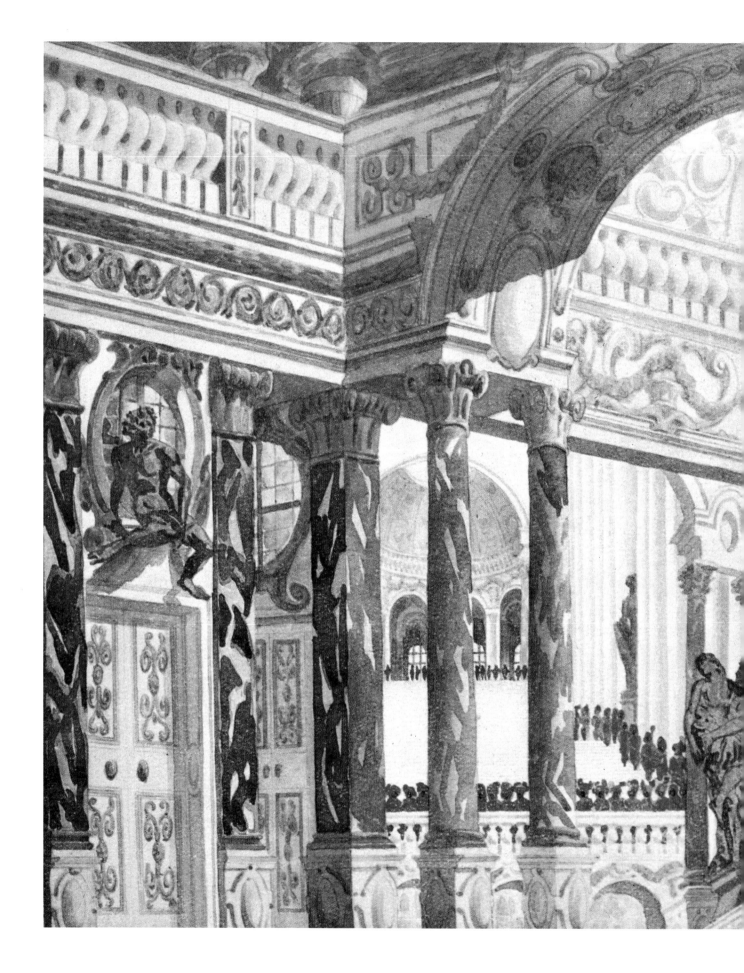

77 Set design for the Prologue to Piotr Tchaikovsky's
ballet *The Sleeping Beauty*. 1921

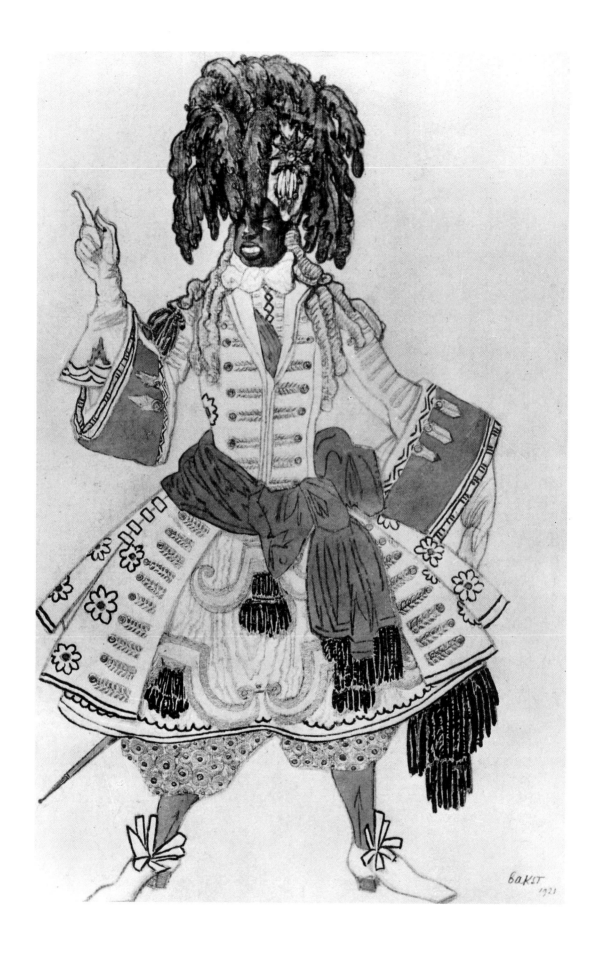

78 MOOR GUARDSMAN

Costume design for Piotr Tchaikovsky's
ballet *The Sleeping Beauty*. 1921

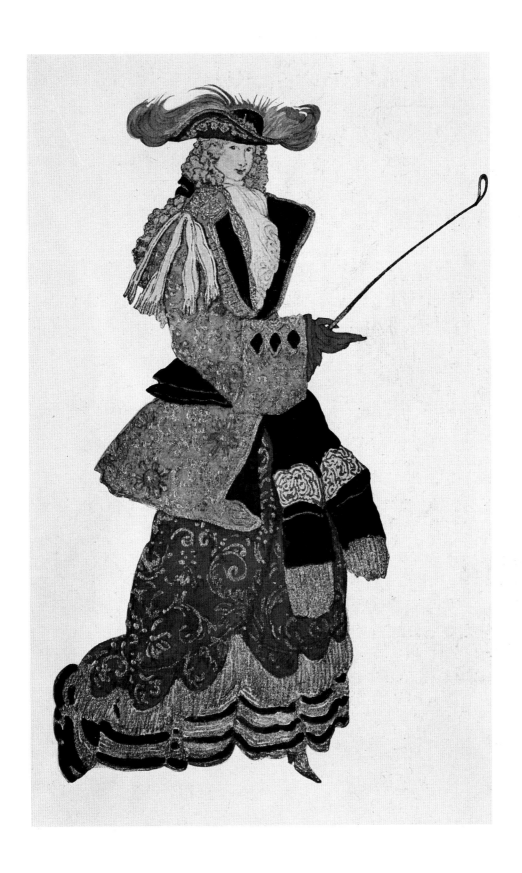

79 COUNTESS

Costume design for Piotr Tchaikovsky's
ballet *The Sleeping Beauty*. 1921

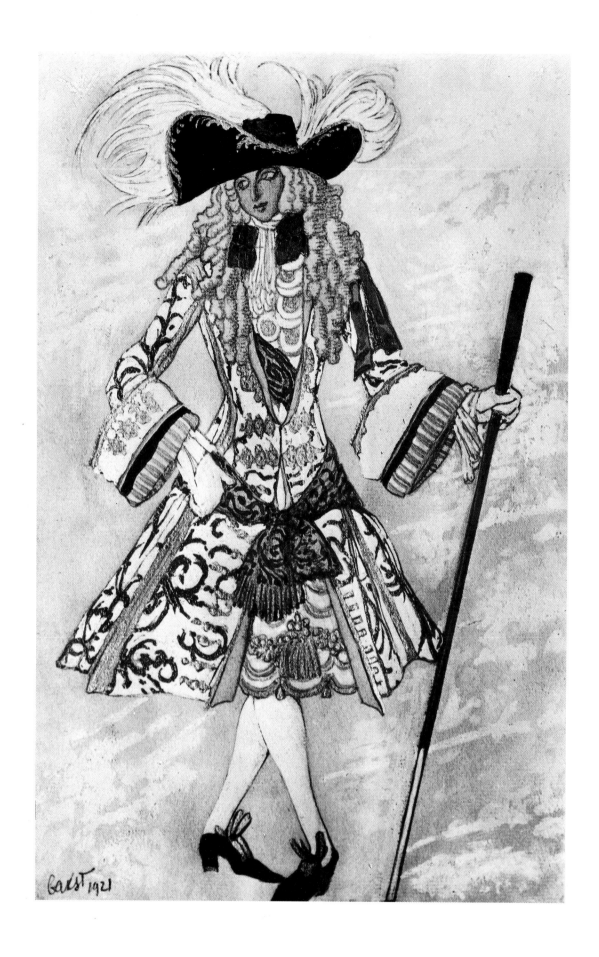

80 PRINCE CHARMING

Costume design for Piotr Tchaikovsky's
ballet *The Sleeping Beauty*. 1921

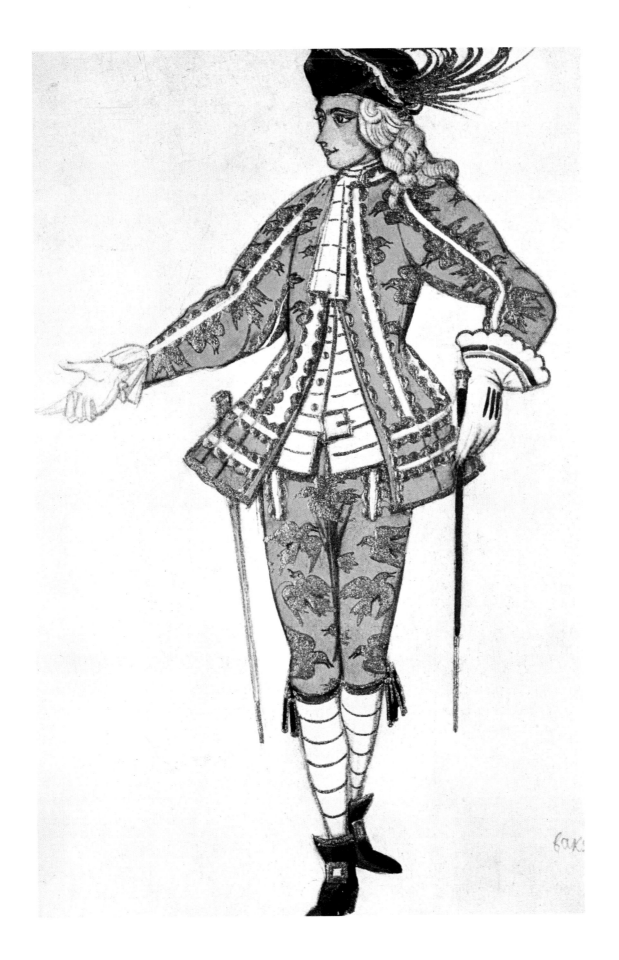

81 PAGE TO THE FAIRY OF THE SINGING BIRDS

Costume design for Piotr Tchaikovsky's
ballet *The Sleeping Beauty*. 1921

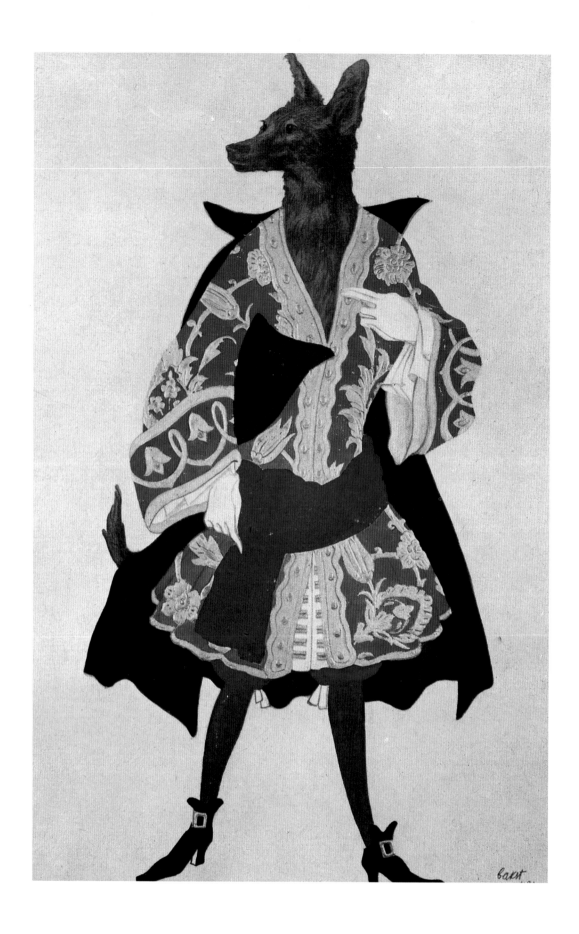

82 WOLF

Costume design for Piotr Tchaikovsky's
ballet *The Sleeping Beauty*. 1921

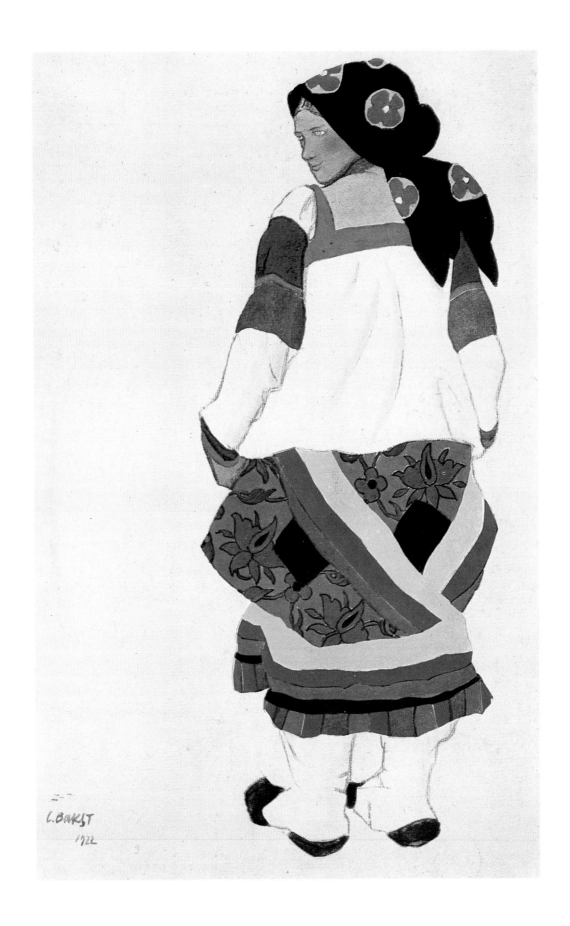

83 RUSSIAN PEASANT WOMAN. 1922

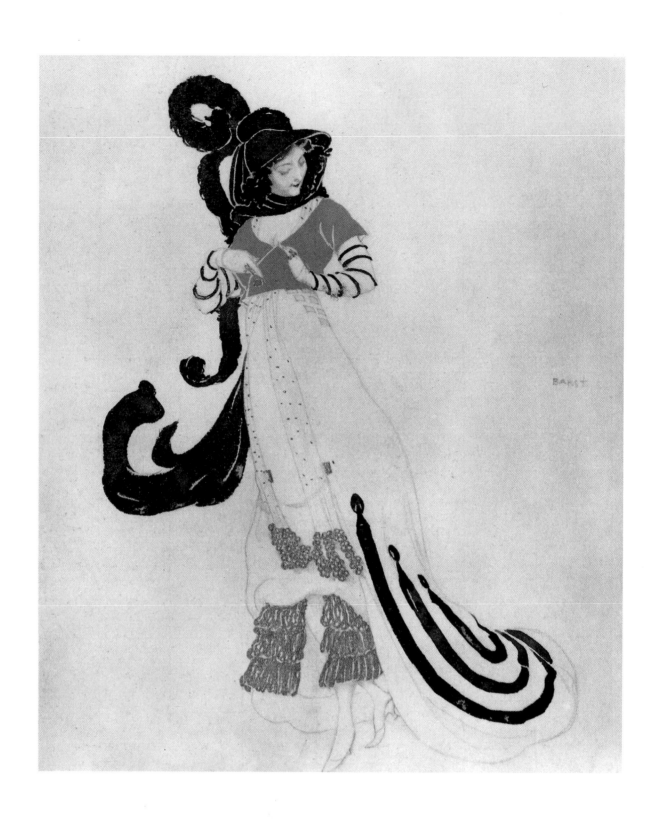

84 Design for a lady's dress. 1910s

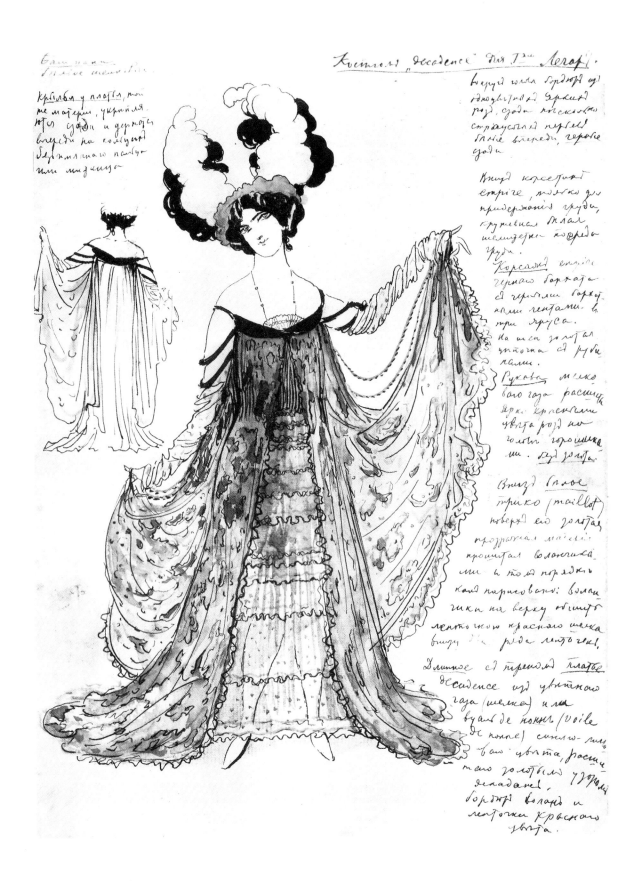

85 Design for a 'Decadence' dress. 1910s

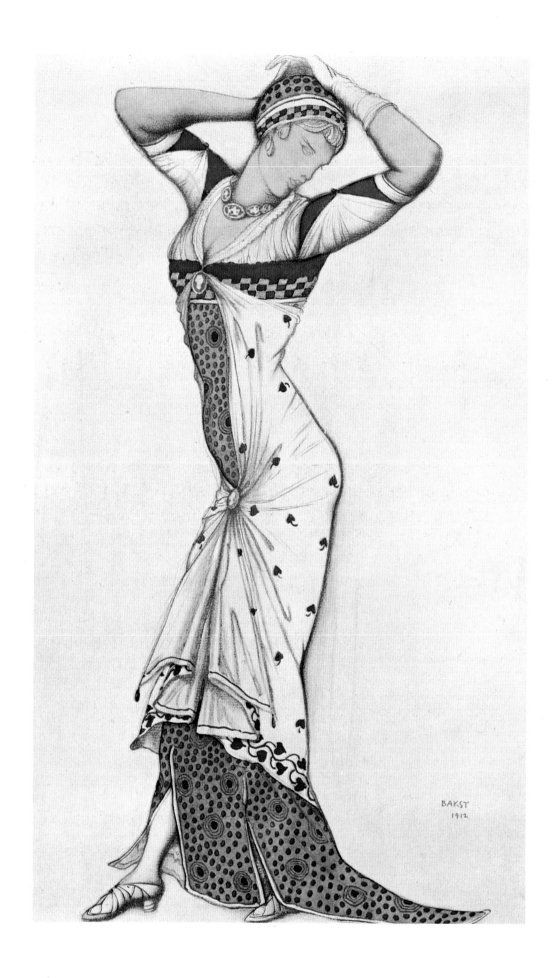

86 Design for a lady's dress. 1912

BOOK ILLUSTRATION

As regards his graphic gifts, Bakst stands ... between Benois and Somov. He is more of a vignettist than the first and more of an illustrator than the latter. His vignettes possess a characteristic perfection of technique; at the same time their compositional content is ever of interest and is always detailed ... Bakst interprets his favourite classical themes with fine, clear-cut lines.

Nikolai Radlov

We know the headpieces and covers he has produced for *Mir iskusstva* [*World of Art*] and other publications. They always display virtuosity and are honed with exquisite taste ...

Sergei Makovsky

His graphic pieces for the *World of Art* (mostly on themes of antiquity), executed in the finest of dotted lines, often as silhouettes, were amazingly decorative, and they brimmed with a peculiarly mysterious poetry, yet at the same time were very 'bookish'.

Mstislav Dobuzhinsky

87 EAGLE

Colophon for the *Mir iskusstva* [*World of Art*] journal. 1898

88 Colophon for the journal *Novy put* [*New Path*]. 1902

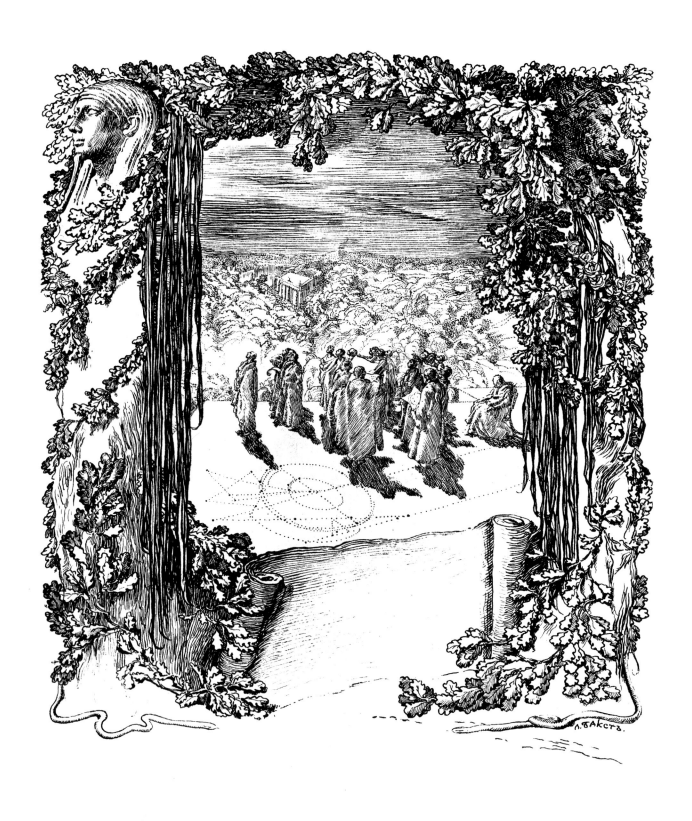

89 Headpiece for the article 'The Stars'
by Vasily Rozanov (*World of Art*, 1901, No. 7)

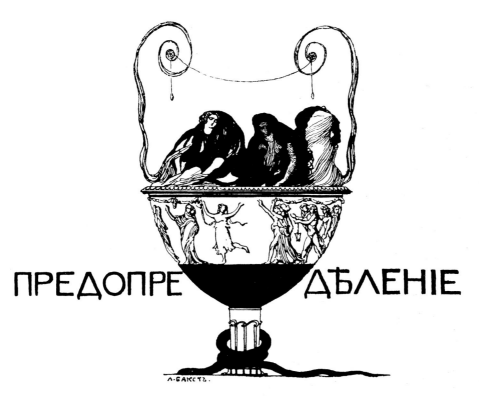

ПРЕДОПРЕ ДѢЛЕНIE

90 Headpiece for Konstantin Balmont's poem
'Predestination' (*World of Art*, 1901, No. 5)

91 Headpiece for Konstantin Balmont's poem
'Night' (*World of Art*, 1901, No. 5)

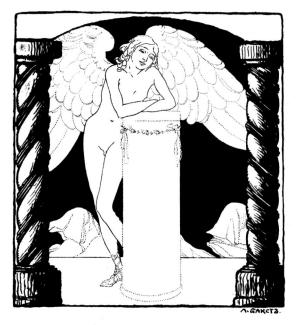

К.БАЛЬМОНТЪ

92 Headpiece for Konstantin Balmont's poem 'I'm the refinement of the Russian speech' (*World of Art*, 1901, No. 5)

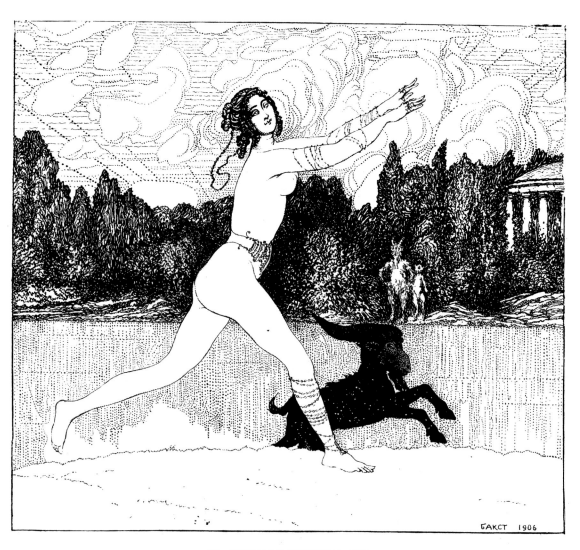

93 VISION OF ANTIQUITY. 1906

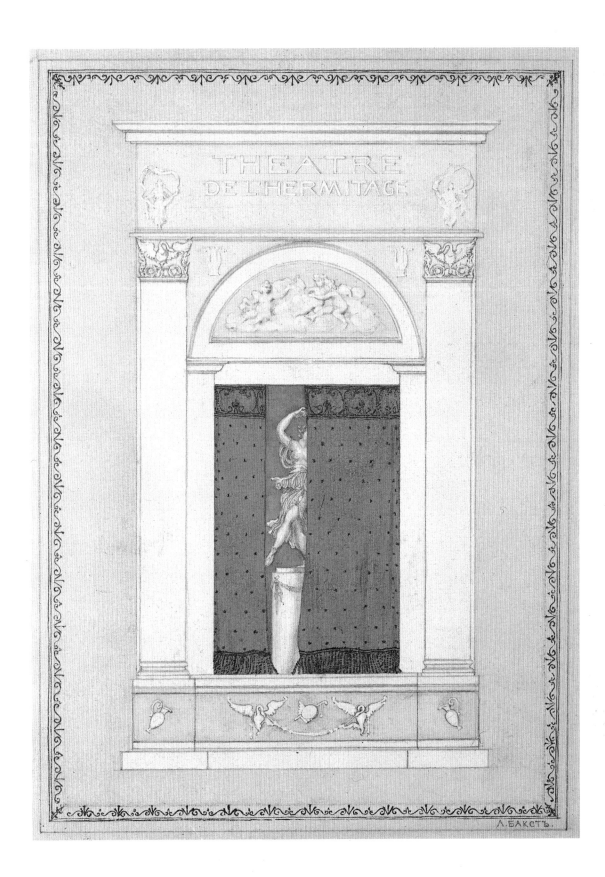

94 Cover to the programme for the ballet *Le Cœur de la Marquise*
to the music of G. Guiraud. 1902

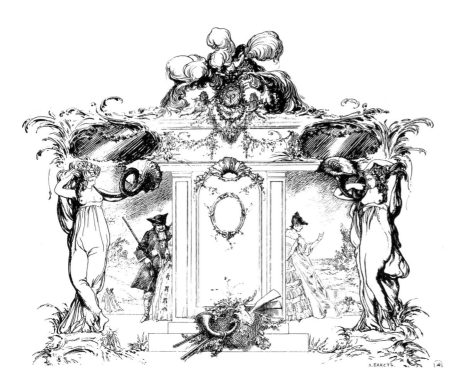

95 Headpiece for the historical essay
*Royal Hunting in Medieval Russia
in the Late Seventeenth and Eighteenth Centuries*
by Nikolai Kutepov
(St Petersburg, 1902, vol. 3, chapter 3)

96 Border for the journal
Khudozhestvennye sokrovishcha Rossii
[*Art Treasures of Russia*], 1901, No. 7

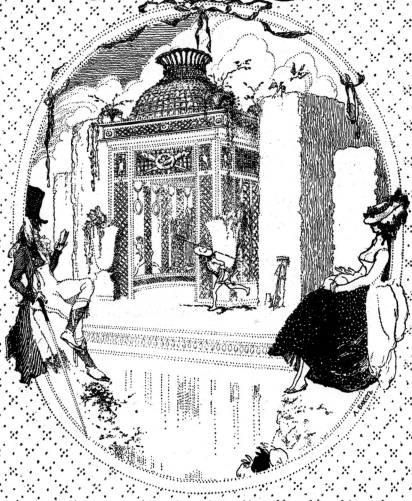

97 Cover for the *World of Art* journal. 1902

98 The 1902 Exhibition of Historical Portraits.
Half-title (*World of Art*, 1902, No. 4)

˚ПЕСТУМЪ˚

99 Headpiece for the essay 'Paestum'
by Vasily Rozanov (*World of Art*, 1902, No. 2)

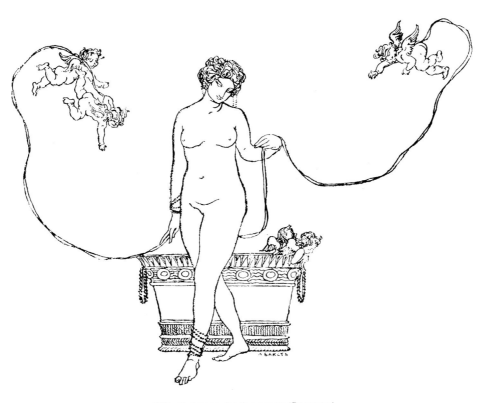

100 Tailpiece for the essay 'Paestum'
by Vasily Rozanov (*World of Art*, 1902, No. 2)

101 Headpiece to a photograph of the boudoir
designed by Bakst (*World of Art*, 1903, Nos. 5/6)

102 RODIN

Headpiece (*World of Art*, 1902, Nos. 9/10)

103 Cover for *Russian Bookplates*
by Vasily Vereshchagin (St Petersburg, 1902)

АРХАНГЕЛЬСКОЕ

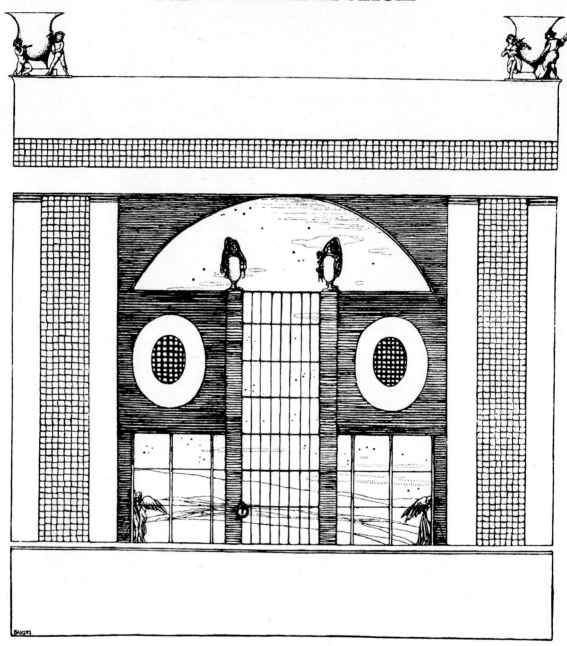

104 ARKHANGELSKOYE
Frontispiece (*World of Art*, 1904, No. 2)

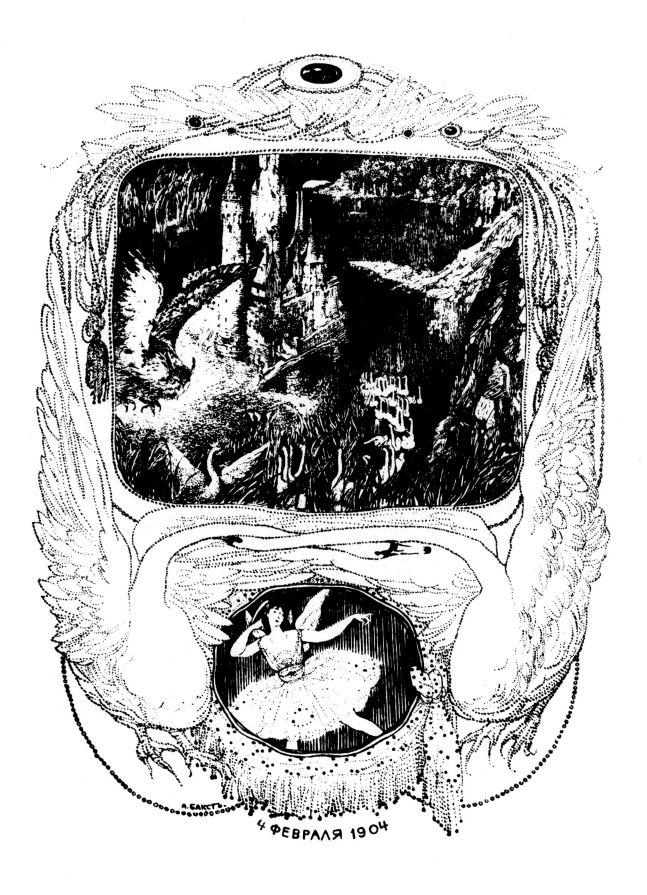

А. БАКСТ

4 ФЕВРАЛЯ 1904

105 Cover to the programme for Piotr Tchaikovsky's
ballet *Swan Lake*. 1904

106 Cover for *The Russian Museum of Emperor Alexander III*
by Alexander Benois (1906, Moscow)

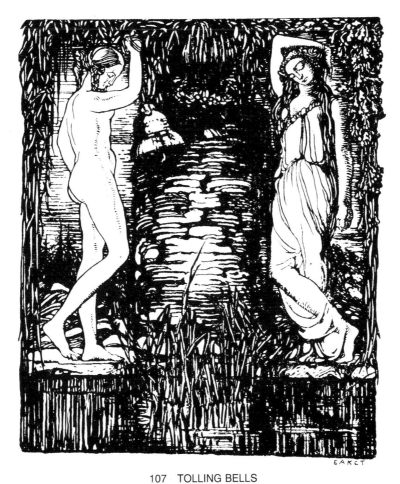

107 TOLLING BELLS

Frontispiece for the journal
Zolotoye runo [*The Golden Fleece*], 1906, No. 3

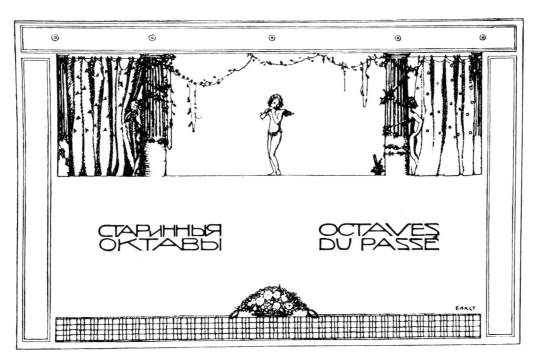

108 Vignette for the poem 'Octaves of Old'
by Dmitry Merezhkovsky
(*Zolotoye runo*, 1906, Nos. 1–4)

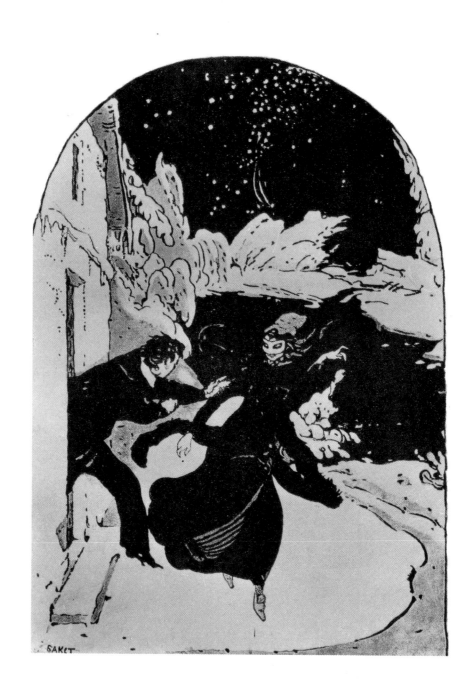

109 Frontispiece for *Snow Mask*, a collection of poems by
Alexander Blok (St Petersburg, 1907)

ЛЕБЕДЬ

ЖУРНАЛЪ ЛИТЕРАТУРЫ
И ИСКУССТВА

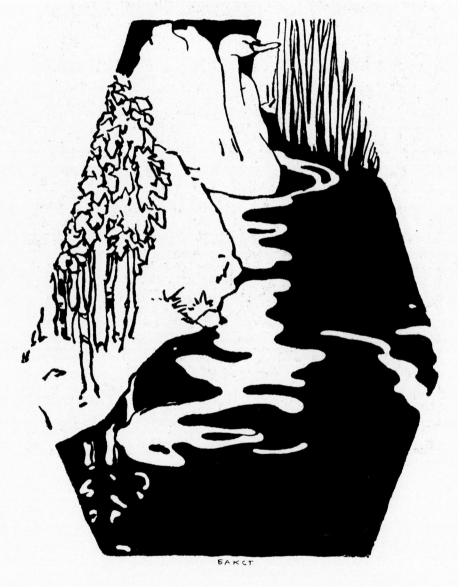

БАКСТ

110 Cover for the journal *Lebed* [*The Swan*]. 1908

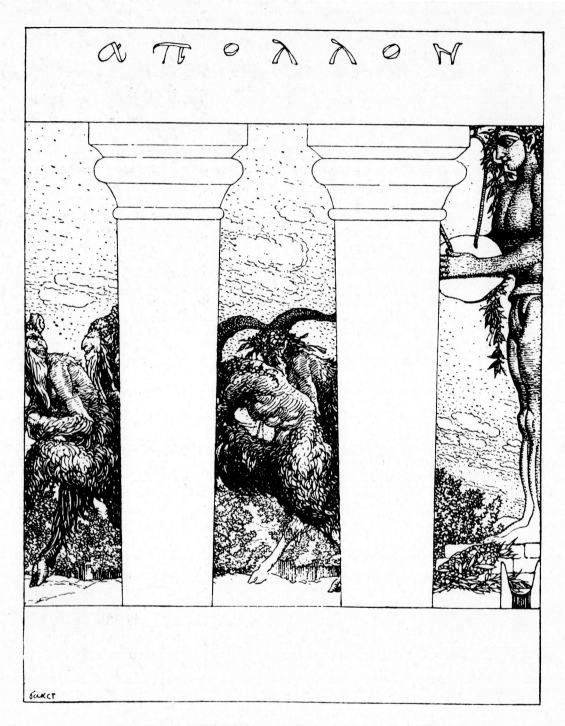

111 Frontispiece for the journal *Apollon* [*Apollo*]. 1909

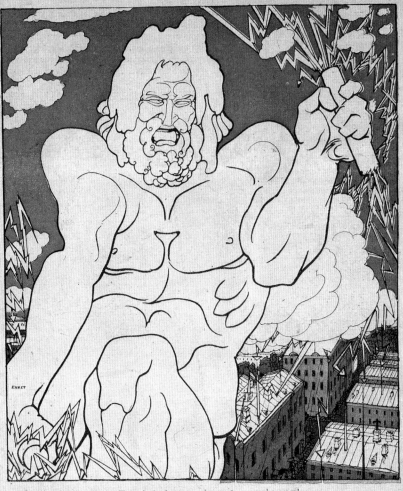

112 ZEUS THE THUNDERER

Cover for the journal *Satiricon* (1908, No. 1)

ЦѢНА ОТЪ РУБЛЯ

113 DOLL MARKET

Sketch of a poster. 1899

114 IN A LADY ARTIST'S STUDIO

Sketch of the poster advertising an exhibition
of Russian artists at the Viennese Sezession. 1908

PAINTINGS AND GRAPHIC WORKS

Though a connoisseur of the 'old style' and the painterly chiaroscuro, he is more a modern stylist (in the narrow sense of the word) than Somov or Lanceray, responsive to all the challenges posed by contemporary western European art. Meeting these challenges, he merged his ideas regarding the function of colour with his use of a refined and lovely line, and produced a stylistic synthesis in which one glimpses the potential re-emergence of Neo-Classicism. One is aware of this Neo-Classical mood in everything that Bakst has produced in recent years.

Sergei Makovsky

His canvases are ennobled by intent observation, free brushwork and magnificent colouring. The portraits of the Serov school do not betray great effort... Bakst does not dismember the soul of the sitter. Everything that emerges from his brush appears to be an improvisation, a fortunate chance discovery. In these portraits a contour-line limns the person spatially, disposes him in space, discloses his character and conveys his volume.

André Levinson

Bakst has shown himself to be a first-rate master... and in a field where attainments in Russian art were generally rare before the close of the nineteenth century: in sketching from the nude.

Alexei Sidorov

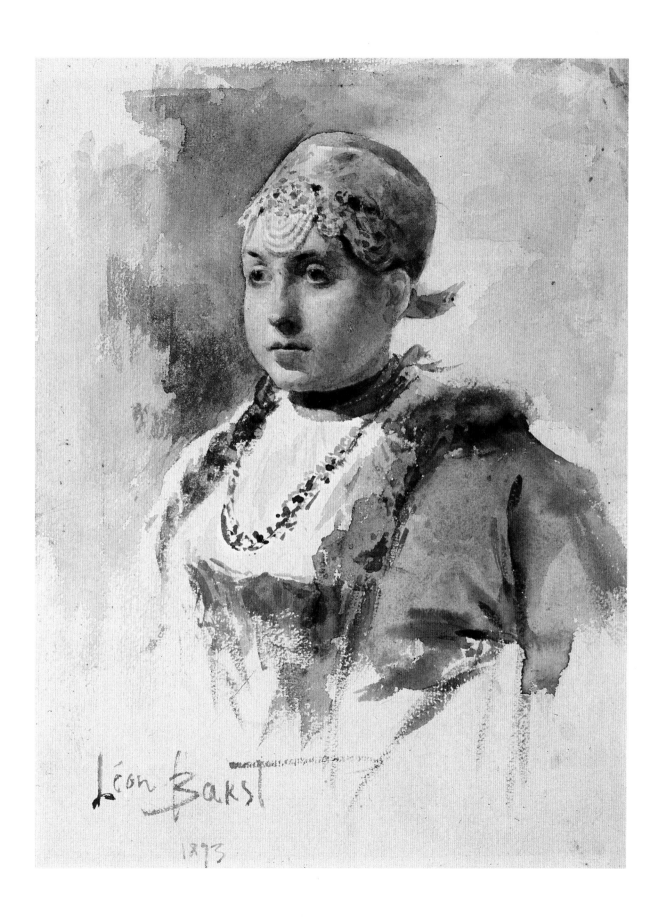

115 GIRL IN RUSSIAN COSTUME. 1893

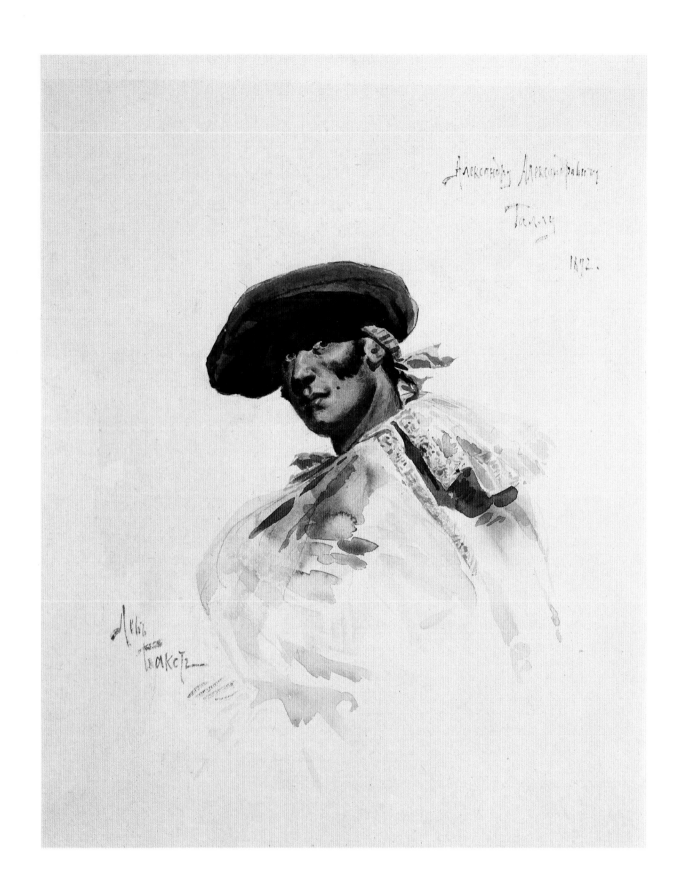

116 SPANIARD. 1891

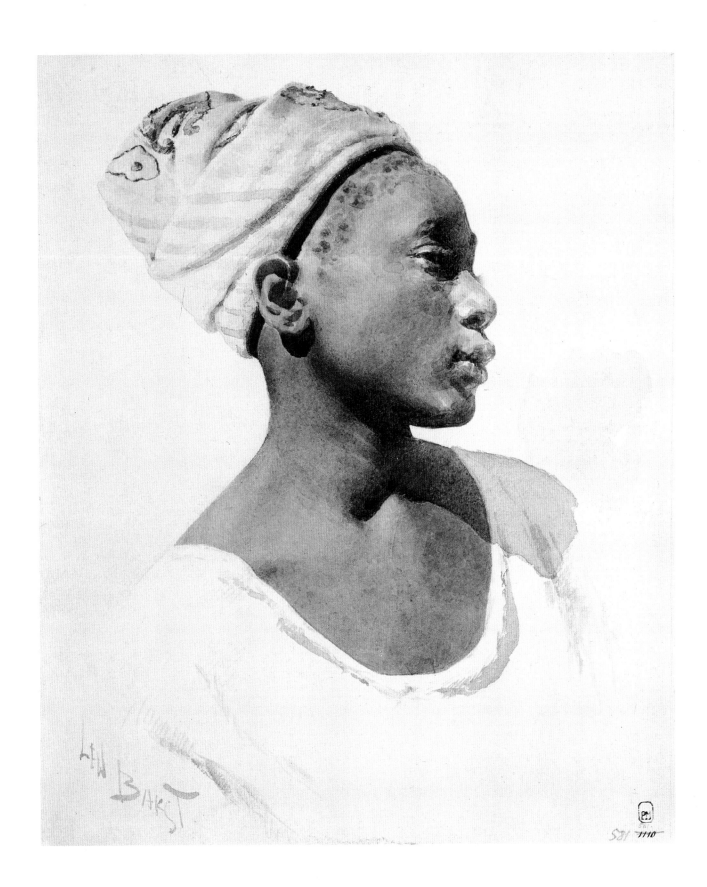

117 YOUNG DAHOMEYAN. 1895

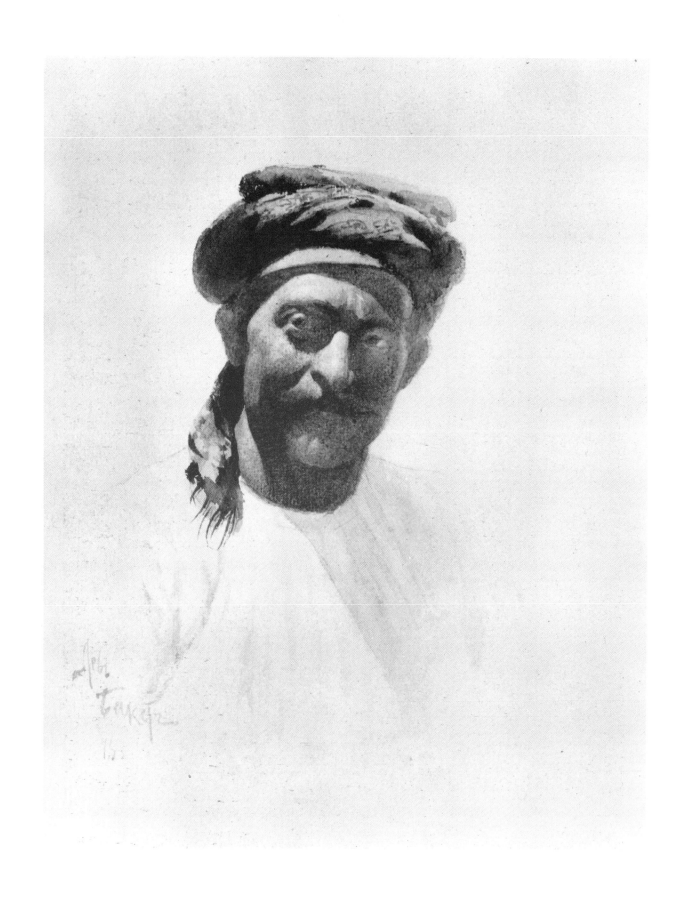

118 HEAD OF AN ARAB. 1893

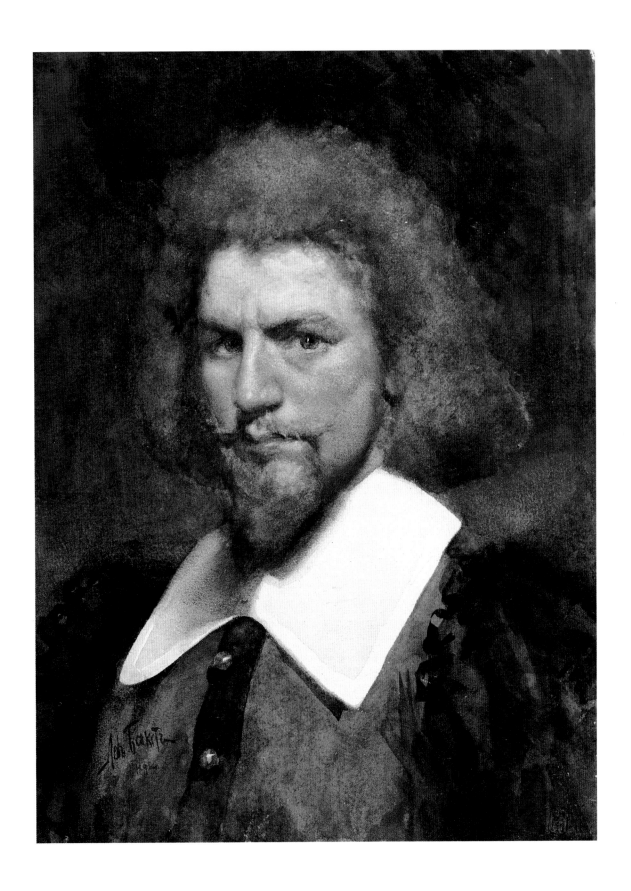

119 URIEL ACOSTA. 1892

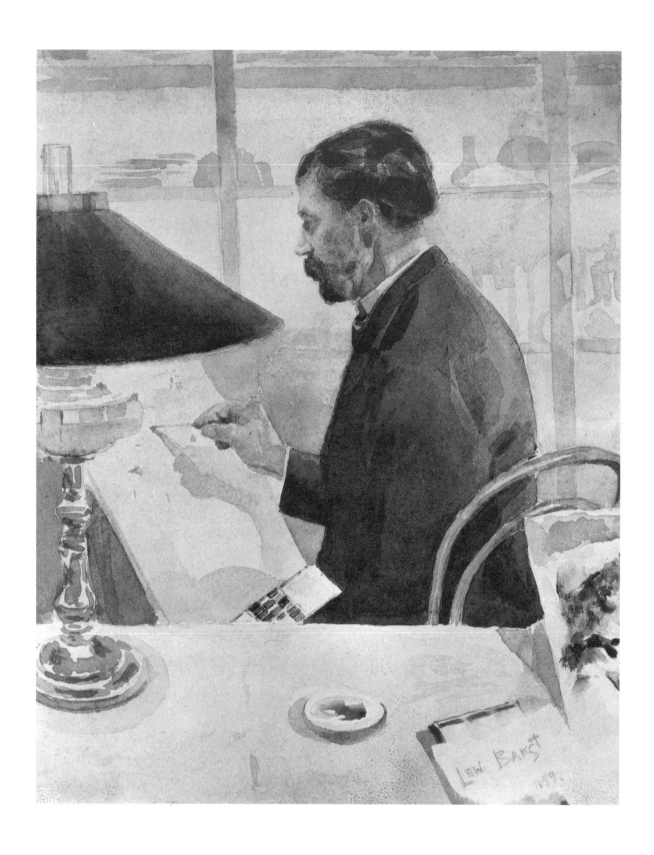

120 PORTRAIT OF ALEXANDER ALEXEYEV. 1894

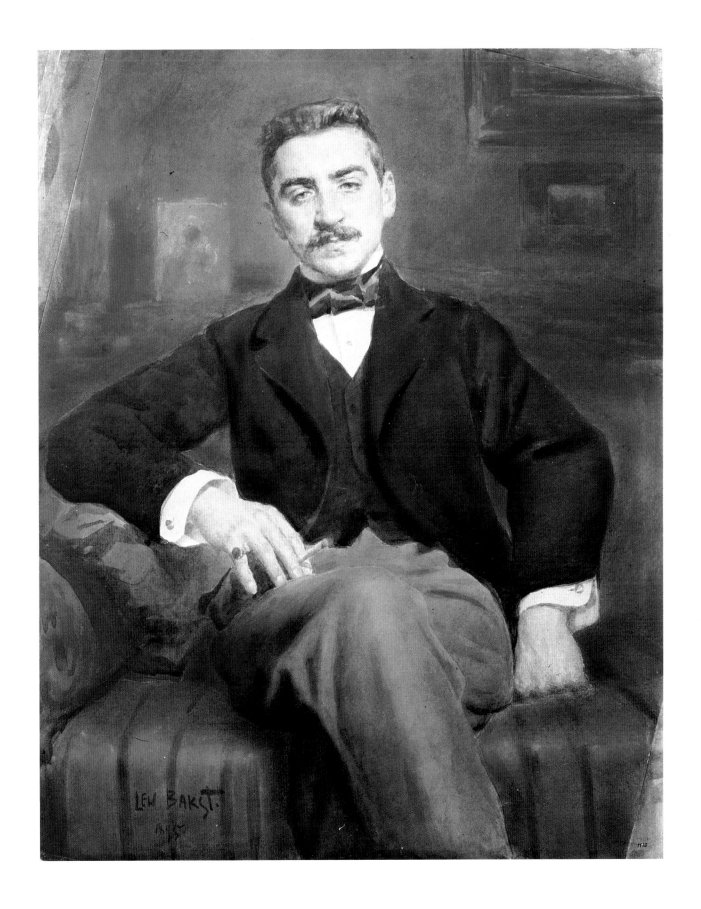

121 PORTRAIT OF WALTER NOUVEL. 1895

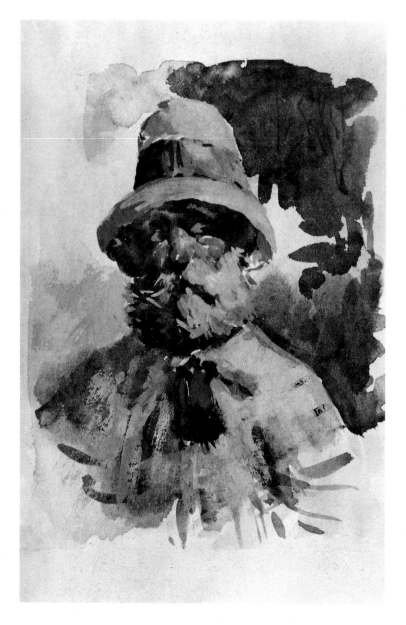

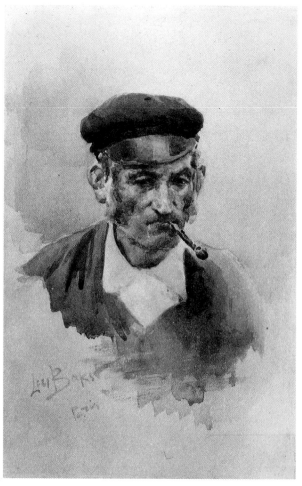

123 FINNISH FISHERMAN. 1895

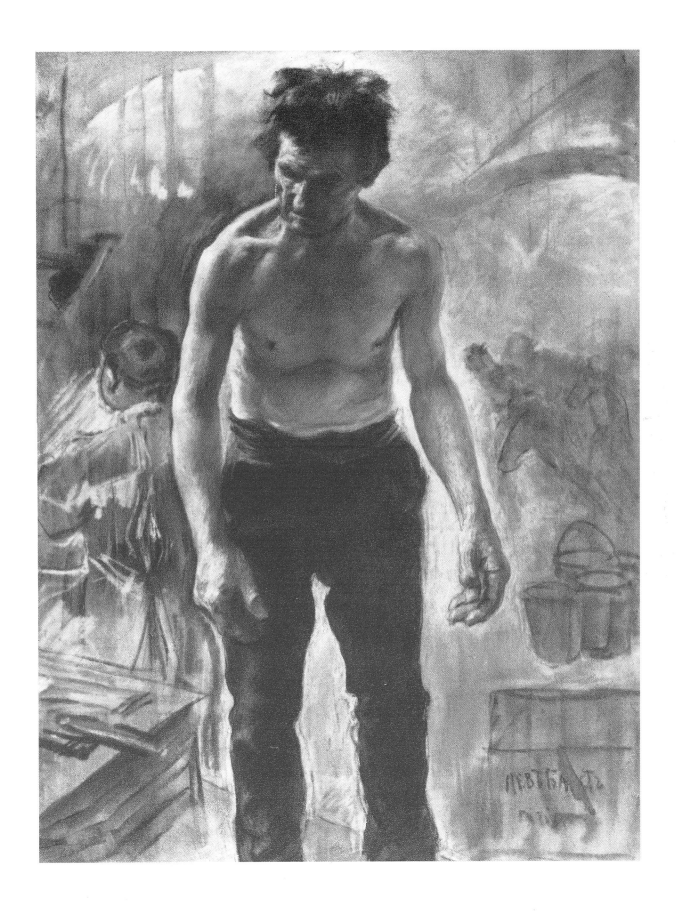

124 BLACKSMITH. 1896

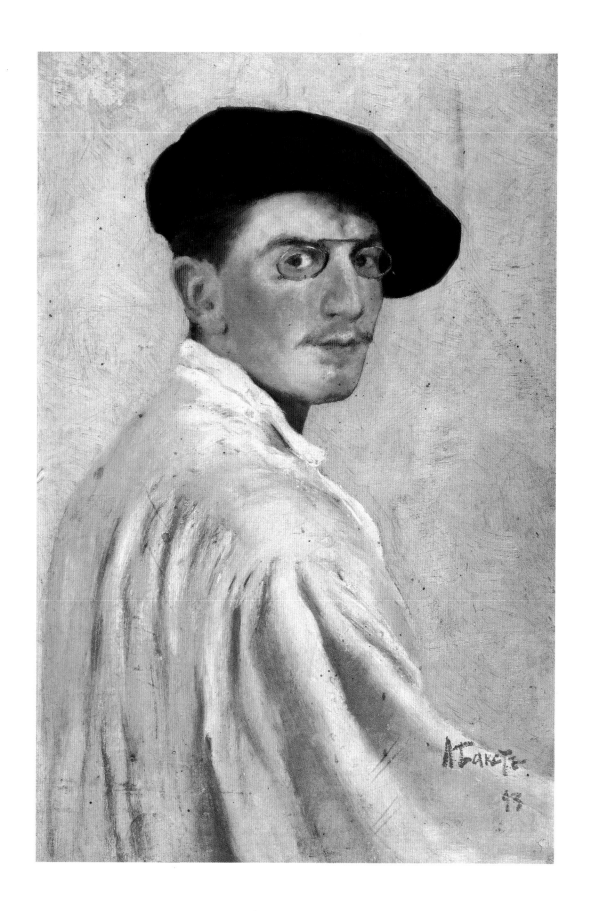

125 SELF-PORTRAIT. 1893

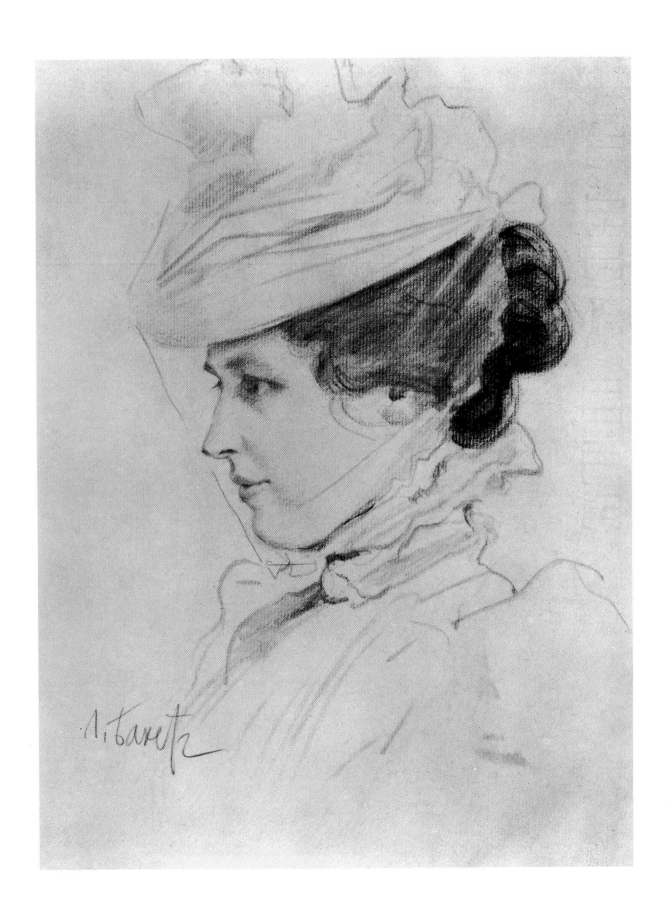

126 PORTRAIT OF THE ACTRESS MARIA SAVINA. 1899

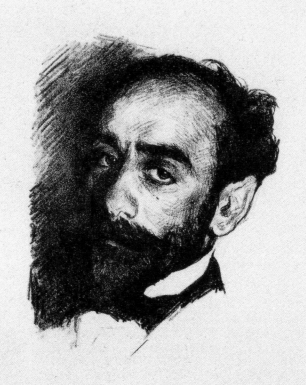

127 PORTRAIT OF ISAAC LEVITAN (*World of Art*, 1899, No. 6)

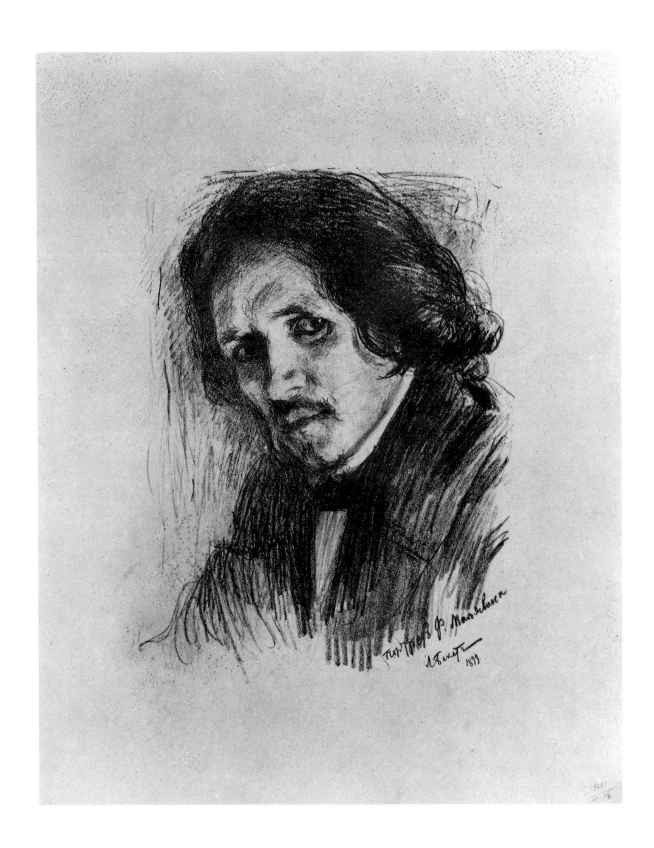

128 PORTRAIT OF PHILIP MALIAVIN (*World of Art*, 1899, Nos. 23/24)

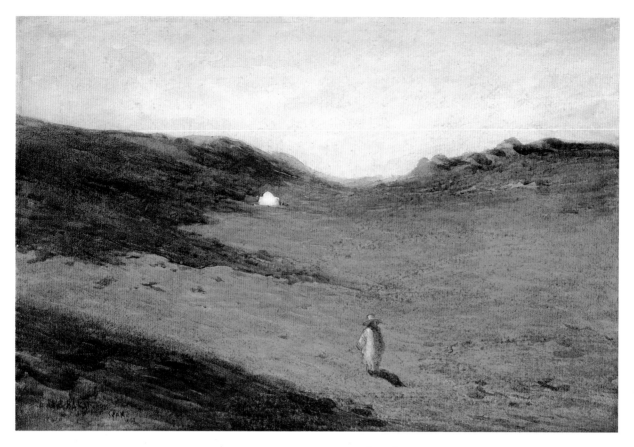

129 EVENING IN THE NEIGHBOURHOOD OF AÏN-ZAÏNFOUR, SFAX. 1897

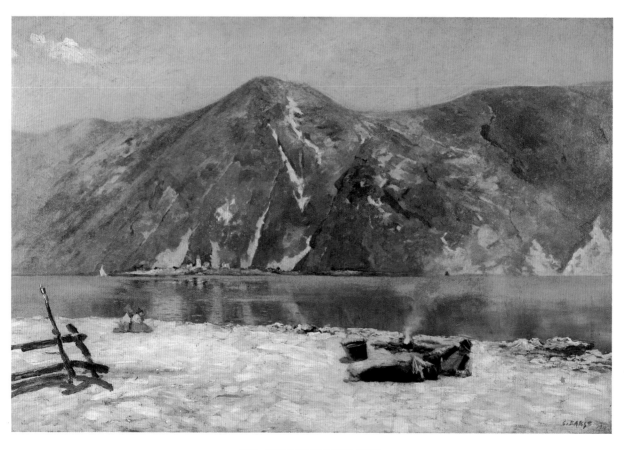

130 MOUNTAIN LAKE. 1899

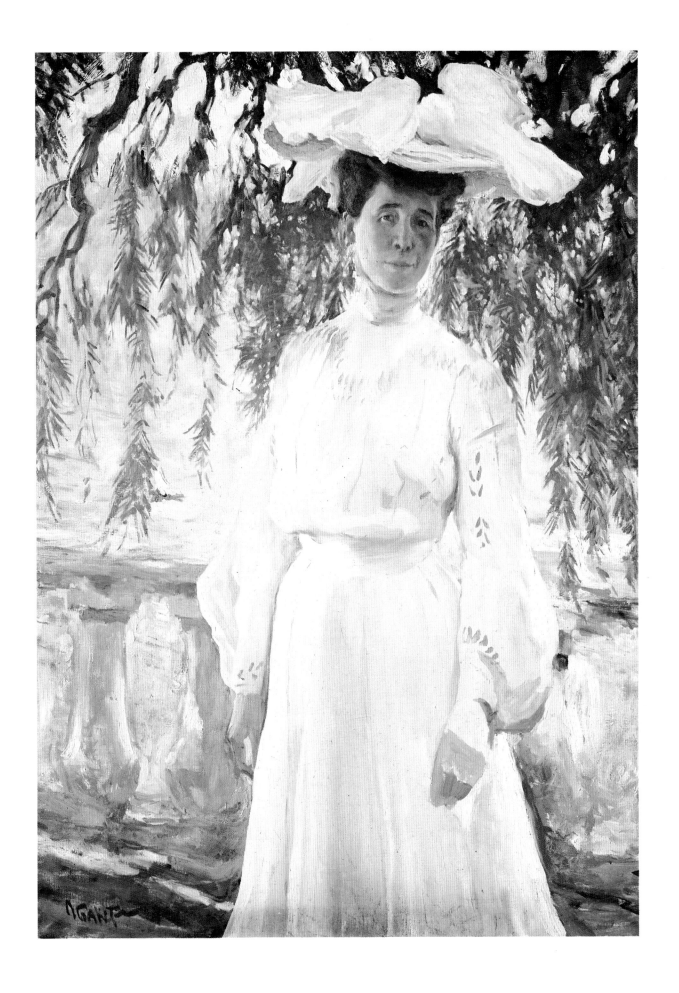

131 PORTRAIT OF LUBOV GRITSENKO. 1903

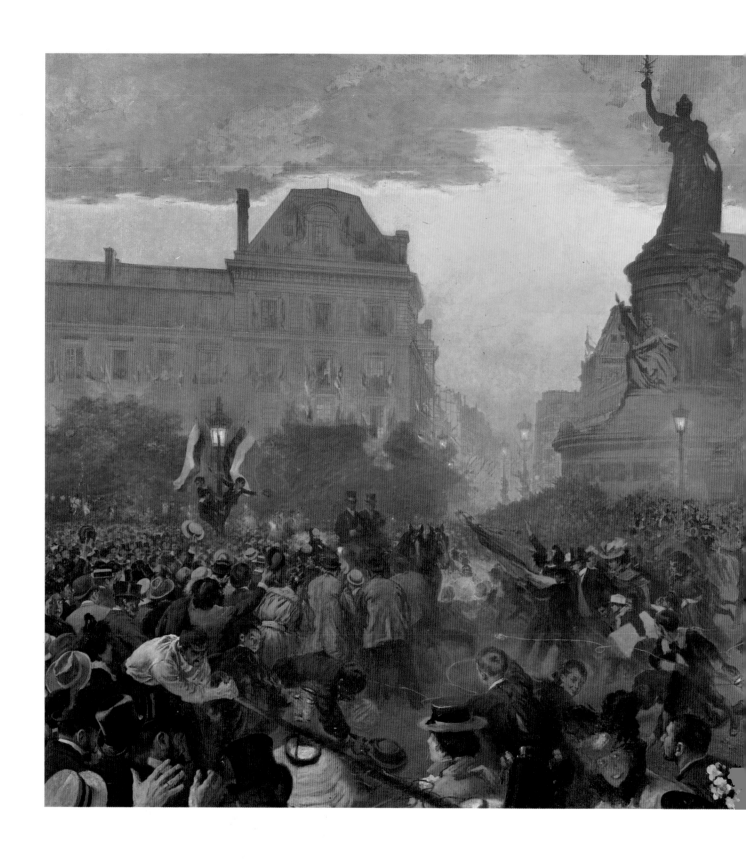

132 PARIS WELCOMES ADMIRAL AVELAN. 1900

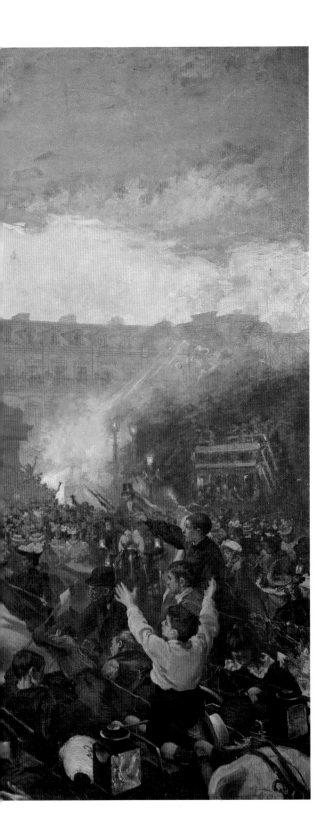

133 BOY CRAWLING ON ALL FOURS
Study for the painting 'Paris Welcomes Admiral Avelan'. 1896

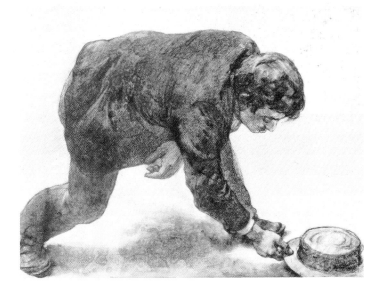

134 MAN PICKING UP HIS HAT FROM THE GROUND
Study for the painting 'Paris Welcomes Admiral Avelan'. 1895

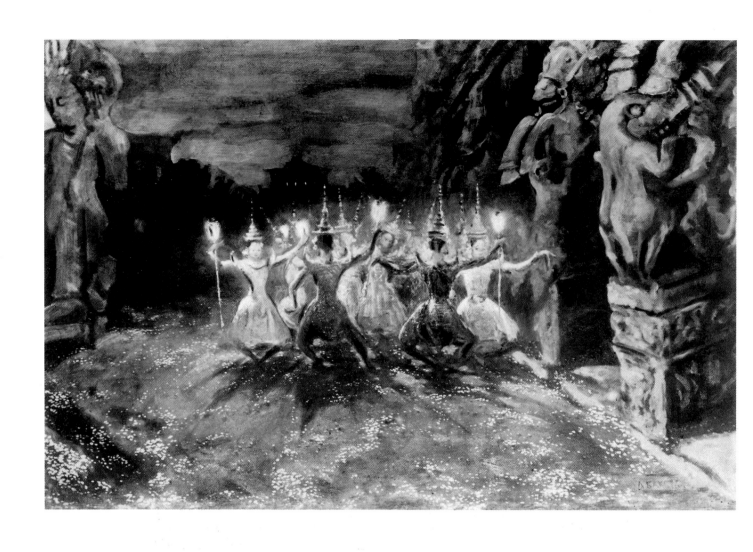

135 SIAMESE RITUAL DANCE. 1901

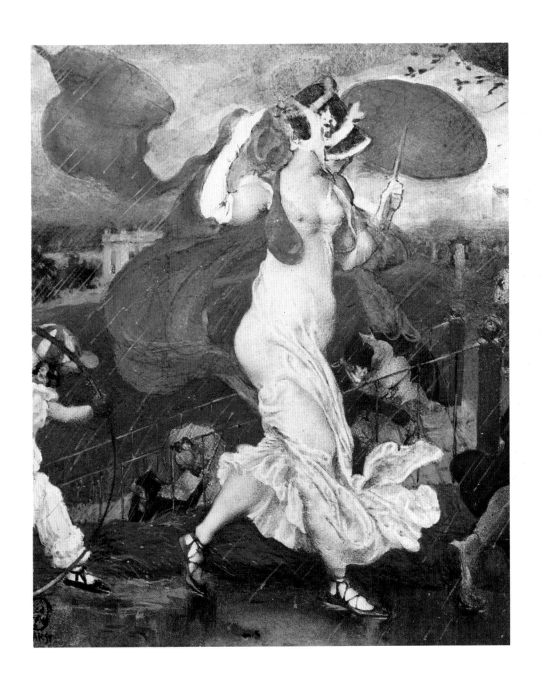

136 THE DOWNPOUR. 1906

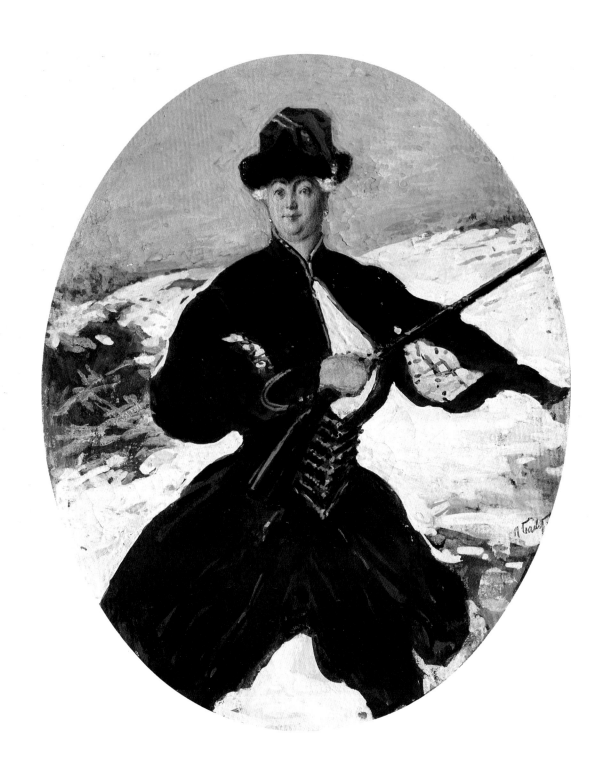

137 ELIZAVETA PETROVNA HUNTING. 1902

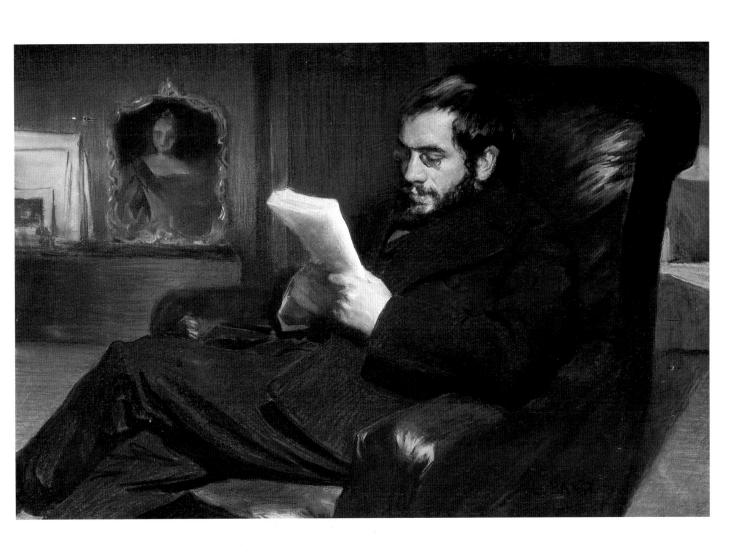

138 PORTRAIT OF ALEXANDER BENOIS. 1898

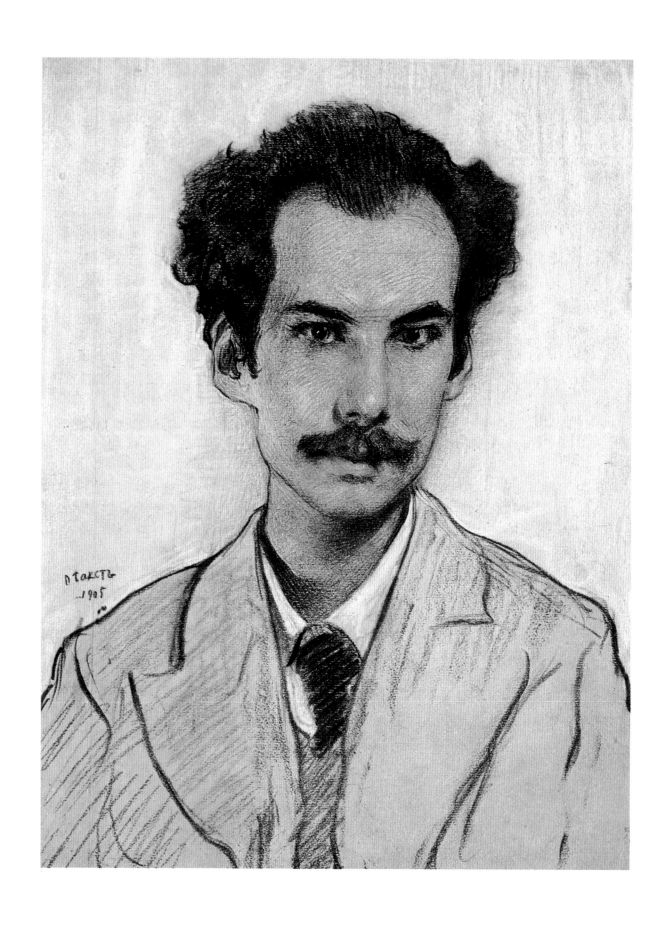

139 PORTRAIT OF ANDREI BELY. 1905

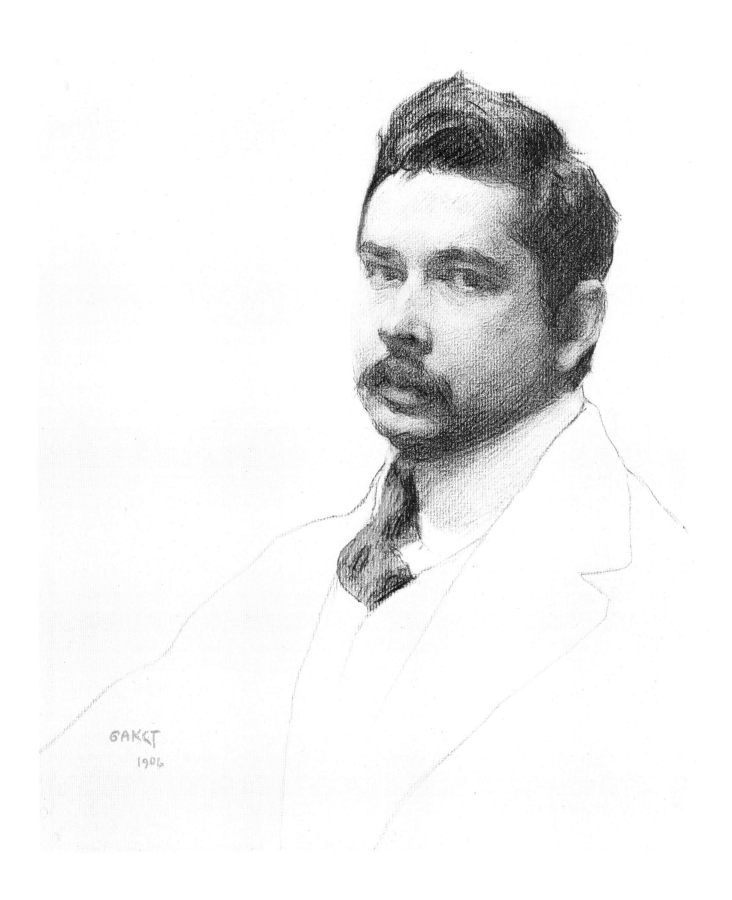

БАКСТ
1906

140 PORTRAIT OF KONSTANTIN SOMOV. 1906

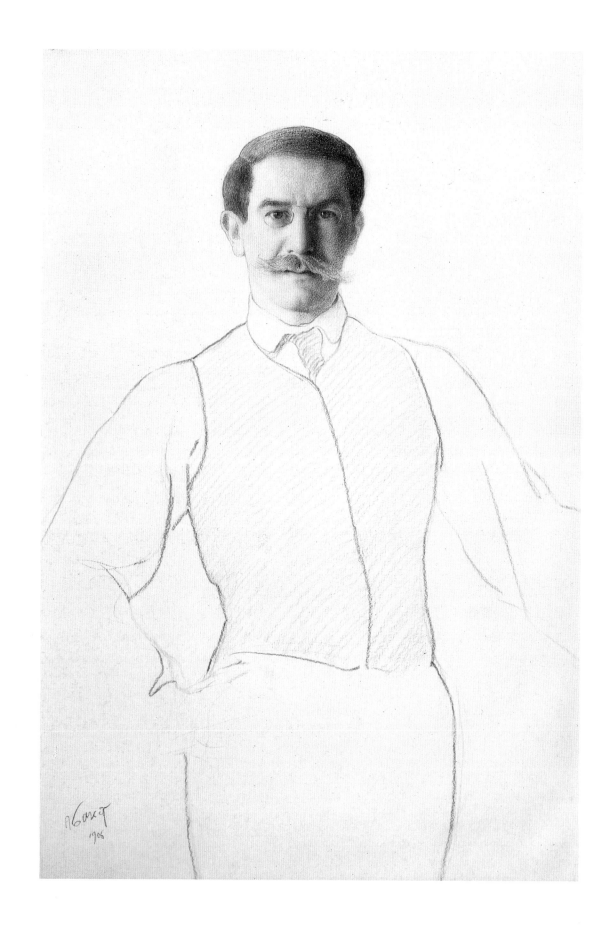

141 SELF-PORTRAIT. 1906

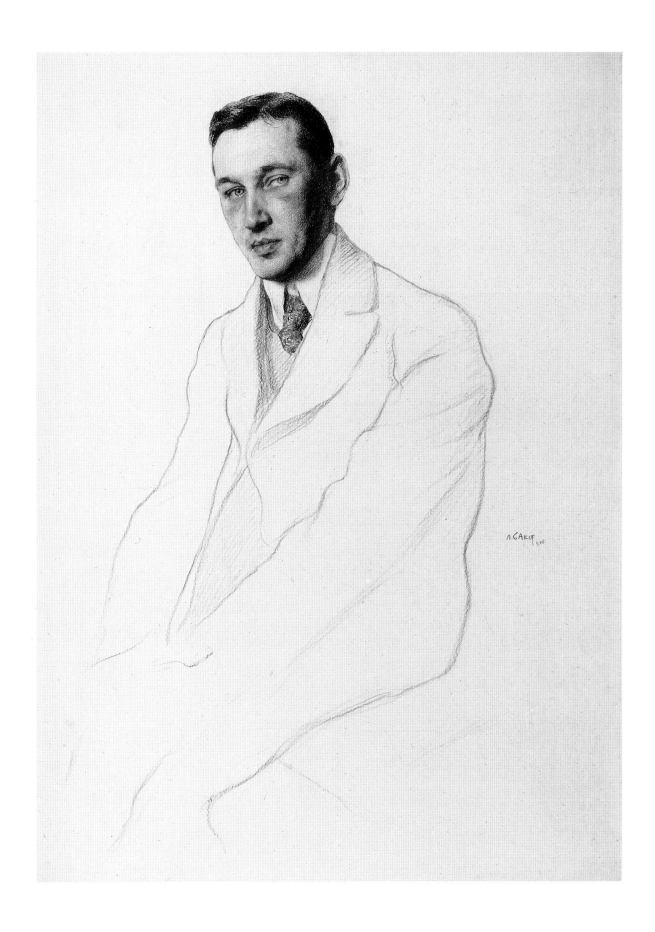

142 PORTRAIT OF ALEXANDER KOROVIN. 1906

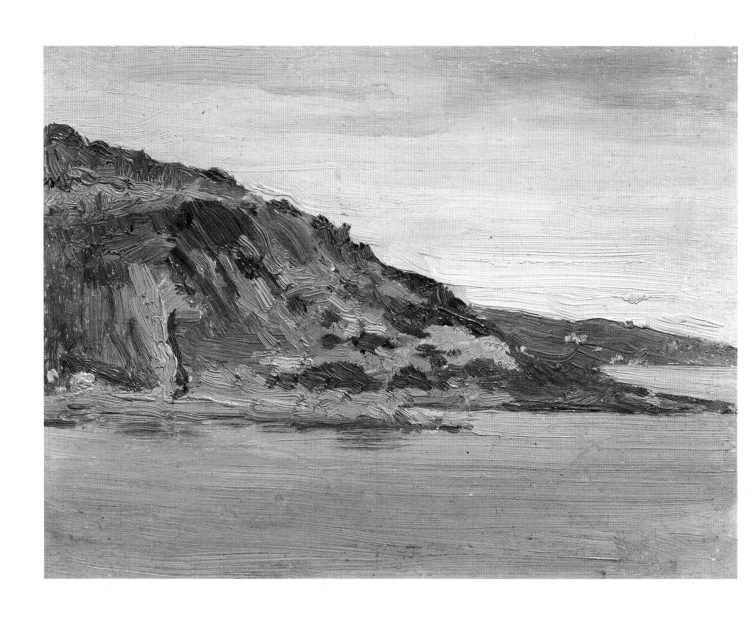

143 VIEW OF VENTIMIGLIA. 1903

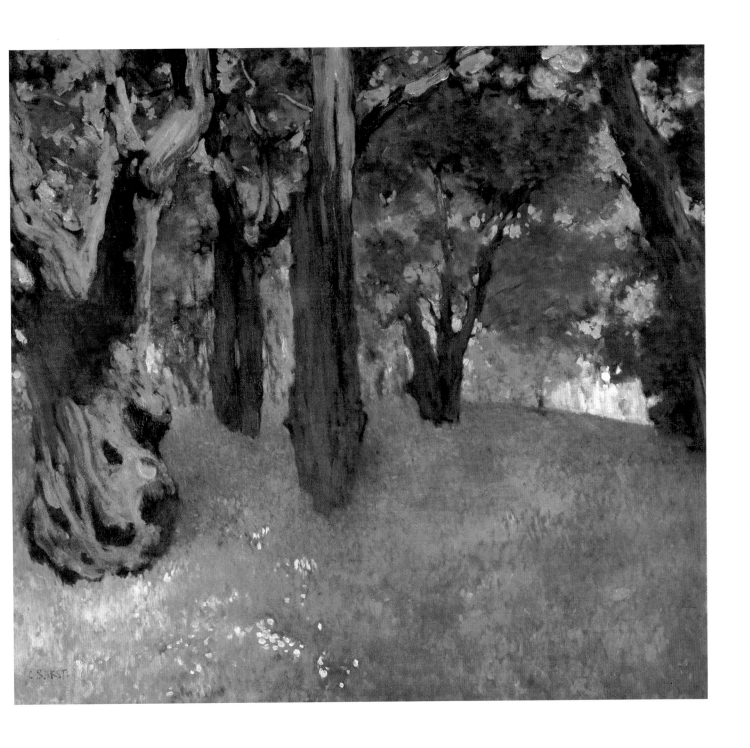

144 OLIVE GROVE. 1903–4

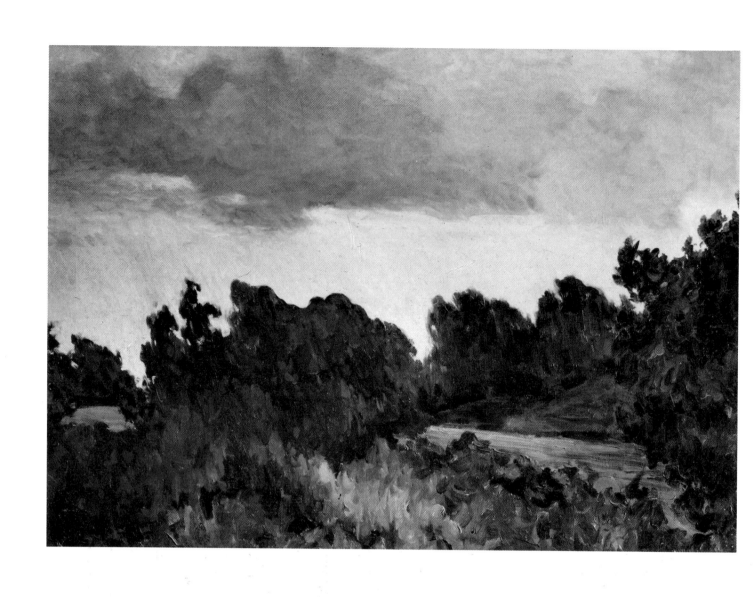

145 LANDSCAPE. 1903–4

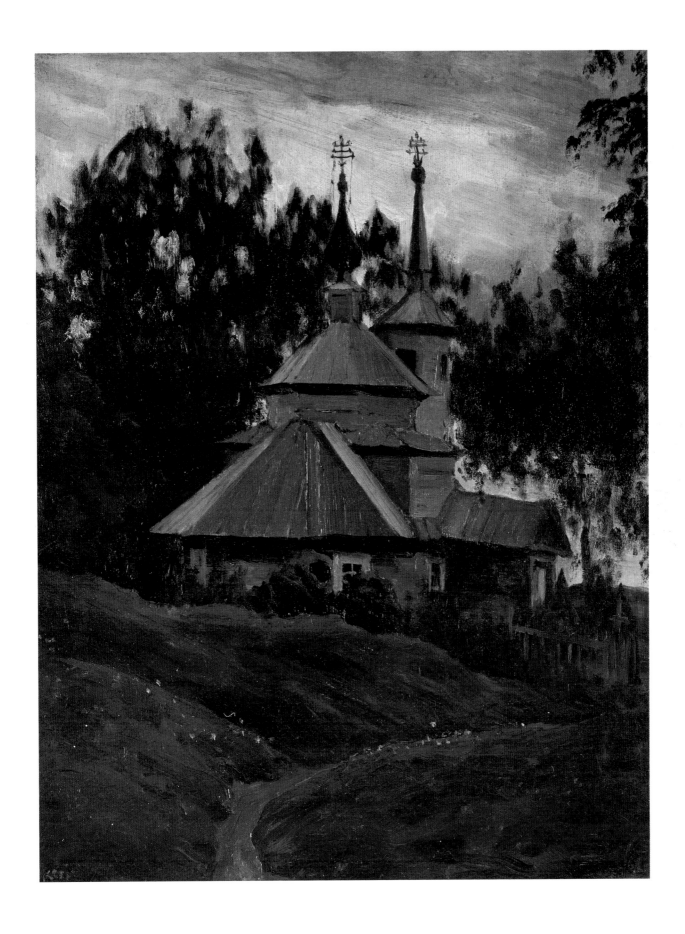

146 VILLAGE CHURCH. 1903–4

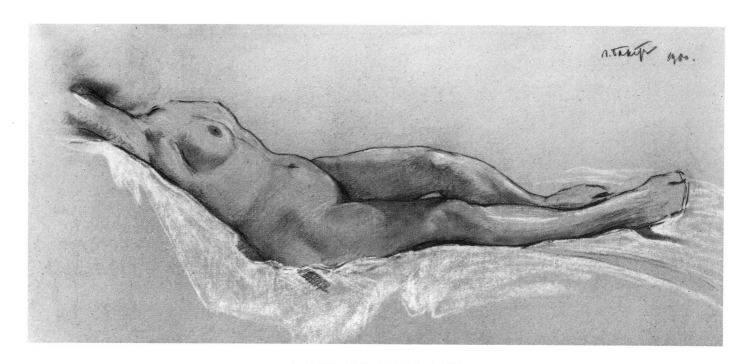

147 FEMALE MODEL LYING. 1900

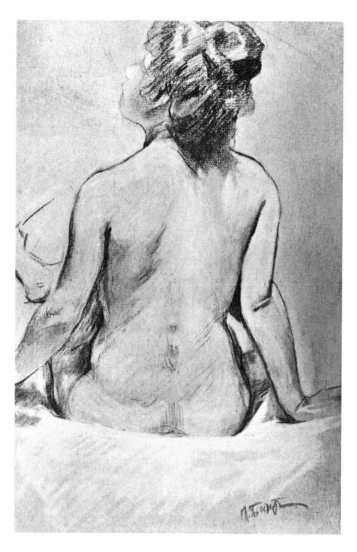

148 SEATED MODEL FROM THE BACK. 1906

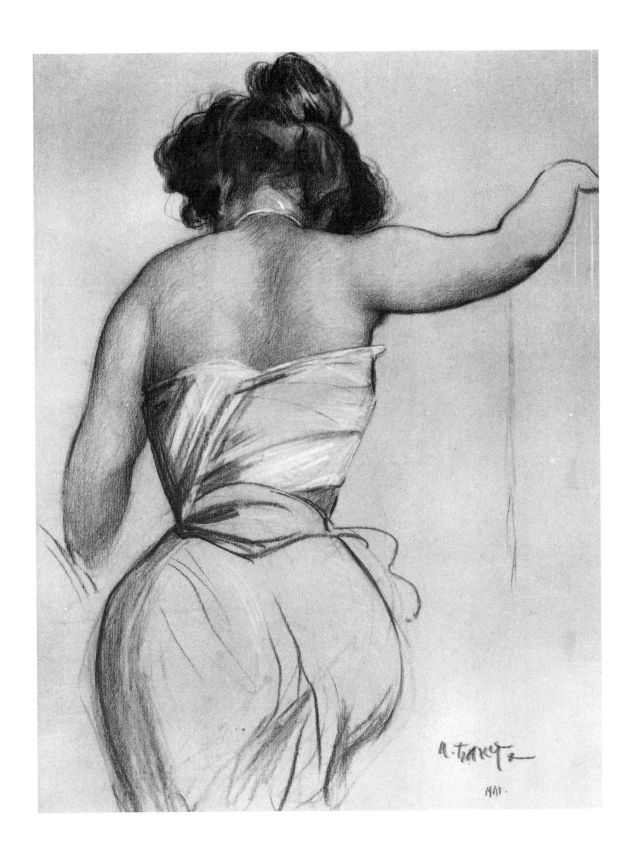

149 STANDING MODEL FROM THE BACK. 1901

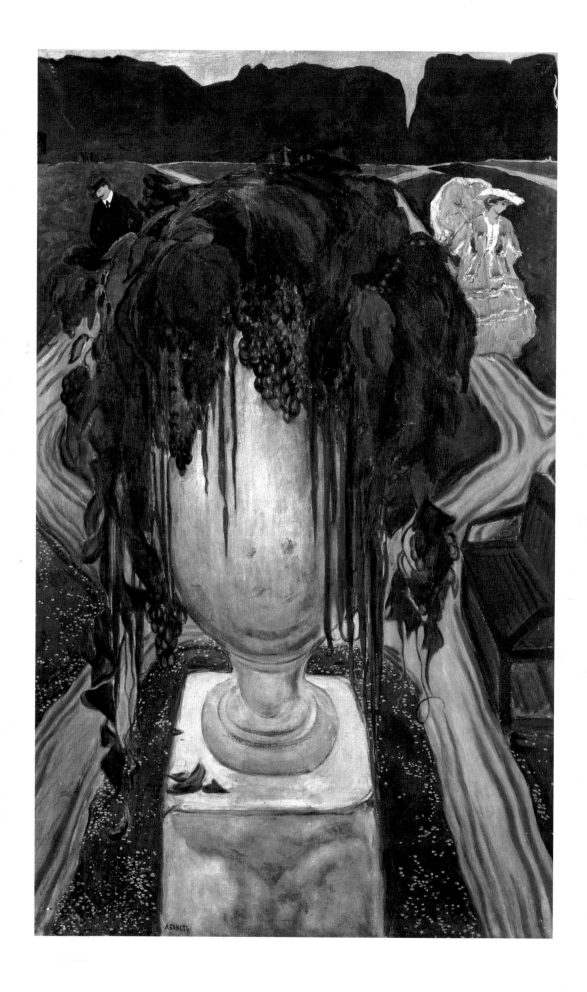

150 THE VASE (SELF-PORTRAIT). 1906

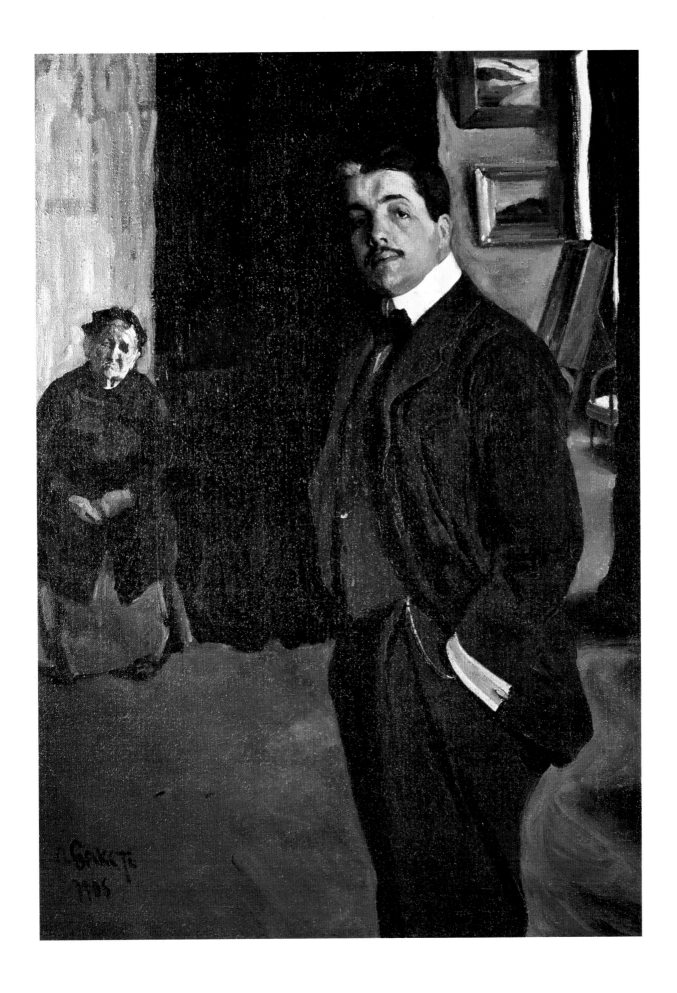

151 PORTRAIT OF SERGEI DIAGHILEV AND HIS NURSE. 1906

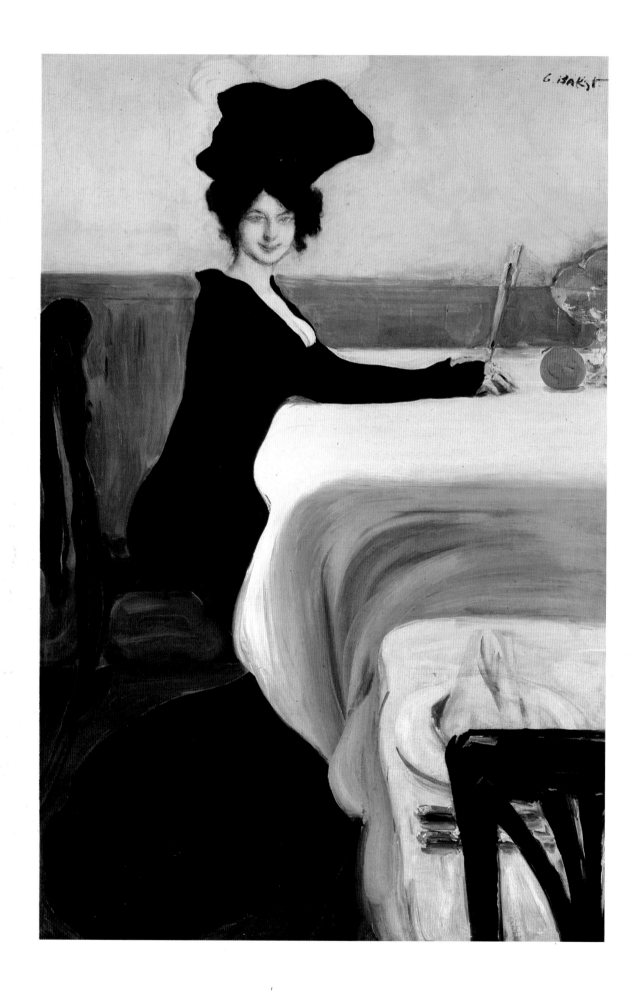

152 THE SUPPER. 1902

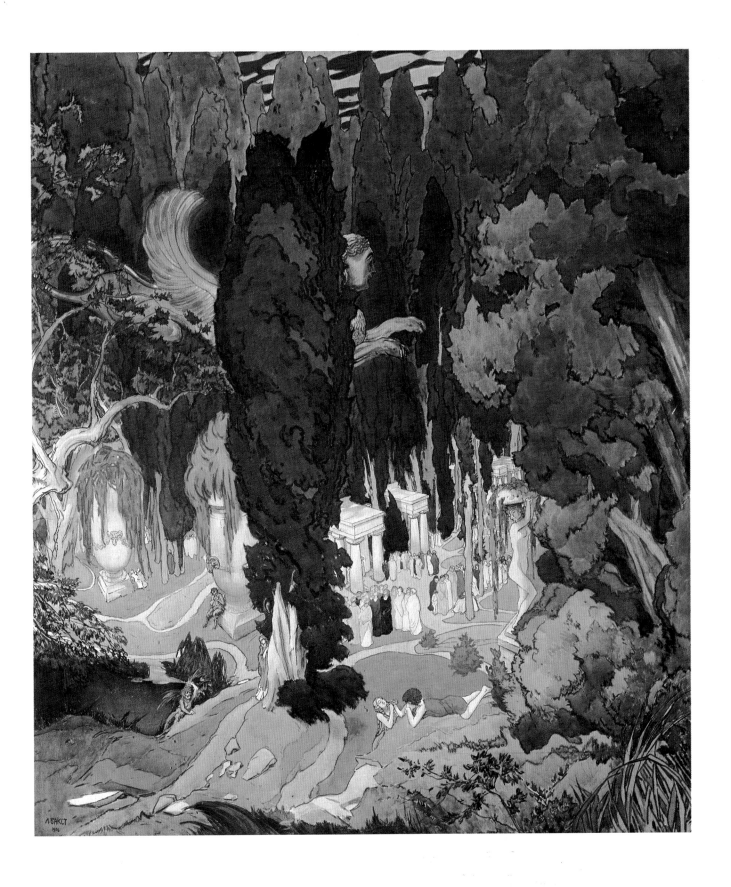

153 ELYSIUM. 1906

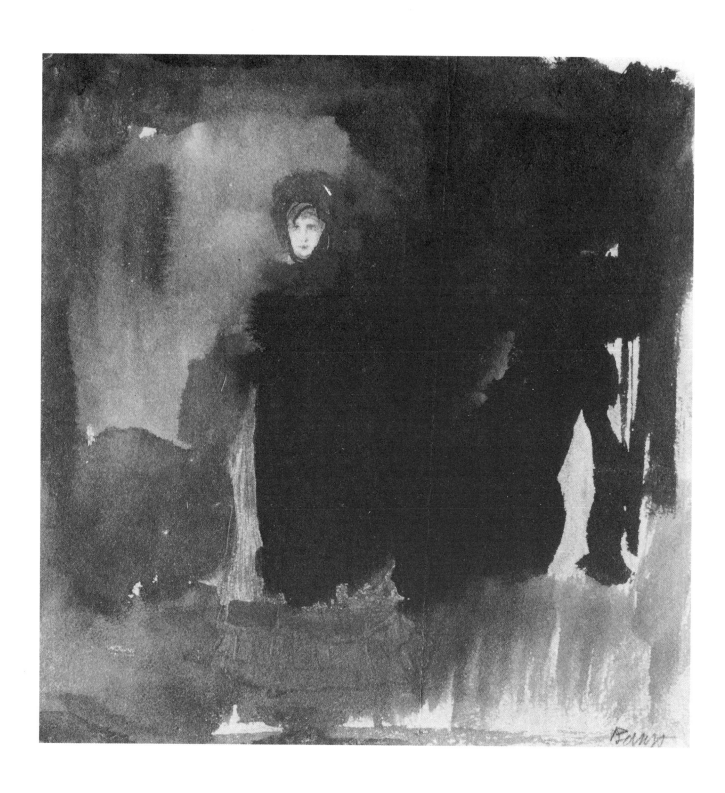

154　THE UNKNOWN LADY

Illustration (?) for Alexander Blok's poem of the same name. 1907

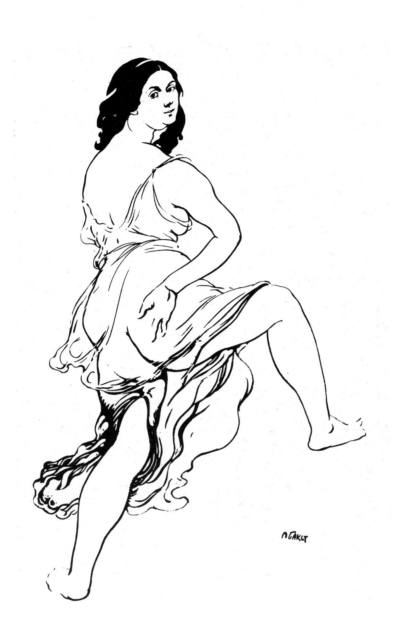

155 ISADORA DUNCAN DANCING

(*Birzhevye vedomosti* [*Stock Exchange News*], 12 December 1907)

156 PORTRAIT OF MILY BALAKIREV

(for the programme of 'Five Historical Russian Concerts' in Paris). 1907

157　SELF-PORTRAIT. 1913

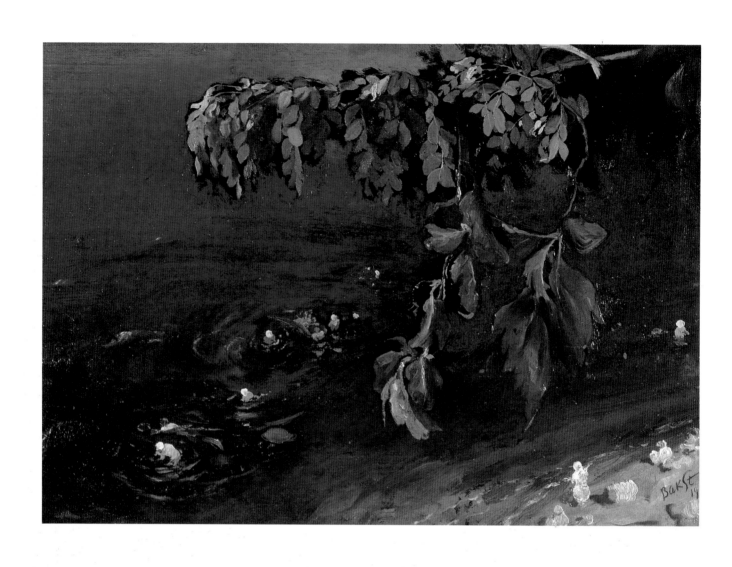

158 ACACIA BRANCH ABOVE THE SEA. 1908

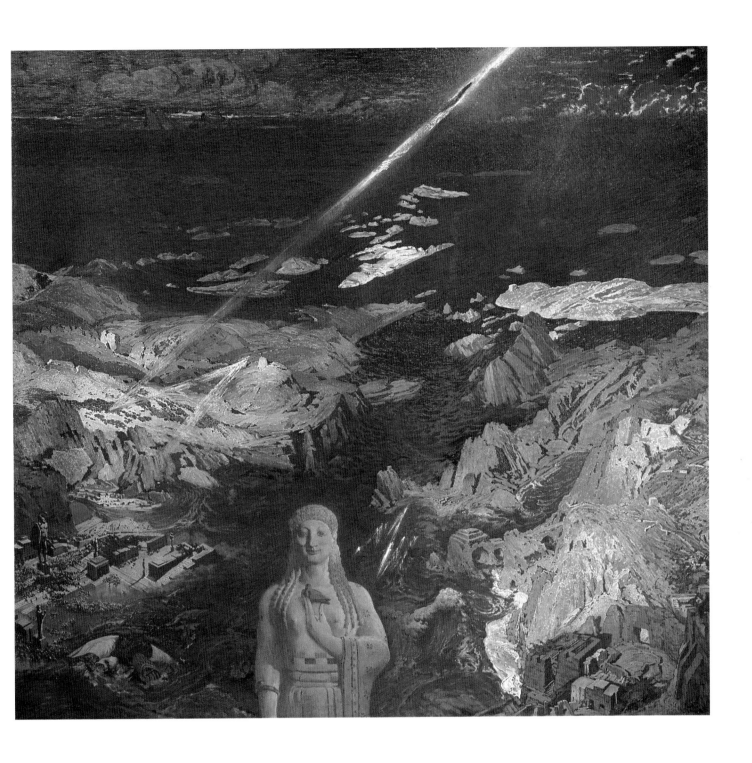

159 TERROR ANTIQUUS. 1908

160 PORTRAIT OF ISADORA DUNCAN. 1908

161 PORTRAIT OF ALEXANDER GOLOVIN

(for the programme of the Paris production of
Modest Mussorgsky's opera *Boris Godunov*). 1908

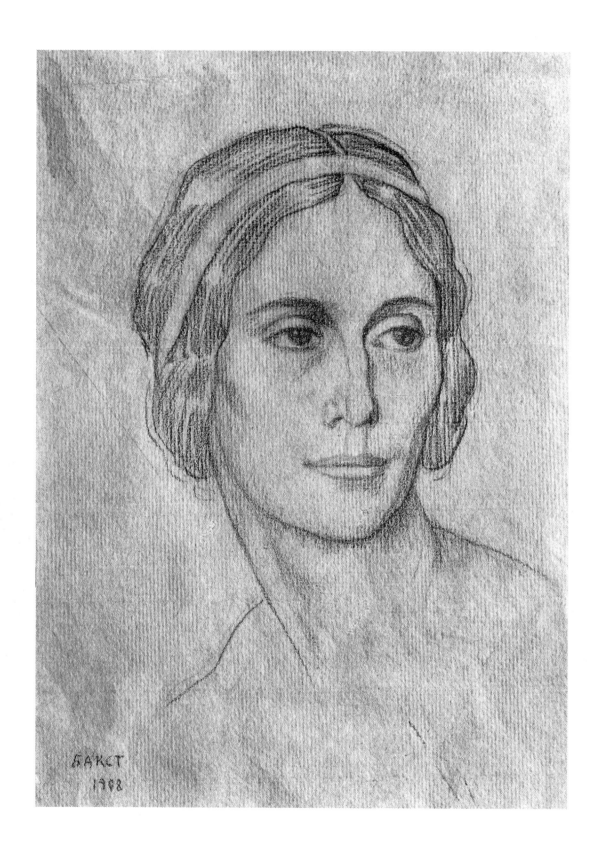

162 PORTRAIT OF ANNA PAVLOVA. 1908

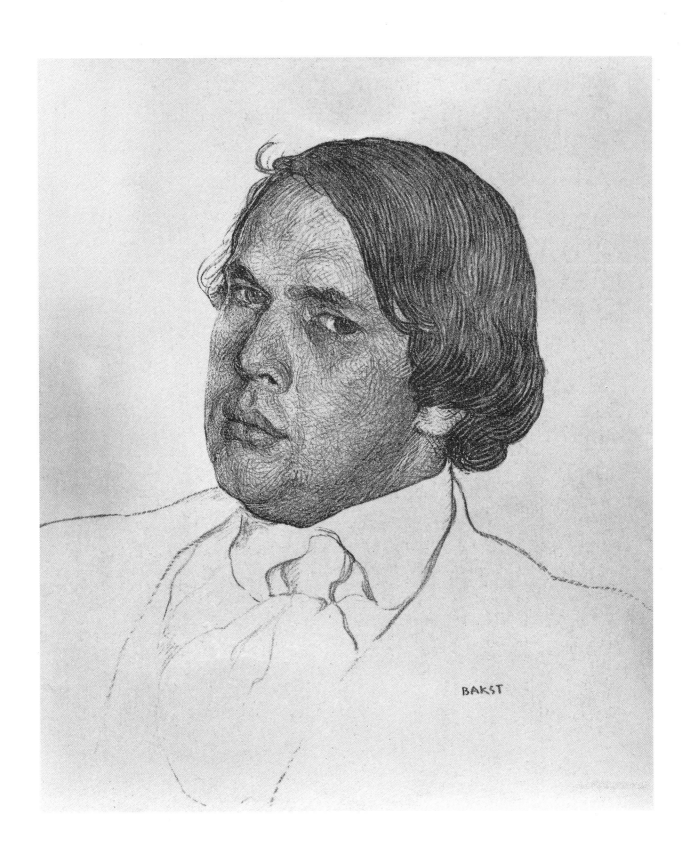

163 PORTRAIT OF ALEXEI TOLSTOI. 1909 (*Apollon*, 1909, No. 3)

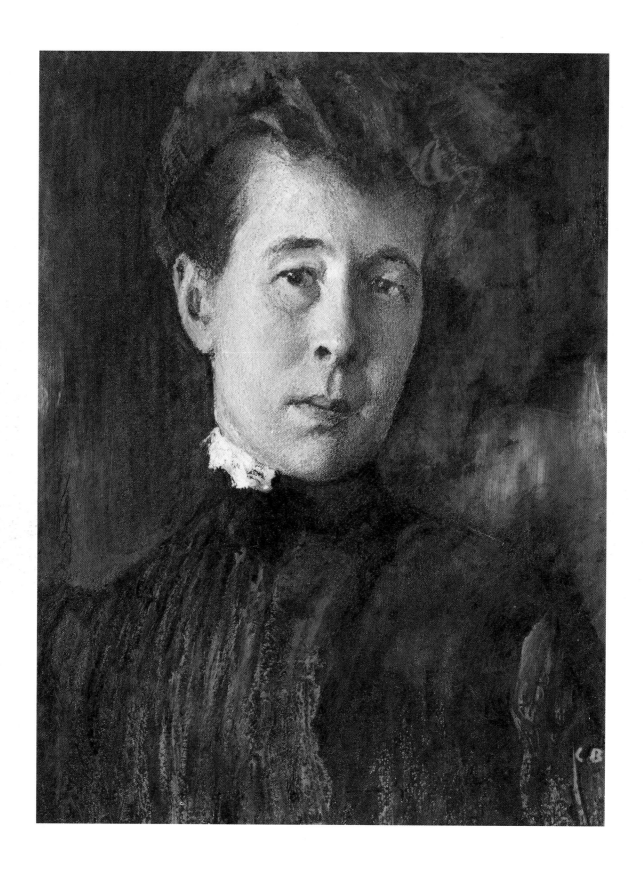

164 PORTRAIT OF LUBOV GRITSENKO-BAKST. 1900s

165 PORTRAIT OF THE ARTIST'S SON, ANDRIUSHA BAKST. 1908

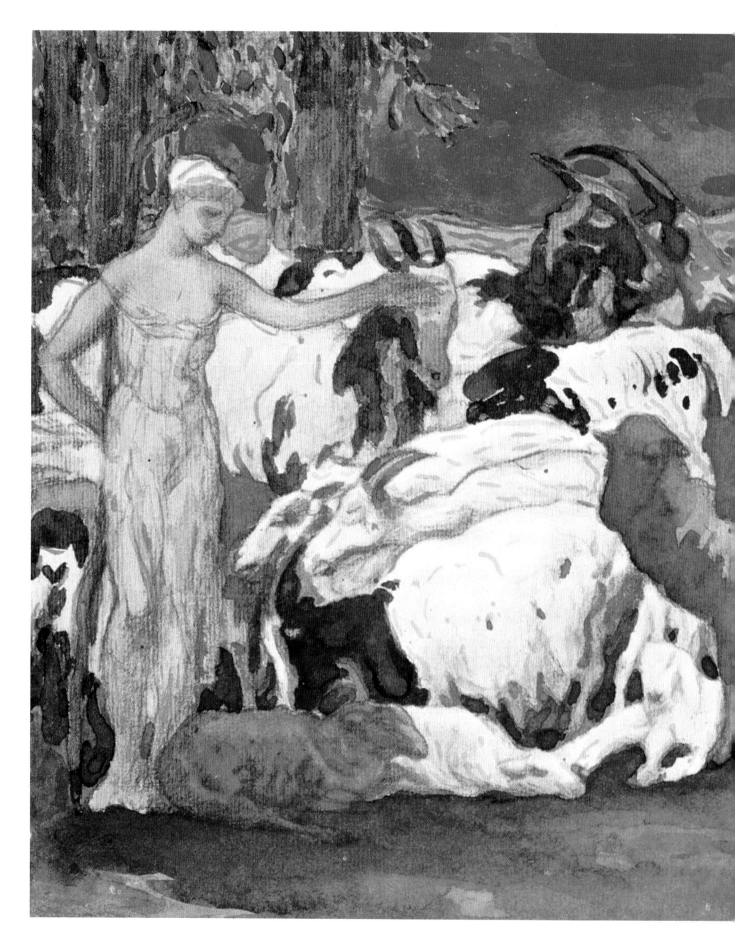

166 DAPHNIS' FLOCK SEPARATES FROM CHLOË'S FLOCK

Decorative panel after *Daphnis and Chloë*, a Greek pastoral romance
ascribed to Longus. Sketch. 1910–11

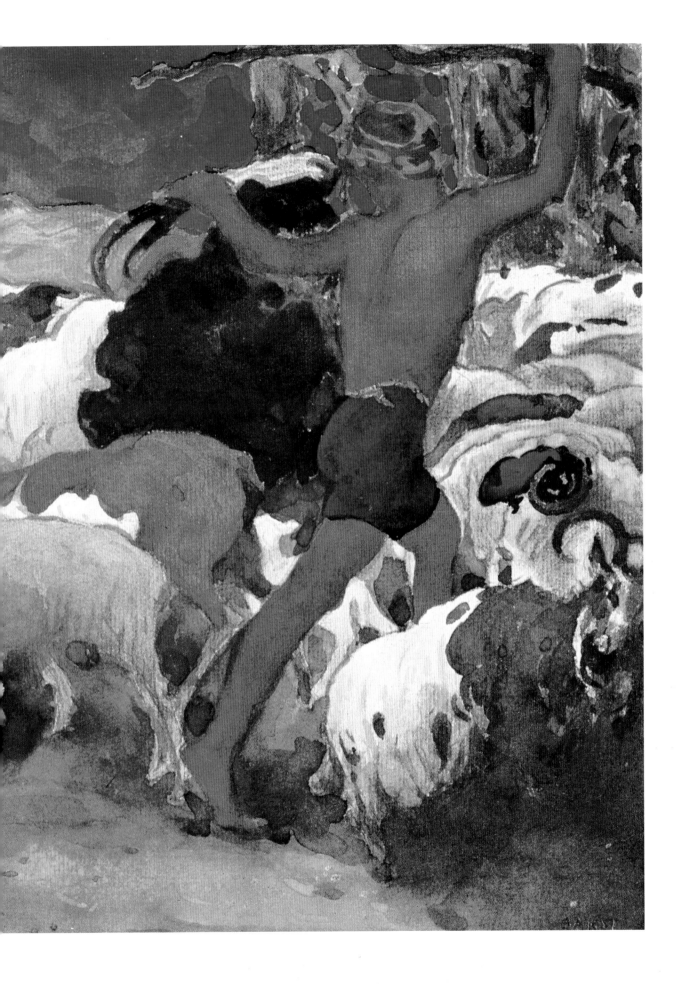

167 BATHERS ON THE LIDO. 1909

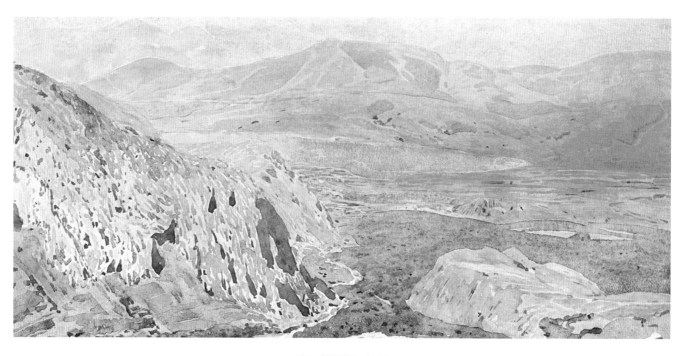

168 DELPHI. 1907

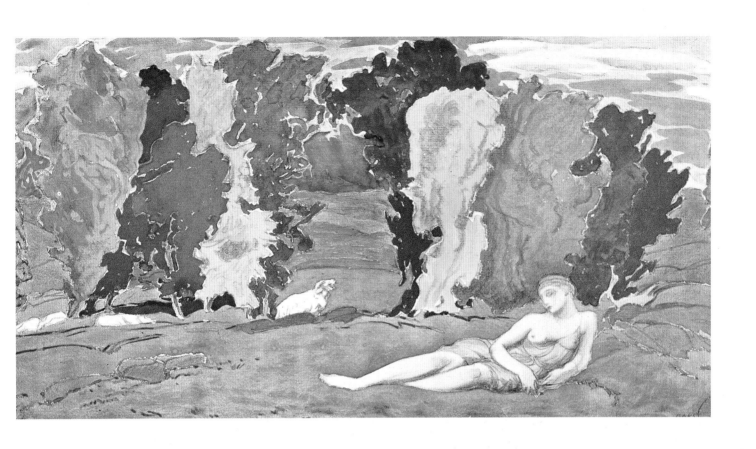

169 CHLOË ABANDONED

Decorative panel after *Daphnis and Chloë*. Sketch

170 STREET IN FIESOLE. Drawing from the artist's sketchbook. 1915

171 VIEW OF MONT BLANC. Drawing from the artist's sketchbook. 1910s

172 SAVOY
Drawing from the artist's sketchbook. 1910s

173 SPRIG OF BERRIES
Drawing from the artist's sketchbook. 1910s

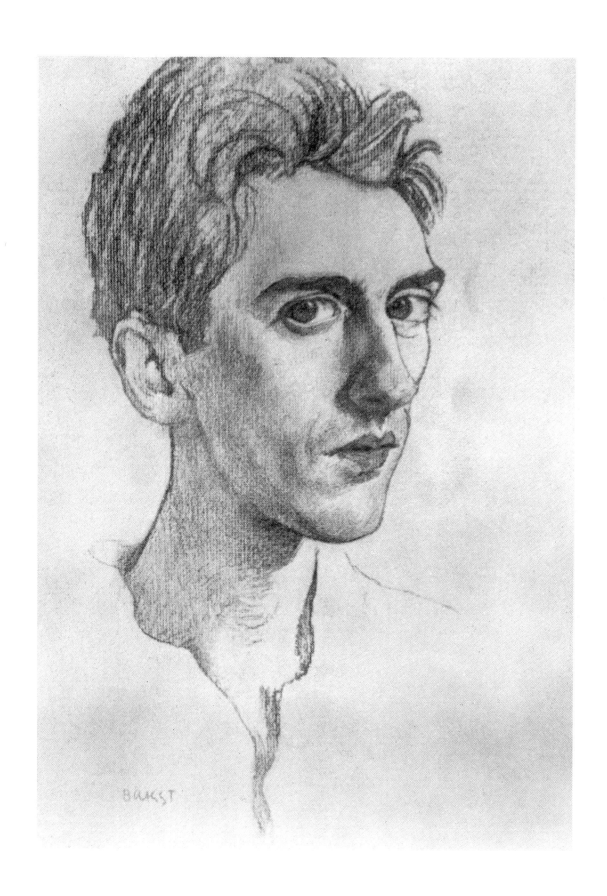

174 PORTRAIT OF JEAN COCTEAU. 1911

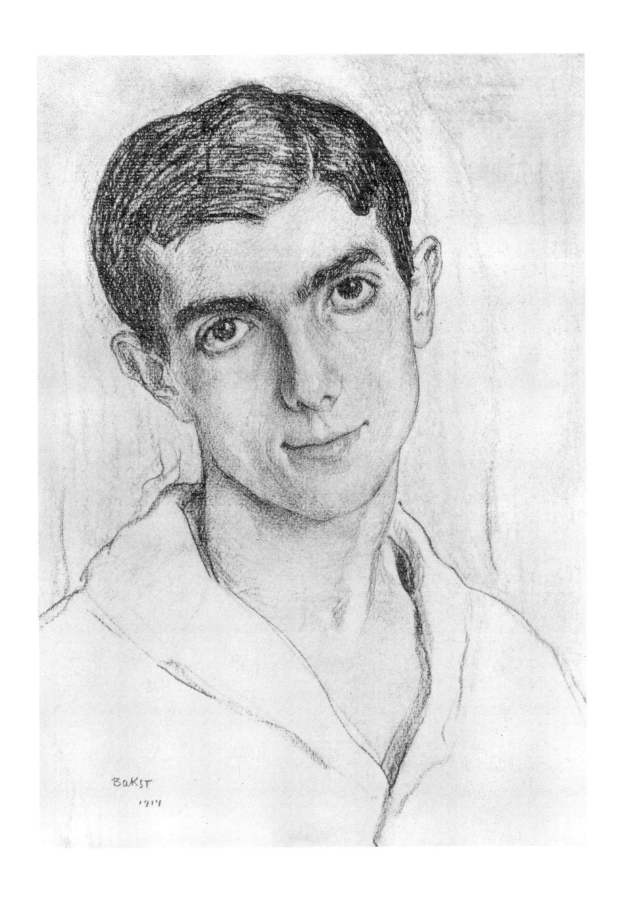

175 PORTRAIT OF LÉONIDE MASSINE. 1914

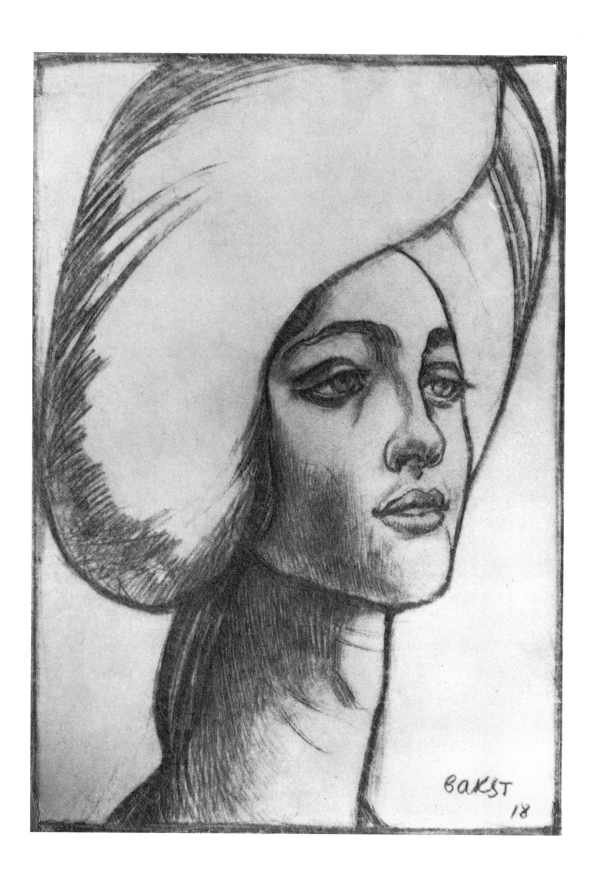

176 PORTRAIT OF M^{ME} T. 1918

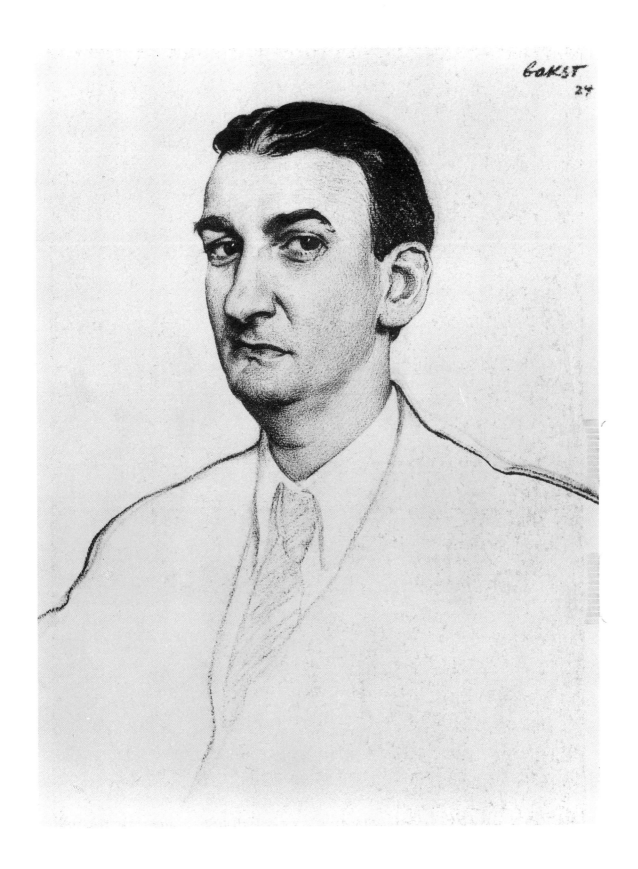

177 PORTRAIT OF LOUIS THOMAS. 1924

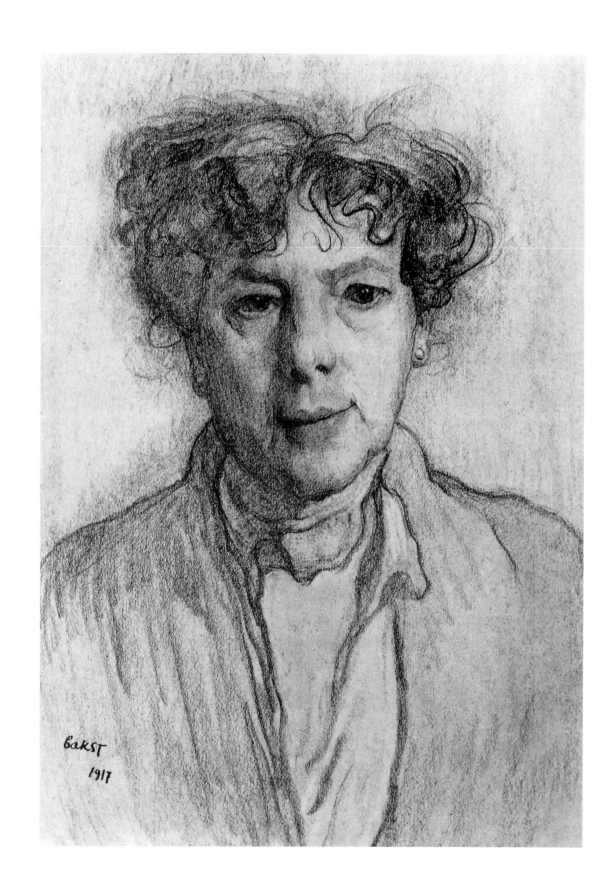

178 PORTRAIT OF VIRGINIA ZUCCHI. 1917

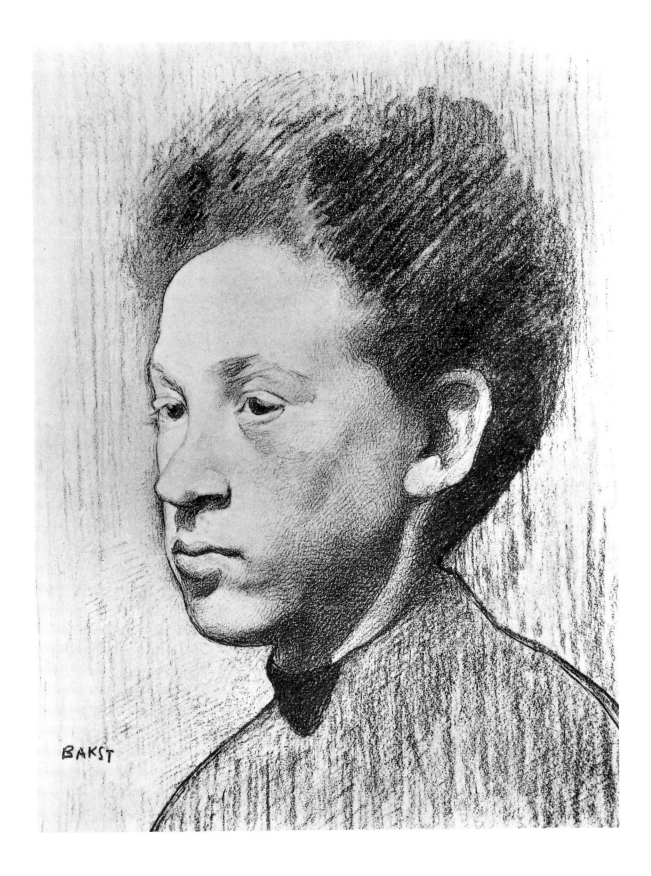

179 PORTRAIT. 1910s

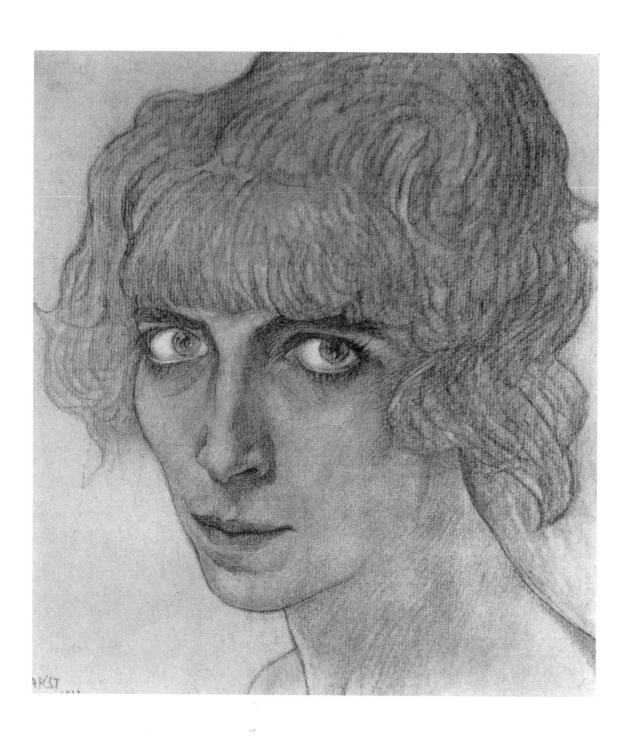

180 PORTRAIT. 1910s

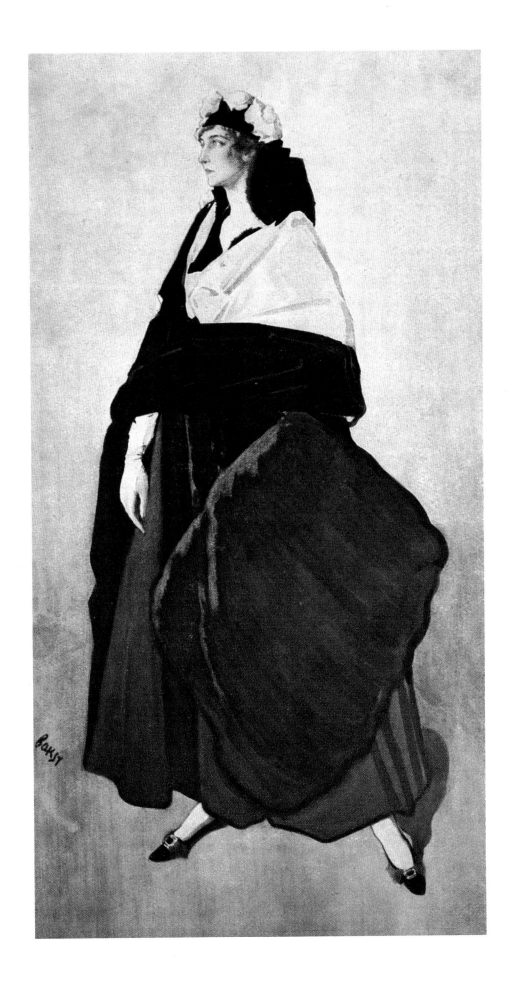

181 PORTRAIT OF IDA RUBINSTEIN. 1921

Léon Bakst:
A Chronology

1866

Born Lev Samoilovich Rosenberg on 27 April (Old Style) in Grodno, to a lower-middle class family.

1874–83

Attended the 6th gymnasium (public school) in St Petersburg. Began to draw.

1883

Entered the St Petersburg Academy of Arts where his teachers were Isaac Asknazi, Karl Wenig and Pavel Chistiakov.

1886

Entered 'The Pietà' for the Grand Silver Medal; however, the Academy board turned it down. Was introduced to the teacher and writer Alexander Kanayev, at whose home he met Anton Chekhov for the first time. Kanayev commissioned him to do a portrait of Leo Tolstoy from a photograph.

1887

Dropped out of the Academy of Arts.

1888–91

Illustrated children's books.

1889

Participated in his first art exhibition with the painting 'The Married Couple'. Began to sign his efforts *Bakst*, modifying the surname of his maternal grandmother (Bakster).

1890

In March met Albert Benois and his younger brother Alexander at the former's art studio, becoming firm friends with them and with their friends, Konstantin Somov, Dmitry Filosofov, Walter Nouvel, Alfred Nurok and Sergei Diaghilev (Filosofov's cousin). Spent the summer with Albert Benois at his country house in Oranienbaum near St Petersburg where he began to study watercolour technique and produced the picture 'The Drunken Pall Bearer'.

The young Liova ⟨Lev⟩ Rosenberg easily slipped into our company and by the close of the very first evening spent with us felt so much at home that he began to air his views freely, even to the point of arguing with us... It was quite clear that *in his heart he was a real artist.* I was also moved by the eagerness with which Rosenberg perused the illustrations in magazines and books; moreover, some of his comments showed that he generally took a thoughtful attitude to art. Scarcely three months had passed since we met when we found ourselves on a first-name basis and he was accepted as an 'equal member' of our group. True, our friendly disposition to Lev Rosenberg was tinged with a certain degree of pity. He confessed to me and Walter ⟨Nouvel⟩ that he was having a very hard time of it. Left destitute after his father's sudden death — his father had been rather well-to-do... and had managed to give his children a decent elementary education — Lev had not only to earn his own living, but also to support his mother, grandmother, two sisters and a younger brother.

A. Benois, *My Recollections*, pp. 609, 611, vol. 3, Moscow, 1980*

* All references in this section, unless otherwise specified, are to works in Russian.

Léon Bakst in his studio. St Petersburg, *ca.* 1900

Léon Bakst. 1885

Léon Bakst, Romulus Desmond and Konstantin Somov
in Oranienbaum near St Petersburg. 1902

1891

Continued to illustrate children's books. Did drawings for the journal *Khudozhnik* [*The Artist*]. Began to participate in exhibitions mounted by the Society of Russian Watercolourists and in the drawing socials ('Fridays') it arranged. In early June travelled abroad to Germany and Belgium, visiting the international art show in Berlin. In July went to live in Paris for a while. There visited exhibitions and artists' *ateliers*, studied French art at the Luxembourg Museum where he made sketches and studies. Spent five days in Spain where he again made several watercolour studies.

In August travelled in the south of France, Italy and Switzerland before returning to St Petersburg in mid-September.

The wild scenery, the rocks, the scorched crags, the mountains, everything is grey, hot and dusty, while above it all is the dome of the sky, of the deepest blue; if one catches sight of a human figure with his face shaded by an enormous pancake-like hat, it seems to blaze in the bright sunshine... While in Spain I did several studies of a toreador — what else! — and also several landscapes in pencil. I promised myself that the moment I could manage it I would certainly go there again.

> Letter from Bakst to A. Benois dated 24 July 1891, Spain

On Isola Bella, in the ideally beautiful garden of Conto di Borromeo, I suddenly felt as if I were a Greek or Roman of ancient times... Before me is a magnificent lake of cerulean blue as smooth as a mirror, and in the distance mountains, also of cerulean blue but with sparkling white caps, are dozing on top of one another... The broad terraces of the marble palace descend to the blue water. The whole is flanked by cypresses, cedars and orange trees of classical proportions, that loom black and green against the backdrop of the Italian sky... I feel as if I have now a brimmingly full bag of reminiscences, colours, scenes and impressions, and I am afraid I will lose it all in going back to Russia. I already have some eighty studies, including some poor watercolours.

> Letter from Bakst to A. Benois dated 1 September 1891, Lugano

1892

Lived in St Petersburg. Painted watercolours, illustrated children's books, and drew news-of-the-day sketches for the magazine *Khudozhnik* and the newspaper *Peterburgskaya zhizn* [*St Petersburg Life*]. Was officially commissioned to paint the arrival in Paris of the Russian Admiral Avelan, marking the Franco-Russian alliance.

1893

Painted a self-portrait. Again travelled to Paris where began to make studies for the commissioned picture. Exhibited these studies both at the Paris showrooms of the editorial offices of the newspaper *Le Figaro* and at an exposition mounted in St Petersburg by the Society of Russian Watercolourists. Attended classes at Jean-Léon Gérôme's studio and at the academies of Rodolphe Julian and Albert Edelfeldt. Studied the art of the Impressionists.

I am working on my picture 'Welcome', doing a whole heap of studies and sketches for it, two at least for each figure, with hands and heads separate. It's a hell of a job, but it is awfully fascinating and boosts the morale.

> Letter from Bakst to A. Benois dated 20 July 1893, Paris

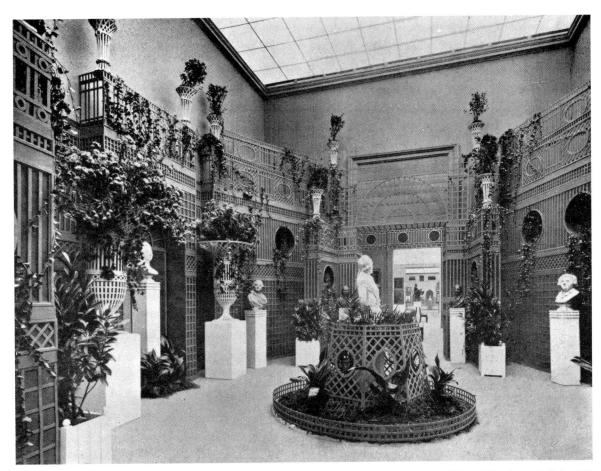

Eighteenth-century sculpture room at the exhibition of Russian art in Paris. 1906

After much thought I have arrived at the idea that one cannot reduce everything to the truthfulness of colouring, as is the case with Dagnan or Besnard, or above all Puvis, Carrière or Böcklin. My friend, it is the talent, the heart of a great artist that we must look for in a picture. That Hals used soot and dirt is of no importance as he was a genius. To attain some happy effect the artist often accidentally loses sight of the objective that he must never forget — that is life, genuine feeling, the artist's cachet.

> Letter from Bakst to A. Benois dated 9 November 1893, Paris

Edelfeldt is a very clever fellow, a man who reads a lot, shows an interest in everything and passes good judgement on art ... I like his unaffected manner ... and the way he listens when one has something to say.

> Letter from Bakst to A. Benois dated 20 July 1893, Paris

1894

Spent most of the year in St Petersburg. Painted watercolour portraits.

1895

Spent the summer in Paris. Studied French painting at the Louvre. Continued to make studies for the commissioned painting. Princess Maria Tenisheva purchased several of his watercolours for her collection.

I have only two ready really good watercolours. The first and best is the portrait of Wally ⟨Nouvel⟩. Frankly speaking, all my watercolours taken together are not worth this one alone.

> Letter from Bakst to A. Benois dated 30 August 1895, Paris

Mr Nouvel's portrait is a superb piece, quite lifelike and moreover so excellently done that it may well compare with the best foreign efforts of this kind. With deft yet serious technique, Bakst does not employ any devices to facilitate the attainment of his objective, everything is very strict, simple and strong.

> A. Benois, Author's copy of an article about the Fifteenth Exhibition of the Society of Russian Watercolourists, 1895

In recent years Mr Bakst, a young artist who has spent several years in Paris, has come much to the fore at exhibitions of watercolours. He is fluent in drawing and has all the makings of a colourist. His exhibited studies for the picture 'Franco-Russian Festivities' are most interesting despite their fragmentary character, and the fact that they are far from finished. They are simply pages torn from a sketchbook, hasty sketches in pen and pencil that are, in places, touched by the brush. Everywhere one senses the hand of a draughtsman who has a great feeling for colour.

> I. Grabar, 'Fifteenth Exhibition of Russian Watercolourists', *Niva* [*Field of Grain*], p. 290, 1895, No. 12

1896

In early May visited Benois and Somov at Martyshkino, near St Petersburg. Spent most of the year in Paris. Took part for the

Alexander Benois and Léon Bakst visiting Maria Tenisheva in Talashkino near Smolensk. 1895—96

first time in an international art exhibition (in Berlin), displaying his portrait of the actress Marcelle Josset. Travelled to Madrid and visited the Prado Museum.

I went *aller et retour* to Madrid, to see Velázquez. It killed me. Nobody is and nobody can be better!!! The three days I spent there were three days of bliss and agony because I could never do anything like this!!! He is a genius, a genius and once again a genius. This trip was of greater benefit to me than a year spent in Paris.

Letter from Bakst to A. Benois dated 1896, Paris

1897

In March produced several pastel portraits and at the Academy of Arts spring show exhibited his paintings 'The Blacksmith' ('At the Factory') and 'Evening in the Neighbourhood of Aïn-Zaïnfour, Sfax', the latter bought by Pavel Tretyakov for his art gallery. At that time in St Petersburg Sergei Diaghilev mounted an exhibition of German and English watercolourists, the first show he ever arranged. In summer Bakst went to Paris where he saw a great deal of the Benois and Aubert families, as well as Somov, Nouvel, Diaghilev and Ostroumova. Travelled to Algeria and Tunisia in northern Africa, where he produced numerous studies.

Have persuaded him ⟨Diaghilev⟩ to arrange for us 'young Russian artists' the same thing he arranged for the English, that is, to

pick out everything of interest at the studios in the spring and mount an exhibition under his auspices. He is quite willing.

Letter from Bakst to A. Benois dated 26 May 1897, St Petersburg

1898

In January participated in the Exhibition of Works by Russian and Finnish Artists which Diaghilev mounted in St Petersburg. Started painting 'Paris Welcomes Admiral Avelan'. In March several of his works, along with other items from the Tenisheva collection, entered the collection of the newly opened Russian Museum in St Petersburg. Ventured into lithography. Did a pastel portrait of A. Benois and drew the colophon for the *World of Art* journal. In November the first issue of this publication came out, with Bakst as chief designer.

My idea is that the *World of Art* is above everything mundane, up among the stars, where it reigns majestically, mysteriously and alone, like an eagle atop a snowy peak. Indeed in this case it is 'the eagle of the midnight countries', that is, of northern Russia... For it I did sketches at the zoo and attempted to interpret them seriously for a schematic, allegorical picture.

Letter from Bakst to A. Benois dated 24 October 1898, St Petersburg

1899

In January participated in the International Art Show that opened in St Petersburg, organized by the *World of Art* journal. Invited by Diaghilev to contribute to the *Imperial Theatres Yearbook*. Painted portraits and landscapes, drew covers, produced the 'Doll Market' poster and several lithographed portraits. Published his first article in the press: 'Posthumous Exhibition of Paintings by Yendogurov, Yaroshenko and Shishkin', *World of Art*, No. 5, 1899.

1900

Completed 'Paris Welcomes Admiral Avelan'. Produced several lithographed portraits. Drew covers for Richard Muther's book *History of Nineteenth-Century Painting* (put out by the Znaniye publishers of St Petersburg in 1899–1902) and for the programme of a Hermitage Theatre performance (14 February 1900).

1901

Did costume sketches for an unrealized production of Léo Delibes' ballet *Sylvia* at the Maryinsky Theatre in St Petersburg. Painted 'Siamese Ritual Dance' and a portrait of Vasily Rozanov which were bought by the Tretyakov Gallery. Did decorative drawings for the *World of Art* (Nos. 5 and 7) and *Khudozhestven-nye sokrovishcha Rossii* [*Art Treasures of Russia*] (Nos. 3, 7, 10–12) journals as well as the cover for A. Benois's book *History of Painting in the Nineteenth-Century: Russian Painting*, put out by the Znaniye publishers of St Petersburg in the same year. First met his future wife, Lubov Gritsenko.

Bakst is amazing; he is the leading calligrapher in Russian art after Somov, and his finest efforts are purely ornamental drawings — vignettes, head- and tailpieces, etc. His ornamental ingenuity is inexhaustible and, having a solid knowledge of the human figure, Bakst copes with the most cunningly contrived compositions with ease.

A. Benois, *The Russian School of Painting*, p. 66, St Petersburg, 1904

I am very glad that all artists, including the most severe judges, acknowledge it ⟨'Portrait of Rozanov'⟩ to be uncommonly good; this is most encouraging for me.

Letter from Bakst to V. Rozanov

1902

Designed the set and costumes for Frédéric Febvre's pantomime *Le Cœur de la Marquise* [*The Heart of the Marchioness*] to music by Guiraud, choreography by Marius Petipa (first performance 22 February at the St Petersburg Hermitage Theatre) and for Euripides' tragedy *Hippolytus*, produced by Yuri Ozarovsky (first performance 14 October at the St Petersburg Alexandrinsky Theatre). Produced drawings for the *World of Art* (Nos. 2, 9/10) and *Khudozhestvennye sokrovishcha Rossii* (Nos. 2, 6) journals, for the publishing house of the community of St Eugenia and for Nikolai Kutepov's historical essay *Royal Hunting in Medieval Russia in the Late Seventeenth and Eighteenth Centuries* (St Petersburg, 1902, vol. 3, chapter 3). Also did bookplates, the colophon of the journal *Novy put* [*New Path*] and the cover for the 1903 issue of the almanac *Severnye tsvety* [*Flowers of the North*]. Painted a portrait of M. Keller and 'The Supper'. On 22 December published in the *Peterburgskaya gazeta* [*The St Petersburg Daily*] the article 'Woman in the Artist's Studio'.

The settings of the tragedy ⟨*Hippolytus*⟩ were better than the acting. The decor demanded of the talented Mr Bakst much effort and special training. I saw him in the poorly-lit lower rooms of the Hermitage where he industriously studied fragments of hoary antiquity, sketching the material required from everything — from tombstones, vases and scholarly publications. He achieved a great deal, imparting to the settings a novelty, in the sense of greater verisimilitude with life as it was actually lived in antiquity. His were not the usual Greeks in the Empire style or, worse still, operetta Greeks but Greeks from Etruscan vases, from the bas-reliefs on tombstones, from the latest archaeological discoveries. The costumes were handsome and new and the make-up in most cases was like terracotta. As I am no specialist I cannot say whether the introduction of the Oriental element is fully justified, but I will say that its presence contributes in a significant degree to the archaic impression produced by the settings.

Y. Beliayev, 'Hippolytus', *Novoye vremia* [*New Times*], 16 October 1902

1903

In January, a boudoir that Bakst designed was displayed at the St Petersburg Modern Art Exhibition. In February, his painting, 'The Supper', shown at the fifth World of Art exhibition, enjoyed a 'succès de scandale', evoking negative press comment. Designed sets and costumes for Josef Bayer's *Die Puppenfee* [*The Fairy Doll*] (book by Josef Haßreiter and F. Gaul, choreography by Sergei and Nikolai Legat, first performance 7 February at the Hermitage Theatre, next performance 16 February at the Maryinsky Theatre). On 16 February a general meeting of the World of Art society resolved to discontinue all further exhibitions and affiliate themselves with the Moscow Union of Russian Artists. Designed the costume of Wilhelm Meister for Leonid Sobinov (in Ambroise Thomas's opera *Mignon*, produced by an Italian company, first performance 19 March at the St Petersburg Conservatoire). Spent late March and April in Menton, painted a portrait of Lubov Gritsenko. Did landscape studies and drawings for a production of Sophocles' tragedy *Oedipus at Colonus*. In mid-May went to Rome where, with Benois and Ostroumova, who

Léonide Massine, Natalia Goncharova, Mikhail Larionov, Igor Stravinsky and Léon Bakst in Lausanne. 1915

Léon Bakst, Sergei Diaghilev and Vaslav Nijinsky in Venice. 1912

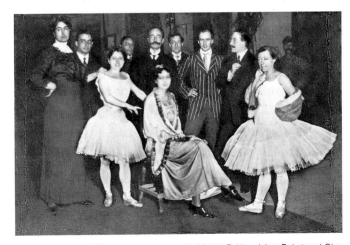

Ida Rubinstein (seated centre), Michel Fokine, Léon Bakst and Olga Preobrajenska (standing at right) with Italian singers during a rehearsal at La Scala, Milan. 1910s

had taken up residence there, did studies in the city and its surroundings. Fell ill and returned to St Petersburg. In July 'The Supper' was shown at a Munich Sezession exhibition and reproduced on the cover of the journal *Jugend*. In this same month visited Valentin Serov at his country house in Finland. Later, began to design the interiors for Alexander Korovin's St Petersburg house. Also did sketches of vases for the Imperial Porcelain Factory, drew the cover of the journal *Vesy* [*The Balance*] for 1904, and a poster advertising the artistic picture postcards of the Red Cross. In November married Lubov Gritsenko.

You simply cannot imagine how the public assails my unfortunate lady with the oranges ⟨'The Supper'⟩! Terrible! Incredible vilification... And the visitors at the show are simply mad! But why?!! And Ostroukhov says I jeopardized the entire exhibition with my piece. Serov says, on the contrary, he liked it.

> Letter from Bakst to L. Gritsenko dated 16 February 1903, St Petersburg

This production ⟨*Die Puppenfee*⟩ enabled the artist Bakst to create an amazingly refined illustration of our fifties, and it would be fair to say that this ballet will be wholly indebted for its likely success to the talented work of a man who, by his art, has been able to ennoble the trite and common material. All the settings are charming, especially the one depicting the realm of dolls by means of a witty combination of children's toys. The costumes which the artist has so subtly based on Second Empire fashion are splendid. Indeed, the entire style of the epoch portrayed is conveyed in a meticulously faithful manner.

> 'Art News', *World of Art*, p. 43, 1903

Today what was to be expected has happened. The World of Art exhibitions, that is, exhibitions under the aegis of this society, have ceased to exist. The general meeting has decided to end it all, and it is now necessary to organize a new society, from the same members, and somehow come to an agreement with the '36' society exhibiting in Moscow...
It's happened. The new society has absorbed all of the '36' and the entire World of Art and is to be known as the Union of Russian Artists. Full freedom and exhibitions without a jury in both St Petersburg and Moscow.

> Letters from Bakst to L. Gritsenko dated 16 and 17 February 1903, St Petersburg

1904

Designed sets and costumes for Sophocles' tragedy *Oedipus at Colonus* (produced by Yuri Ozarovsky, first performance 9 January at the Alexandrinsky Theatre, St Petersburg). Did drawings for the *World of Art* journal (Nos. 1, 5/6, 10–12) and illustrations for Gogol's novella *The Nose*. In April started a portrait of Sergei Diaghilev and continued to work on it up to mid-June in both St Petersburg and in Salmele, Finland, where his family lived at the time. Also did landscape studies there. Designed costumes for another Sophocles tragedy, *Antigone* (produced by Yuri Ozarovsky as an anonymous debut for Ida Rubinstein at Lydia Yavorskaya's New Theatre in St Petersburg, first performance 16 April). In July went to Moscow to visit the Tretyakovs at their estate in Kurakino and the Yurgensons at their estate outside Moscow where he painted landscape studies. In October and November visited France and Italy.

How lovely it is here. How endless and plentiful Russia is, with its birch trees, mushrooms, windmills, and peasant women in red; I inhale its fragrance like a person who has at last come to rest in a shady place.

> Letter from Bakst to L. Gritsenko-Bakst dated July 1904

I had my debut in St Petersburg as Antigone... What a brilliant idea it was to ask Léon Bakst to do the costume! With his austere, peerless originality the great artist eschewed the conventions and traditions that overburdened and deformed classical figures. He conjured up from the depths of time the crude and naked spirit of those ages when Oedipus cried out and Antigone wept. He gave the human figure that acute sense of tragedy which emanates from the lines of the classics. Ever since then, Léon Bakst has never deserted me. I have an artistic compact with him which is very precious to me.

> 'Ida Rubinstein about Herself', *Solntse Rossii* [*Sun of Russia*], p. 12, No. 25, 1913

1905

In April and March worked on the designs for Diaghilev's Russian Portraits Exhibition at the Tauride Palace, St Petersburg. In July helped to organize the satirical journal *Zhupel* [*The Bugaboo*]. Fell ill and went abroad for a cure. Established a close relationship with Symbolist writers. Did a pastel portrait of his stepdaughter, Marina Gritsenko, drawings for the publishing house of the community of St Eugenia and the covers for Nikolai Romanov's book *The Rumiantsev Gallery of Moscow* published in 1905 by I. N. Knebel of Moscow, for the *Severnye tsvety* almanac and the programme of the Ziloti recitals. In December drew a portrait bust of Andrei Bely.

In St Petersburg the meeting was quite representative, with all the Finlanders besides Gorky, Andreyev and others... It is fine that newspapers of different trends expect a lot of good from this publication ⟨*Zhupel*⟩ and all to a man are afraid that the censors might close it. I wonder how it will turn out. There is no doubt that this is a militant publication, and under favourable conditions and with God's help it will be fated to play a prominent part in the movement.

> Letter from Bakst to L. Gritsenko-Bakst dated 2 August 1905, Baden-Baden

This year Bakst is extremely diverse and, as always, extremely interesting. His 'Portrait of Andrei Bely' attracts by virtue of its inspired mood. The veils masking the spirit have been lifted, and only the very essentials are left. It seems that were the artist to add one more touch to the portrait the charm would evaporate — and there would remain only an image very much like the real thing.

> K. Sunnenberg, 'The World of Art Show', *Vesy* [*The Balance*], p. 66, Nos. 3/4, 1906

1906

In January and February completed the 'Portrait of Sergei Diaghilev and His Nurse'. In February did the interior decoration for the World of Art exhibition that Diaghilev mounted in St Petersburg. Did portraits of Louise Desmoulins (the maiden name of Louise Korovina), of Alexander Korovin, of Andrei Bely (three-quarter length), of Konstantin Somov and a self-portrait, the last two commissioned by Nikolai Riabushinsky for the journal *Zolotoye runo* [*The Golden Fleece*]. Produced the panels 'The Vase' ('Self-portrait'), 'Sunflowers Beneath the Window' and 'The Downpour'. Did the covers for the literary and artistic

almanac *Shipovnik* [*Dog-rose*] and illustrations for the journal *Zolotoye runo* (Nos. 1–3 and 4) and for A. Benois' book *The Russian Museum of the Emperor Alexander III* published by I. N. Knebel of Moscow. Continued with the interior decoration of the Korovin residence. Spent October and November designing the retrospective exhibition of Russian art ('Two Centuries of Russian Painting and Sculpture') that Diaghilev arranged at the Salon d'Automne in Paris. With other exhibition entrants was elected an Honorary Member of the Salon d'Automne. Helped to organize Vera Komissarzhevskaya's New Drama Theatre and painted the Elysium curtain for it (later reworked into a panel). Was invited, with Mstislav Dobuzhinsky, to teach at Elizaveta Zvantseva's art school in St Petersburg.

We see before us the Elysium that Virgil extolled, with its ever-green forests, fields with plentiful harvests, and its pure and wonderfully limpid air. Graceful phantoms recite poetry, play or lie in the shade of laurel trees, listening to the lyre of Orpheus and the gurgling of springs. It is far from the hustle and bustle of life, and flowers here do not fade the moment they blossom...

> N. Yevreinov, 'The Artists of V. Komissarzhev-skaya's Theatre', in *In Memoriam Vera Fiodorovna Komissarzhevskaya*, pp. 137–8, St Petersburg, 1911

Bakst instructed us the way some people are taught to swim, by tossing them into the water and letting them clamber out by themselves. He deliberately refused to furnish any ready-made patterns for copying... We chose the poses for our models together; they always sat against a vivid backdrop... They were all chosen for what was singular in their appearance, whether in face or figure.

> Y. Obolenskaya, 'At Zvantseva's School under the Guidance of L. Bakst and M. Dobuzhinsky, 1906–10'

1907

In February began to collaborate with Michel Fokine. Designed costumes for dances that the latter choreographed for a charity performance on 10 February at the Maryinsky Theatre in St Petersburg; these were for Mathilda Kshessinska in the ballet *Eunice* (music by Andrei Shcherbachov) and also for Anna Pavlova and Mikhail Obukhov in the 'Moon Vision' waltz (music by Frédéric Chopin). Did portraits of the composers Mily Balakirev and Sergei Liapunov for the program for the 'Five Historical Russian Concerts' that Diaghilev arranged in Paris. Did the frontispiece for *Snow Mask*, a collection of verse by Alexander Blok, put out by the St Petersburg Horae Publishers in 1907, and several covers. In May and June travelled in Greece with Valentin Serov, visiting Athens, Crete, Thebes, Mycenae, Delphi and Olympia. His son was born, and christened Andrei. On 12 December the newspaper *Birzhevye vedomosti* [*Stock Exchange News*] carried Bakst's drawing of Isadora Duncan dancing. Again designed costumes for dances choreographed by Fokine for a charity performance on 22 December at the Maryinsky Theatre; these were for Anna Pavlova in the *Dying Swan* (music by Camille Saint-Saëns) and for Tamara Karsavina in the *Torch Dance* (music by Anton Arensky).

How many new impressions! Their very unexpectedness has jumbled and confused all previous notions of the heroic ancient Greece that I brought with me from St Petersburg. One has to reinterpret and rearrange everything, and classify it anew...

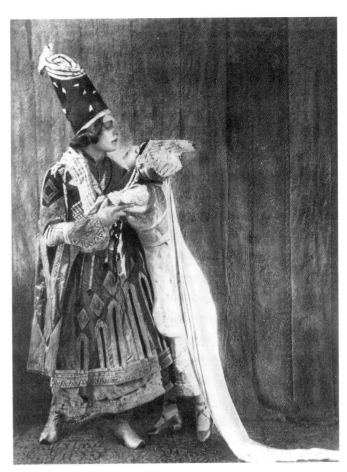

Lubov Tchernicheva and Adolf Bolm in *Thamar*

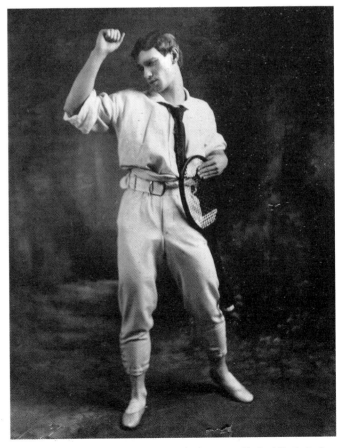

Vaslav Nijinsky in *Jeux*

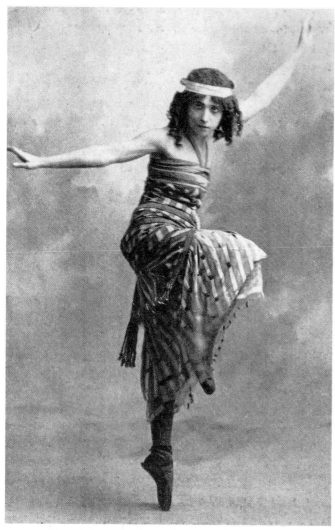

Sophia Fedorova in *Cléopâtre*

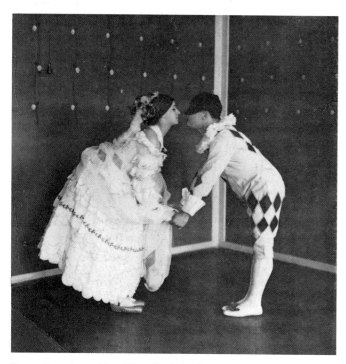

Tamara Karsavina and Leonid Leontiev in *Le Carnaval*

Though we kept teasing each other, we lived in harmony and accord, assiduously drawing and searching for a modern way of portraying the Greek myths... We wanted to have everything as ancient as possible, near to Homer.

> L. Bakst, *With Serov in Greece: Travel Notes*, pp. 19, 41, Berlin, 1923

It was Bakst who gave us a taste for the archaic epoch of Hellenistic art... Bakst's role is highly significant, as he was the man who stirred up in Serov's mind his dormant proclivity for antiquity.

> S. Yaremich, *Drawings of Valentin Serov*, pp. 8, 9, Leningrad, 1936

It's good, if you like, because it's new and, one could say, pregnant with the future, but I would think that she ⟨Isadora Duncan⟩ has little of the *feu sacré* in her... In places Chopin's presto is beautiful. She herself, however, is more like an inebriated, crazy Amazon.

> Letter from Bakst to A. Benois dated 1903

1908

Did portraits of Alexander Golovin (for the programme of Modest Mussorgsky's opera *Boris Godunov* that was produced in Paris), of Isadora Duncan, Anna Pavlova and of his son Andrei. Designed a poster advertising an exhibition of works by modern Russian artists at the Viennese Sezession, and the cover and some drawings for the journal *Satiricon*. In April lectured on the painting of the future and its relationship to ancient art at the Theatre Club in St Petersburg. Mid-year completed 'Terror Antiquus', which was exhibited at the Paris Salon d'Automne and in the following year at the St Petersburg Salon. Designed the set and costumes for *Salomé*, after Oscar Wilde, Ida Rubinstein's unrealized production, a section of which she performed at an artistic dance evening on 20 December at the Grand Hall of the St Petersburg Conservatoire. Did two sketches of the costume of Armand for Dmitry Smirnov in Verdi's *La Traviata*. Participated in the preparations made by Diaghilev for the first ballets which he was to take to Paris.

Bakst is completely taken with Greece; one must really hear the infectious enthusiasm with which he speaks of it, especially of Evans's latest discoveries in Crete, and one must see him at the Antiquities Departments of the Hermitage and the Louvre, pedantically copying the ornamental designs and the details of the costumes and the furnishings, to realize that what we have here is more than a superficial historical craze. Bakst is obsessed with ancient Greece, he is delirious about it and that is the only thing he can think of.

> A. Benois, 'Letters on Art: The Salon Once Again', *Rech* [*Speech*], 10 February 1909

I have made a lot of changes in 'Terror Antiquus'; the statue is now more fearful and the background gloomier; I keep on wanting to have the picture terrify me. The water in the foreground should seem bottomless — this is absolutely necessary.

> Letter from Bakst to L. Gritsenko-Bakst dated 29 July 1908, St Petersburg

1909

Did cover, frontispiece and a lithograph portrait of the writer Alexei Tolstoi for the journal *Apollon*. Published in its Nos. 2 and 3 an essay 'Classical Trends in Art'. For the performances of the

Diaghilev company (the first season of the Ballets Russes), which took place at the Théâtre du Châtelet in Paris, designed the costumes for Nijinsky and Karsavina (the Blue Bird and Princess Florine) in the *pas de deux* from Tchaikovsky's ballet *The Sleeping Beauty* (the Festin divertissement, first performance 19 May), and costumes for Act III of Alexander Serov's opera *Judith* (also performed in May). Designed the sets and costumes for the choreographic drama *Cléopâtre* (choreographed by Michel Fokine to a score that was a mixture of music by Arensky, Taneyev, Rimsky-Korsakov, Glinka, Glazunov, Mussorgsky and Cherepnin; first performance 2 June). In July and September had a holiday in Carlsbad with Diaghilev and Nijinsky. Later went to Venice to study the painting of the Venetian school. Did studies on the Lido, including one depicting Nijinsky.

I remember the wonderful year of 1909 and the staggering impression produced by the novelty of all the performances. Paris was literally inebriated by Bakst.

> A. Levinson, 'Bakst Returns', *Zhar-ptitsa* [*Firebird*], No. 9, 1922

Nothing is so reminiscent of the *palettes* of Veronese, Tiepolo, and Canaletto as Venice on a bright sunny day. It's a real miracle, for here all the shadows are not at all Impressionistic, but exactly as in Veronese and Canaletto... Oddly enough though, however much I tried to go back, I am unable to go as far back as Bellini or even Veronese — all that comes to life is the Venice of Tiepolo, and partly — and mainly — Longhi! The last is really alive and in the same way as Paris *est toujours en plus 1840* so does Venice smack of the eighteenth century — in the main lines and environment, in the *choice* of dominant colours, in that *parfum* that is felt in everything here, even the gondoliers...

> Letter from Bakst to A. Benois dated 1909, Venice

I am up to my ears in work, even though I managed to do studies on the Lido where it is *fantastically lively, colourful and interesting*. I have now a new and an extremely bright colour range that has come of its own accord and come to stay.

> Letter from Bakst to A. Benois dated September 1909, Venice

Anna Pavlova. 1914

1910

Designed a number of costumes — of Thaïs for Maria Kuznetsova (in Jules Massenet's opera of the same name, first performance 16 January at the Grand Hall of the St Petersburg Conservatoire); for Anna Pavlova and Laurent Novikoff in *Bacchanale* (to Alexander Glazunov's *The Seasons*, choreographed by Fokine, first performance 22 January at the Nobility Assembly in St Petersburg); for the 'Cobold' dance to the music of Edvard Grieg and for the 'Oriental Dance' to the music of Christian Sinding, orchestrated by Igor Stravinsky (these were first performed by Vaslav Nijinsky at the Maryinsky Theatre in St Petersburg on 20 February and were subsequently integrated into the *Orientales* divertissement included in the second Russian season at the Paris Opera, first performance 25 June). Designed the costumes for *Le Carnaval*, the one-act ballet-pantomime choreographed by Fokine to the music of Robert Schumann, orchestrated by Arensky, Glazunov, Liadov, Cherepnin and Rimsky-Korsakov (at Pavlova's Hall in St Petersburg, 20 February). For the second Russian season designed the sets for *Le Carnaval* (Theater des Westens, Berlin, first performance 20 May); the sets and costumes for the one-act choreographic drama *Schéhérazade*, choreographed by Michel Fokine to the

Michel Fokine. After 1905

221

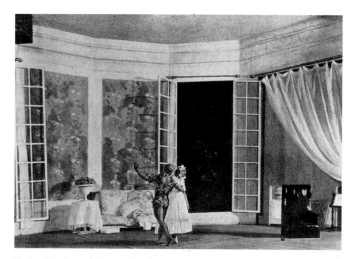

Vaslav Nijinsky and Tamara Karsavina in *Le Spectre de la Rose*

music of Rimsky-Korsakov, book by A. Benois (the Paris Opéra, first performance 4 June), and the costumes of the Firebird and the Tsarevna for the ballet *L'Oiseau de Feu* by Igor Stravinsky, choreographed by Michel Fokine, with sets by Alexander Golovin (the Paris Opéra, first performance 25 June). Exhibited theatre designs at the Bernheim Gallery in Paris at a show of theatre decor and costumes by Russian artists; many of the items shown were bought by the Musée des Arts Décoratifs. At the International Art Exhibition in Brussels was awarded First Gold Medal for his 'Terror Antiquus' panel. In the introductory article to the catalogue of an exhibition of the work of Zvantseva school students, mounted in April at the editorial offices of the *Apollon* journal, elaborated his views of modern art. Quit teaching at the Zvantseva school, recommending Petrov-Vodkin in his place. Divorced his wife and took up residence at 12 boulevard Malesherbes, Paris, where he lived until his death. Made the acquaintance of Henri Matisse. In September visited Nuremberg, Cologne and Dresden to study German art, in expectation of work for the production of Gounod's opera *Faust*. In October took part in the organization of a new World of Art society in St Petersburg but exhibited only at the 1913 show.

1910–11

Did two decorative panels on the theme of Daphnis and Chloë for a suburban Moscow villa.

Bakst is indeed to be credited for having created *Schéhérazade* as a spectacle that is enchanting and, I would say, unprecedented. The moment the curtain rises over this stupendous green 'alcove', one enters a world of very special sensations of the kind provoked by reading the *Arabian Nights*. The emerald green of the veils, curtains and throne, the blue skies of night that stream through the latticed windows from the harem garden, and the heaps and piles of embroidered cushions and pillows... One finds it hard to imagine a more subtle, more apt or less intrusive exposition of the drama than Bakst's settings. Where on earth did he find the ability to do so much with colour and paint? Indeed, he has at last found his real calling.

> A. Benois, 'Russian Performances in Paris (*Schéhérazade*)', *Rech* [*Speech*], 12 July 1907

Picasso considered *Schéhérazade* a masterpiece; that was the only ballet production he admired.

> I. Stravinsky, *Dialogues*, p. 78, Leningrad, 1971

He ⟨Matisse⟩ is most charming and simple and I feel that we will be good friends. Contrary to my expectations, he is a shy and earnest man, with a simple nature.

> Letter from Bakst to L. Gritsenko-Bakst dated 1910, Paris

There are plans in Paris to produce *Faust* with my sets. So I observed and drank in the German spirit in Nuremberg and then stayed for a long time in the Cologne Cathedral imbibing, most assiduously, the Gothic spirit. The Dresden Gallery amazed me, although the Sistine Madonna left me almost indifferent. The two artists that fascinated me, by virtue of a strongly pronounced decorative element (although their objectives are diametrically opposed), are Veronese, and... Lucas Cranach in his portraits.

> Letter from Bakst to L. Gritsenko-Bakst dated 14 September 1910, Paris

I myself am head over ears in colours, and don't want to hear a word of black and white; I plan, on my return, to convert both Kostia and Shura ⟨Somov and Benois⟩ to the 'painterly' faith, and you too, of course, my dear Anna Petrovna. I have noticed that it is easier to sense and synthesize form through the medium of colour, which makes it more authentic and real.

> Letter from Bakst to A. Ostroumova-Lebedeva dated 12 November 1910, Paris

1911

Designed new sets for the production of *Le Carnaval* at the Maryinsky Theatre in St Petersburg (first performance 6 February). For the third Ballets Russes season designed the sets for the choreographic tableau *Le Spectre de la Rose* from a poem by Théophile Gautier (choreographed by Michel Fokine to the music of Weber's 'Invitation to the Dance', orchestrated by Hector Berlioz, book by Jean-Louis Vaudoyer, at the Casino Theatre, Monte Carlo, first performance 19 April) and for the ballet *Narcisse* to his own libretto (choreographed by Michel Fokine to the music of Nikolai Cherepnin, also at the Casino Theatre in Monte Carlo, first performance 26 April). Did the costumes for the unrealized production of the ballet *La Péri*, choreographed by Michel Fokine, with music by Paul Dukas. For Ida Rubinstein's company, designed the sets for a production of Gabriele d'Annunzio's mystery play *Le Martyre de St Sébastien*, choreographed by Michel Fokine to the music of Claude Debussy (Théâtre du Châtelet, Paris, first performance 22 May). In June, an exhibition of 120 of Bakst's stage designs — many of which were subsequently bought by French, Spanish and Italian museums — was mounted at the Musée des Arts Décoratifs in Paris. Was elected vice-president of the jury panel of the Paris Society of Decorative Arts. In the following month went to London with Diaghilev's company, where presented along with other productions were *Le Carnaval*, *Schéhérazade*, *Cléopâtre* and *Le Spectre de la Rose*. Also designed the sets for the opera *Ivan Grozny* [*Ivan the Terrible*] to the music of Raoul Ginzburg (Théâtre de la Gaîté-Lyrique, Paris, first performance 31 October) and for the opera *Mephistopheles* to the music of Arrigo Boito (at the Royal Opera House, Covent Garden, London). Illustrated Valerian Svetlov's book on modern ballet, published by R. Golike and A. Vilborg of St Petersburg. Did a portrait of Jean Cocteau.

1911–12

For Maria Kuznetsova sketched costumes for Manon in Jules Massenet's opera of the same name, for Marguerite in Gounod's

opera *Faust*, and for Salomé in Richard Strauss's opera of the same name; designed a costume for Marchesa Casati for her Indian and Persian dances.

The Covent Garden season closed last night. The house was packed. There were curtain calls without end. Whole hothouses of flowers were carried off the stage. Russian ballet abroad is in foreign eyes the synthesis of Russia's entire aesthetic tastes... What happened to Bakst in London was exactly what had happened to Byron, who said: 'I awoke one morning and found myself famous.' Not so long ago nobody in England knew anything about Bakst, but now his name is held in repute by every critic and artist.

> S.I.R., 'The Anglo-Russian Season', *Rech* [*Speech*],
> 27 July 1911

1912

For the fourth Ballets Russes season at the Théâtre du Châtelet, designed the sets and costumes for the ballet *Le Dieu Bleu*, choreographed by Michel Fokine to music by Reynaldo Hahn, book by Jean Cocteau and Federico de Madrazo (first performance 13 May); for the choreographic drama *Thamar* choreographed by Michel Fokine to music by Mily Balakirev, the book by Bakst himself, based on Lermontov's poem (first performance 20 May); for the ballet *L'Après-midi d'un Faune*, choreographed by Nijinsky to music by Claude Debussy, with libretto after Mallarmé's eclogue (first performance 29 May); and for the ballet *Daphnis and Chloë*, choreographed by Michel Fokine to the music of Maurice Ravel, with libretto based on the pastoral by Longus (first performance 8 June). For performances of Ida Rubinstein's company at the Théâtre du Châtelet designed the sets for Emile Verhaeren's tragedy *Helen of Sparta*, produced by Alexander Sanin to music by Déodat de Séverac (first performance 4 May) and for Oscar Wilde's *Salomé*, choreographed by Michel Fokine and produced by Alexander Sanin to music by Alexander Glazunov (first performance 10 June). Also designed the costumes for the one-act mime ballet *Papillons*, choreographed by Michel Fokine to the music of Robert Schumann, orchestrated by Nikolai Cherepnin, with sets by Piotr Lambin (at the Maryinsky Theatre, first performance 30 September). With Diaghilev's company went to London, where for the first time had a one-man show, mounted by the Fine Art Society. In October returned to St Petersburg for a fortnight. Did a portrait of Marchesa Casati.

It is a noisy, complex and confused season, and I am a bit sick and fed up with everything and do not even read what they write. I would like everyone to leave me alone and let me spend three or four months in absolute silence and monotony... I want to paint studies, sleep ten hours at a stretch every day, and *not rush anywhere*!

> Letter from Bakst to L. Gritsenko-Bakst dated 8 June
> 1912, Paris

One could not wish for a more faithful and more poetic illustration to this brief and immortal work ⟨Lermontov's poem *Thamar*⟩ than the settings that Bakst has devised and in which the epitome of the Caucasus shines and sparkles.

> I. Yakovlev, 'Russian Ballets at the Châtelet',
> *Novoye vremia* [*New Times*], 29 May 1912

1913

For Sergei Diaghilev's Ballets Russes season at the Théâtre des Champs-Elysées in Paris designed the sets and costumes for the

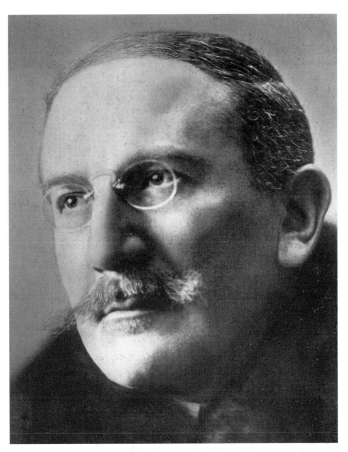

Léon Bakst. About 1914

Portrait of Léon Bakst by Serov. *Ca.* 1900

223

ballet *Jeux*, to the music of Claude Debussy, choreographed by Nijinsky who wrote the book (first performance 15 May), and for the fourth scene ('By the Fountain') in Mussorgsky's opera *Boris Godunov*, produced by Alexander Sanin (first performance 22 May); also designed new costumes for the Firebird, the Tsarevna and the Tsarevich Ivan in Igor Stravinsky's ballet *L'Oiseau de Feu*, and wrote the book and devised the choreography for the ballet *Midas* after Ovid's *Metamorphoses*, but did not complete it due to illness (it was produced in Paris in 1914 with designs by Mstislav Dobuzhinsky). For Ida Rubinstein's company designed the sets and costumes for a production of Gabriele d'Annunzio's mystery play *La Pisanella*, staged by Vsevolod Meyerhold and choreographed by Michel Fokine, with music by De Parmas (Théâtre du Châtelet, first performance 11 June). For Anna Pavlova's company designed the sets and costumes for the ballet *Les Orientales*, choreographed by Piotr Zajlich to the music of M. Ippolitov-Ivanov and Modest Mussorgsky and shown in New York. Designed the sets for Ermanno Wolf-Ferrari's comic opera *Il Segreto di Susanna*, book by Enrico Golisciani (at the Royal Opera House, Covent Garden, London, 1913). Invited by the Directors of the Imperial Theatres to design the Maryinsky Theatre production of the mime-drama *Orpheus* to be choreographed by Michel Fokine to the music of Jean-Paul Roger-Ducasse. Painted a self-portrait. Had his first one-man show in New York. The Brunoff publishing house put out a *de luxe* art book, *The Decorative Art of Léon Bakst*, with an introduction by Arsène Alexandre (published the same year in English by the Fine Art Society, London).

Last night's dress rehearsal ⟨of *La Pisanella*⟩ was a tremendous success. When it finished, there was no end of applause, firstly for Bakst, secondly for Meyerhold, thirdly for De Parmas and fourthly for Fokine. The enthusiasm backstage was also great, reminiscent of the times of Komissarzhevskaya's theatre.

> Letter from Vsevolod Meyerhold to his wife dated 11 June 1913, Paris

1914

In January was elected a full member of the St Petersburg Academy of Arts, which thus entitled him to take up residence in the Russian capital. Upon arrival in St Petersburg published several articles. One of his essays ('Contemporary Theatre. No One in the Theatre Wants to Listen Any More — They Want to See') provoked criticism from actors. In the USA the Buffalo Fine Arts Academy mounted Bakst's one-man show, exhibiting 163 works. For Diaghilev's Ballets Russes designed the costumes for the mime-drama *La Légende de Joseph*, choreographed by Michel Fokine, with music by Richard Strauss, libretto by Hugo von Hofmannsthal and Harry von Kessler, and sets by José Maria Sert (at the Paris Opera, first performance 13 May), and for Maria Kuznetsova designed the costume of Leila in Bamberg's opera of the same name, performed at Monte Carlo. Did a portrait of Léonide Massine as well as the cover and colophon for the illustrated journal *Lukomorye* [*Sea Cove*].

We are facing a viable new form of dramatic art, a mute form, if one could put it that way.

> L. Bakst, 'Contemporary Theatre. No One in the Theatre Wants to Listen Any More — They Want to See', *Peterburgskaya gazeta* [*The St Petersburg Daily*], 21 January 1914

Incidentally, the most interesting thing about this performance ⟨*La Légende de Joseph*⟩ is that a well-known biblical legend is

treated from nineteenth-century artists' point of view. The sumptuous brilliance of Oriental colours will have passed through the prism of the artistic *Weltanschauung* of the Renaissance epoch.

> M., 'Interview with L. Bakst', *Den* [*Day*], 29 January 1914

Joseph is a super-Veronesian production. And despite the participation of Bakst himself we have a little of what happens at times in the house of some merchant, where his interior decorators try to cater to his tastes by having as much marble and mahogany (imitation, of course) as possible, with the result that the imitation marble comes out far more 'marbly' than the real thing. Everything is aimed exclusively at producing a sumptuous effect. What is best in it — the music of Strauss — is merely an accompaniment.

> A. Lunacharsky, 'Russian Performances in Paris', *Sovremennik* [*The Contemporary*], p. 255, Nos. 14/15, 1914

1915

Spent most of the year taking a cure in Switzerland. Travelled from Geneva to Ouchy where Diaghilev, Massine, Larionov and Goncharova were staying at the time. For the Ballets Russes designed new costumes for the Firebird, the Tsarevna and the Tsarevich Ivan in *L'Oiseau de Feu*. Also designed the set and costumes for the 'Enchanted Princess' *pas de deux* in Tchaikovsky's ballet *The Sleeping Beauty*, and the costumes for a new production of *Schéhérazade*. Began a series of seven decorative panels based on Charles Perrault's fairy-tale *La Belle au Bois Dormant* for a private house in London (completed in 1922).

1916

Spent May in Florence studying frescoes. For Anna Pavlova's company designed the sets and costumes for Tchaikovsky's *The Sleeping Beauty*, choreographed by Marius Petipa, with libretto by Petipa and Ivan Vsevolojsky (produced by Ivan Khliustin in an abbreviated version at the Hippodrome Theatre, New York, first performance 31 August).

1917

In mid-January wrote the introduction to the Ballets Russes programme ('The Choreography and Decoration of New Russian Ballets'); painted a portrait of Virginia Zucchi. For the Ballets Russes designed sets and costumes for the mime-drama *Les Femmes de Bonne Humeur* after Carlo Goldoni, choreographed by Léonide Massine to the music of Domenico Scarlatti, orchestrated by Vincenzo Tommasini who also wrote the book (at the Teatro Costanzi, Rome, first performance 12 April). Also designed the costumes for an unrealized Paris Opéra production of Rimsky-Korsakov's opera *Sadko*, and the sets and costumes for Gabriele d'Annunzio's tragedy *Phèdre* to the music of Ildebrando Pizetti. In London, the Fine Art Society mounted an exhibition of Bakst's designs for *The Sleeping Beauty*. Sat for a portrait by Modigliani.

As charming was another ballet set to medieval music, namely *Les Femmes de Bonne Humeur*... Bakst did enchanting costumes (before breaking with Diaghilev) reminiscent of what one sees in old puppet shows; the scenery is in perfect accord, with its restrained rusty red, and with only one inoffensive concession to time — the buildings all seem slightly tilted. A frank mockery was the puppet-like choreography, with the grotesque personages of Goldoni's play moving and gesturing as if pulled by

strings. Nevertheless that piquant note did not impair the enchanting impression that *Les Femmes de Bonne Humeur* produced.

> A. Benois, *My Recollections*, p. 198, vol. 5, Moscow, 1980

I so eagerly listen for any word and I am so happy to see the bright dawn breaking so gloriously over our motherland.

> Letter from Bakst to L. Gritsenko-Bakst dated 22 April 1917, Paris

We shall see each other some time, then at last I will have the great good fortune to see all of you serene and happy. I believe in Russia's good fortune and future!

> Letter from Bakst to L. Gritsenko-Bakst dated 4 November 1917, Paris

1918

Designed the costumes for the Ballets Russes for the ballet *La Boutique Fantasque*, choreographed by Léonide Massine, to the music of Gioacchino Rossini, orchestrated by Ottorino Respighi. But when Diaghilev invited André Derain to do the sets, Bakst took offence and broke with Diaghilev.

1919

Designed the costumes for 'Rip's divertissement' in *Aladdin ou la Lampe Merveilleuse* at the Théâtre Marigny in Paris and also the sets for an unrealized production of the *Chopin Nocturne* ballet.

1921

Designed the sets and costumes for the Ballets Russes for Tchaikovsky's *The Sleeping Beauty*, with the music partly orchestrated by Igor Stravinsky (book by Ivan Vsevolojsky and Marius Petipa, with the latter's choreography revived by Nikolai Sergeyev and supplemented by additional numbers by Bronislava Nijinska; first performance 2 November at the Alhambra Theatre, London). Did a portrait of Ida Rubinstein and published in *Comoedia Illustré* an essay about Tchaikovsky and Russian ballets.

1922

On 11 January published in *Comoedia Illustré* an essay, 'Present-day Performances and *Beggar's Opera* in London'. On 1 April sat for a portrait by Pablo Picasso. For the Ballets Russes designed the costumes for the comic opera *Mavra*, music by Igor Stravinsky, book by Boris Kochno (after Alexander Pushkin's *Cottage in Kolomna*). However, these designs were not executed, as Léopold Survage was invited to do the settings. Broke again, this time for good, with Diaghilev and his Ballets Russes. For Ida Rubinstein's company wrote the libretto and sketched the costumes for the ballet *Artémis Troublée*, choreographed by Niccolo Guerra, with music by Paul Paray (at the Paris Opéra, first performance 28 April). Also did new designs for the mystery play *Le Martyre de St Sébastien* (also at the Paris Opéra, first performance 18 June). Designed the costumes for the drama *Judith* produced by André Antoine with settings by Sergei Sudeikin and book by Henri Bernstein at the Théâtre Gymnase, Paris. Wrote the libretto and designed the sets and costumes for the mime-drama *La Lâcheté* and the vaudeville *Old Moscow* (at the Fomin Theatre, Paris). Drew a Queen of the Night costume for Marchesa Casati. Did a portrait of Vera Stravinsky and pictures of Russian peasants in national costumes and sketched the decorative panels 'Judith with the Head of

Léon Bakst. Drawing by Picasso. 1922

Portrait of Léon Bakst by Modigliani. 1917

Holofernes' and 'Huntress and Dog'. A collection of Ivan Bunin's short stories under the title *The Gentleman from San Francisco* came out in Paris, with Bakst's portrait of the author. A. Levinson published two monographs, one in German, devoted to Bakst's life and work, the other in French, dealing with Bakst's designs for *The Sleeping Beauty*.

Currently Bakst is entirely taken with this forgotten world which surfaces from the past... With every day, the host of Russian images, both groups and individual figures, grows in his studio, images unmistakably Russian not only by virtue of costume but also by virtue of gesture. But what is the sense of it all? The artist himself does not know yet.

> A. Lewinsohn, *Léon Bakst*, S. 226, Berlin, 1922 (in German)

1923

Was invited by John Garrett to decorate the latter's Evergreen Theatre in Baltimore. Had one-man shows in Chicago and New York at which he lectured on costume and textile design. Designed for Ida Rubinstein's company a new production of d'Annunzio's *Phèdre* (at the Paris Opera, first performance 8 June). Also designed the sets for a production of Racine's

tragedy *Phèdre* (at the Théâtre de la Renaissance in Paris). Wrote the book and did the designs for the ballet *The Magic Night* produced by Jacques Rouché, choreographed by Leo Staats to the music of Frédéric Chopin, orchestrated by Louis Aubert (at the Paris Opéra, first performance 31 December). The Slovo publishers of Berlin put out Bakst's recollections, *With Serov in Greece: Travel Notes*.

1924

In January visited Washington and New York. Did portraits. For Ida Rubinstein's company, wrote the book and did the designs of the ballet *Istar*, choreographed by Leo Staats to the music of Vincent d'Indy (at the Paris Opéra). On December 27 died of emphysema at the Rueil-Malmaison clinic and was buried at the Batignolles cemetery.

1925

The membership of the Russian Society of Book Lovers met on 12 June in Moscow for a session dedicated to Bakst, at which four papers were read. The first posthumous exhibition of Bakst's works was opened in November at Jean Charpentier's gallery in Paris (325 pieces in number).

List of Exhibitions Which Included Works by Léon Bakst

1889 Exhibition of M. Sukhorovsky's Painting 'In Captivity', St Petersburg

1890 Exhibition of Paintings at the Academy of Arts, St Petersburg

First Show of Drawings by Russian Artists (Blanc et noir) at the Society for the Advancement of the Arts, St Petersburg

1891 Eleventh Exhibition of the Society of Russian Watercolourists, St Petersburg

Second Show of Drawings by Russian Artists (Blanc et noir) at the Society for the Advancement of the Arts, St Petersburg

1892 Twelfth Exhibition of the Society of Russian Watercolourists, St Petersburg

Show at the Society for the Advancement of the Arts, St Petersburg

1893 Thirteenth Exhibition of the Society of Russian Watercolourists, St Petersburg

1894 Fourteenth Exhibition of the Society of Russian Watercolourists, St Petersburg

1895 Fifteenth Exhibition of the Society of Russian Watercolourists, St Petersburg

Third Show of Paintings of the St Petersburg Society of Artists, St Petersburg

1896 Exhibition of Paintings at the Academy of Arts, St Petersburg

Sixteenth Periodical Exhibition of Paintings of the Moscow Society of Art Lovers, the History Museum, Moscow

All-Russian Exhibition of Art and Industry, Nizhni-Novgorod

Internationale Kunstausstellung, Berlin

1897 Exhibition of Paintings at the Academy of Arts, St Petersburg

Second Exhibition of the Society of Russian Watercolourists, Moscow

Exhibition of Princess Tenisheva's Collection of Drawings and Watercolours at the Society for the Advancement of the Arts, St Petersburg

1898 Exhibition of Works by Russian and Finnish Artists, St Petersburg

Exhibition of Original Drawings from the Journal *Vsemirnaya illustratsiya* [*World Illustration*], St Petersburg

1899 International Art Show Organized by the *Mir iskusstva* [*World of Art*] Journal, St Petersburg

Internationale Kunstausstellung, Sezession, Munich

1900 Second Exhibition of Paintings Organized by the *Mir iskusstva* [*World of Art*] Journal, St Petersburg

1901 Third Exhibition of Paintings Organized by the *Mir iskusstva* [*World of Art*] Journal, St Petersburg

1902 Fourth Exhibition of Paintings Organized by the *Mir iskusstva* [*World of Art*] Journal, St Petersburg

First Exhibition of Paintings Organized by the *Mir iskusstva* [*World of Art*] Journal, Moscow

1903 Fifth Exhibition of Paintings Organized by the *Mir iskusstva* [*World of Art*] Journal, St Petersburg

Modern Art Exhibition, St Petersburg

Internationale Kunstausstellung des Vereins bildender Künstler Münchens, Sezession, Munich

1903/4 First Exhibition of Paintings of the Union of Russian Artists, Moscow

1904/5 Second Exhibition of Paintings of the Union of Russian Artists, St Petersburg and Moscow

1906 World of Art Show, St Petersburg

Third Exhibition of Paintings of the Union of Russian Artists, Moscow

Exhibition of Bills and Posters Mounted by the Leonardo da Vinci Society, Moscow

L'Exposition de l'art russe, Salon d'Automne, Paris

Russische Kunstausstellung, Salon Schulte, Berlin

1906/7 Fourth Exhibition of Paintings of the Union of Russian Artists, St Petersburg and Moscow

1907 Exhibition of Modern Trends in Russian Art, St Petersburg

Esposizione internazionale d'arte della città di Venezia

Salon d'Automne, Paris

1907/8 Fifth Exhibition of Paintings of the Union of Russian Artists, Moscow and St Petersburg

1908 Salon d'Automne, Paris

First Collective Exhibition of Works by Modern Russian Artists, Sezession, Vienna

1908/9 Sixth Exhibition of Paintings of the Union of Russian Artists, Moscow and St Petersburg

1909 Third Exhibition of Paintings from the Collections of Moscow Art Lovers, St Petersburg

Salon: Exhibition of Paintings, Graphic Works, Sculpture and Architecture, St Petersburg

Exhibition mounted by the Northern Circle of Art Lovers, Vologda

1909/10 Seventh Exhibition of Paintings of the Union of Russian Artists, Moscow, St Petersburg and Kiev

Exhibition of Paintings Organized by the V mire iskusstv [In the World of Art] Journal, Odessa, Kiev and Kharkov

1910 Fourth Exhibition of Paintings from the Collections of Moscow Art Lovers, St Petersburg

Exhibition of Drawings by the Satiricon Staff at the Editorial Offices of the Apollon [Apollo] Journal, St Petersburg

Exhibition of Contemporary Russian Female Portraits at the Editorial Offices of the Apollon [Apollo] Journal, St Petersburg

Les Artistes russes. Décors et costumes de théâtre et tableaux, Galerie Bernheim, Paris

Exposition universelle et internationale, Brussels

1911 Salon d'Automne, Paris

Esposizione internazionale, Rome

1911/12 Art in Books and Posters Exhibition at the All-Russian Congress of Artists, St Petersburg

1913 World of Art Show, St Petersburg, Moscow and Kiev

International Exhibition of Posters, Lemercier Gallery, Moscow

1914 Erste internationale graphische Kunstausstellung, Leipzig

Esposizione internationale, Venice

1917 Exhibition of Paintings and Sculptures by Jewish Artists, Moscow

1920 First State Exhibition of Arts and Sciences, Kazan

1921 Art russe ancien et moderne, Galerie Boëtie, Paris

1922 International Theatre Exhibition, Victoria and Albert Museum, London

1923 Twenty-five Years of Russian Lithography, Russian Museum, Leningrad

1924 Russian Art Exhibition, Grand Central Palace, New York

1925 Exhibition of Paintings by Russian Artists, Central Museum of the Crimea, Sevastopol

Exposition des arts au théâtre du XVᵉ au XXᵉ siècle, Hôtel Charpentier, Paris

1926 Exhibition of Paintings from Museum Reserves, Odessa

Salon d'Automne, Paris

1928 Art russe ancien et moderne, Palais des Beaux-Arts, Brussels; Hôtel Charpentier, Paris

1929 Ballets Russes de Diaghilev (1909–1929), Musée des Arts Décoratifs, Paris

French and Russian Modern Art: Stage and Costume Designs. From the Gabrielle Enthoven Collection, Victoria and Albert Museum, London

1930 The Lifar Collection, Arthur Tooth and Sons, London

Exposition rétrospective de maquettes, décors et costumes exécutés pour la compagnie des Ballets Russes de Serge de Diaghilev, Galerie Billiet, Paris

Memorial Exhibition of the Russian Ballet, Claridge Gallery, London

1931 Portraits of Women. Romanticism to Surrealism. Loan Exhibition, Paris

1933 L'Art décoratif au théâtre et dans la musique, Musée Galliera, Paris

Twenty-five Years of Russian Ballet. From the Collection of Serge Lifar, Julien Levy Gallery, New York

1934 Anna Pavlova, Maison de la danse, Paris

International Exhibition of Theatre Art, Museum of Modern Art, New York

The Lifar Collection, Smith College, Northampton; Art Museum, Cleveland; Art Museum, Cincinnati

1935 Exhibition of Russian Art, New Burlington Gallery, London

1939 Ballets Russes de Diaghileff (1909–1929), Musée des Arts Décoratifs, Paris

Painters of Russian Ballets, Manchester

1946 Ballet Designs, The National Gallery, London

1948 Exhibition of Russian Graphic Art, Sverdlovsk

Danse et divertissement, Hôtel Charpentier, Paris

1950 *Mir Iskusstva*, Walker Art Gallery, Liverpool

An Exhibition of Russian Painting of the Period Known as Mir Iskusstva (World of Art), Ashmolean Museum, Oxford

1951/52 Russian Painting of the Second Half of the Nineteenth Century and Early Twentieth Century, Central House of Art Workers, Moscow

1953 Ballet Designs from the Carr Doughty Collection, New Burlington Gallery, London

1954 Exhibition of Portraits, Central House of Art Workers, Moscow

Exhibition of Paintings by Russian Artists (Eighteenth to Early Twentieth Century) from Leningrad Private Collections, Research Museum of the USSR Academy of Arts, Leningrad

1954/55 The Diaghilev Exhibition, Edinburgh Festival, Edinburgh and Forbes House, London

1956 Anna Pavlova, Maison de la danse, Paris

1958 Exhibition of Works by Russian Artists (Second Half of the Nineteenth Century and Early Twentieth Century) from Kiev Private Collections, Kiev

1959 Exhibition of European, Oriental, Russian and Soviet Drawings and Watercolours, Pushkin Museum of Fine Arts, Moscow

Exhibition of Russian Portraits (Eighteenth to Early Twentieth Century), Research Museum of the USSR Academy of Arts, Leningrad

1959/60 Fifty Years of Ballet Designs, John Herron Museum, Indianapolis; Wadsworth Atheneum, Hartford, Conn.

1960 Exhibition of Russian Engravings and Lithographs (Eighteenth to Early Twentieth Century) from the Collection of the Department of the History of Russian Culture, the Hermitage, Leningrad

Russian Art and Life: Exposition of Russian Art from English Collections, Art Museum, Hove

1962 Stravinsky and the Dance, Wildenstein and Co., New York

1963 Exhibition of Drawings, Watercolours, Pastels and Gouaches of the Late Nineteenth and Early Twentieth Centuries from the Collection of the Tretyakov Gallery, Moscow

1964 Exhibition of Drawings and Watercolours by Russian Artists (Late Eighteenth to Early Twentieth Century) from Leningrad Private Collections, Research Museum of the USSR Academy of Arts, Leningrad

Europäische Kunst um die Jahrhundertwende, Pinakothek, Bayerische Staatsgemäldesammlungen, Munich

Il contributo russo alle avant-guardie plastiche, Galleria del Levante, Milan

1965 Exhibition of Drawings, Watercolours, Pastels and Gouaches of the Late Nineteenth and Early Twentieth Centuries from the Collection of the Odessa Art Museum, Odessa

Mostra internazionale di scenografica contemporanea, Naples

The Serge Lifar Collection of Ballet Set and Costume Designs, Wadsworth Atheneum, Hartford, Conn.

1966 Les Années 25, Musée des Arts Décoratifs, Paris

Commémoration des Ballets Russes et du Centenaire de la Naissance d'Eric Satie, Théâtre des Champs-Elysées, Paris

The Carr Doughty Collection, Art Gallery, Leicester

Stage and Costume Designs by Russian Painters from the Collections of Mr and Mrs Nikita D. Lobanov-Rostovsky and Mr George Riabov, Harkness House for Ballet Arts, New York

1966/67 Exhibition of Russian Watercolours (Late Eighteenth to Early Twentieth Century) from the Collection of the Tretyakov Gallery, Moscow

1967 Russian Etchings of the Late Nineteenth and Early Twentieth Centuries, Russian Museum, Leningrad

Ballet Designs and Illustrations: 1581–1940, Victoria and Albert Museum, London

Diaghilev Ballet Designs, Belgrade Theatre, Coventry

Avantgarde 1910–1930: Osteuropa, Akademie der Kunst, Berlin

Exhibition of Russian Theatrical Art, Metropolitan Museum of Art, New York

A Survey of Russian Painting: Fifteenth Century to the Present, The Gallery of Modern Art, New York

1967/68 An Exhibition of Costume and Set Designs Chiefly for Diaghilev's Ballets, Drawn from the Collection of John Carr Doughty, Plymouth, Birkenhead, Blackpool, Reading, Keighley and Birmingham

1967/69 Russian Stage and Costume Designs for the Ballet, Opera and Theatre, from the Lobanov-Rostovsky, Oenslager and Riabov Collections, International Exhibitions Foundation, Washington, D.C.

1968 Exhibition of Pre-Revolutionary Russian and Soviet Art. Paintings, Sculpture and Graphic Art. From New Acquisitions (1963–1968), Tretyakov Gallery, Moscow

Exhibition of New Acquisitions of the Russian Museum, Leningrad (no catalogue)

Russians in Paris: 1900–1930, Shepherd Gallery, New York

1969 Diaghilev Ballet Material: Decor and Costume Designs, Portraits and Posters, Sotheby and Co., London and Bradford

Les Ballets Russes de Serge de Diaghilev (1909–1929), Conseil de l'Europe, Strasbourg

Russian Theatre Designs Drawn from the Collection of Robert L. B. Tobin, McNay Art Institute, San Antonio, Texas

1971 Hommage à Diaghilev. Collections Boris Kochno et Serge Lifar, Musée Galiera, Paris

Painting of the Twentieth Century from the Léonide Massine Collection. Decor and Costume Designs, Portraits and Posters for Ballets and Opera, Sotheby and Co., London

Costume and Decor Designs, Portraits and Posters for Ballet Theatre and Opera, Sotheby and Co., London

The Boris Kochno Collection: Designs for Diaghilev, Public Library, New York

1972 Hommage à Léon Bakst, à André Bakst, à Georges Landrieux, Paris

Ricordi di Serge de Diaghilev, 1872–1929, Museo Teatrale alla Scala, Milano; Teatro la Finiche, Venice

1972/74 Diaghilev and Russian Stage Designers. Stage and Costume Designs from the Collection of Mr and Mrs Nikita Lobanov-Rostovsky, International Exhibitions Foundation, Washington, D.C.

1973 Russian and Soviet Ballet. Exhibition of Material from the Collection of the Leningrad Museum of Theatre and Music, Petrodvorets

Stravinsky–Diaghilev. Exhibition of Works Dedicated to Igor Stravinsky, Serge Diaghilev and Their Associates Marking the Opening of the Stravinsky–Diaghilev Museum in Venice, Milan

Stravinsky–Diaghilev, Cordier and Ekstrom Gallery, New York

1974 Drawings by Russian Artists of the Late Nineteenth and Early Twentieth Centuries, Russian Museum, Leningrad

1974/75 Theatre. An Exhibition of Twentieth-century Theatrical Designs and Drawings, Annely Juda Fine Art Gallery, London and other cities

1975 The Portrait in Russian Painting of the Late Nineteenth and Early Twentieth Centuries, Russian Museum, Leningrad

The Diaghilev Ballets Russes (1909–1929), University of Chicago

1976/78 Stage Designs and the Russian Avant-garde (1911–1929). Stage and Costume Designs from the Collection of Mr and Mrs Nikita Lobanov-Rostovsky, International Exhibitions Foundation, Washington, D.C.

1977 Self-portrait in Russian and Soviet Art, Tretyakov Gallery, Moscow, and Russian Museum, Leningrad

Book Covers by Russian Artists of the Early Twentieth Century, Russian Museum, Leningrad

Russian and Soviet Painting. An Exhibition from the Museums of the USSR, Metropolitan Museum of Art, New York, and Fine Arts Museum, San Francisco

Diaghilev's Ballets Russes (1909–1929), Harvard University, Cambridge, Mass.

1978 New Acquisitions: Paintings from the Eighteenth Century to the Early Twentieth Century, Russian Museum, Leningrad

Diaghilev: Costumes and Designs for the Ballets Russes, Metropolitan Museum of Art, New York

1978/79 Russian Graphic Art (Eighteenth–Twentieth Centuries), Hatton Gallery, University of Newcastle upon Tyne

Russian Painters and the Stage (1884–1965). Stage and Costume Designs from the Collection of Mr and Mrs Nikita Lobanov-Rostovsky, University of Texas, Austin

1979 Diaghilev: Les Ballets Russes, Bibliothèque Nationale, Paris

Paris–Moscou: 1900–1930, Centre Georges Pompidou, Paris

Russian Theatre and Costume Designs, Fine Arts Museum, San Francisco

Dance Image: a Tribute to Serge Diaghilev, Mississippi Museum of Art, Jackson, Miss.

1981 Moscow–Paris: 1900–1930, Pushkin Museum of Fine Arts, Moscow

·The Diaghilev Heritage. Selections from the Collection of Robert L. B. Tobin, Museum of Fine Art, Houston

1981/82 Landscape in Russian Painting: Late Nineteenth and Early Twentieth Centuries, Russian Museum, Leningrad (no catalogue)

Mir iskusstva — Il Mondo dell'Arte. Artisti russi 1898–1924. Museo Diego Aragona Pignatelli, Naples, Turin

1982/84 Russian Stage Design. Scenic Innovation: 1900–1930, from the Collection of Mr and Mrs Nikita D. Lobanov-Rostovsky, Mississippi Museum of Art, Jackson, Miss. and Archer M. Huntington Art Gallery of the University of Texas, Austin

1983 Exhibition of Paintings and Graphic Art Works Donated to the Tretyakov Gallery by Evelyne Cournand, Tretyakov Gallery, Moscow

Exhibition Dedicated to the 225th Anniversary of the Academy of Arts, Tretyakov Gallery, Moscow

One-man Shows

1911
Musée des Arts Décoratifs, Paris

1912
Fine Art Society, London

1913
Fine Art Society, London; Berlin Photographic Co., New York; Theatre Museum, Zurich

1914
Buffalo Fine Arts Academy and Albright-Knox Art Gallery, Buffalo, New York, Boston, Philadelphia and Chicago

1916
Scott and Fowles Galleries, New York

1917
Fine Art Society, London

1920
Knoedler Gallery, New York

1922
Knoedler Gallery, New York

1923
Art Club, Chicago

1924
Baltimore Hotel, Los Angeles

1925
Hôtel Charpentier, Paris

1926
Galerie du Centaure, Brussels

1927
Fine Art Society, London

1928
Hôtel Charpentier, Paris

1929
Gemeentsmuseum, The Hague

1938
Arthur Tooth and Sons, London

1957
Musée Galiera, Paris

1962
Fine Art Society, London

1965
Arthur Tooth and Sons, London

1966
Museum of Theatre and Music, Leningrad

1967
Galleria del Levante, Milan, Rome and Munich

1968
Gemeentsmuseum, The Hague

1973/74
Fine Art Society, London

1976
Fine Art Society, London

CATALOGUE

1 **Nymph Huntress.** Costume design for Léo Delibes' ballet *Sylvia*. 1901
Watercolour, pencil and bronze on paper. 28.1 × 21.1 cm
The Russian Museum, Leningrad

2 Set design for Euripides' tragedy *Hippolytus*. 1902
Gouache and watercolour on paper. 28.7 × 40.8 cm
The Russian Museum, Leningrad

3 **Herald.** Costume design for Euripides' tragedy *Hippolytus*. 1902
Watercolour and gouache touched with silver and pencil on paper.
29 × 21 cm
Picture Gallery of Armenia, Yerevan

4 **Nurse.** Costume design for Euripides' tragedy *Hippolytus*. 1902
Watercolour and gouache touched with gold and pencil on paper

5 Set design for Sophocles' tragedy *Oedipus at Colonus*. 1904

6 Set design for Josef Bayer's ballet *Die Puppenfee*. 1903
Watercolour on paper
Private collection

7 **China Doll.** Costume design for Josef Bayer's ballet *Die Puppenfee*. 1903
Watercolour and pencil heightened with white on cardboard.
25 × 17.2 cm
The Russian Museum, Leningrad

8 **Negro Doll.** Costume design for Josef Bayer's ballet *Die Puppenfee*. 1903
Watercolour and pencil heightened with white on paper.
37.1 × 26 cm
The Russian Museum, Leningrad

9 **French Doll.** Costume design for Josef Bayer's ballet *Die Puppenfee*. 1903
Gouache and watercolour touched with pencil on paper.
39.1 × 28.5 cm
The Russian Museum, Leningrad

10 **Postman.** Costume design for Josef Bayer's ballet *Die Puppenfee*. 1903
Watercolour touched with bronze and India ink on paper.
37 × 20.3 cm
The Russian Museum, Leningrad

11 **Wilhelm Meister.** Costume design for Leonid Sobinov in Ambroise Thomas' opera *Mignon*. 1903
Watercolour on paper. 29 × 21 cm
Picture Gallery of Armenia, Yerevan

12 **Torch Dance.** Costume design for Tamara Karsavina. 1907
Pen and India ink, watercolour, gold and pencil on paper.
30.8 × 23.3 cm
The Russian Museum, Leningrad

13 **Salomé.** Costume design for Oscar Wilde's play of the same name. 1908
Gouache heightened with white, pencil, pen, brush and India ink, gold and silver. 45.5 × 29.5 cm
The Tretyakov Gallery, Moscow

14 **Armand.** Costume design for Giuseppe Verdi's opera *La Traviata*. 1908
Watercolour, pencil and silver on paper mounted on cardboard.
29.5 × 22.2 cm
The Bakhrushin Theatre Museum, Moscow

15 **Thaïs.** Costume design for Maria Kuznetsova in Jules Massenet's opera of the same name. 1910
Watercolour and pencil on paper. 28.5 × 21.5 cm
Ashmolean Museum, Oxford

16 Set design for the ballet *Cléopâtre* to the music of Anton Arensky and other Russian composers. 1909
Watercolour and gouache on paper. 21 × 29.5 cm
Museum of Modern Art, New York

17 **Jewish Dance.** Costume design for the ballet *Cléopâtre* to the music of Anton Arensky and other Russian composers. 1910
Watercolour, gouache, pencil and gold on paper

18 **Syrian Dance.** Costume design for the ballet *Cléopâtre* to the music of Anton Arensky and other Russian composers. 1909
Watercolour, gouache, pencil and gold on paper. 67.5 × 49 cm
Private collection

19 **Valse noble.** Costume design for the ballet *Le Carnaval* to the music of Robert Schumann. 1910
Watercolour and pencil heightened with white on paper.
36 × 24.5 cm
Museum of Theatre and Music, Leningrad

20 **Harlequin.** Costume design for the ballet *Le Carnaval* to the music of Robert Schumann. 1910
Watercolour and pencil on paper
Private collection

21 **Estrella.** Costume design for the ballet *Le Carnaval* to the music of Robert Schumann. 1910
Watercolour and pencil on paper. 31.5 × 24.5 cm
Museum of Theatre and Music, Leningrad

22 **Florestan.** Costume design for the ballet *Le Carnaval* to the music of Robert Schumann. 1910
Watercolour and pencil heightened with white on paper.
20 × 21 cm
Museum of Theatre and Music, Leningrad

23 **Chiarina.** Costume design for the ballet *Le Carnaval* to the music of Robert Schumann. 1910
Watercolour and pencil on paper. 27.5 × 21 cm
Museum of Theatre and Music, Leningrad

24 Set design for the ballet *Schéhérazade* to the music of Nikolai Rimsky-Korsakov. 1910
Watercolour, gouache and gold on paper. 54.5 × 76 cm
Musée des Arts Décoratifs, Paris

25 **Silver Negro.** Costume design for the ballet *Schéhérazade* to the music of Nikolai Rimsky-Korsakov. 1910
Watercolour and silver on paper

26 **Odalisque.** Costume design for the ballet *Schéhérazade* to the music of Nikolai Rimsky-Korsakov. 1910
Watercolour and gold on paper
Private collection

27 **Eunuch.** Costume design for the ballet *Schéhérazade* to the music of Nikolai Rimsky-Korsakov. 1910
Watercolour and gold on paper

28 **Young Indian.** Costume design for the ballet *Schéhérazade* to the music of Nikolai Rimsky-Korsakov. 1910
Watercolour, gouache and gold on paper

29 **The Red Sultana.** 1910
Watercolour, gouache and gold on paper
Private collection

30 **The Firebird.** Costume design for Igor Stravinsky's ballet *L'Oiseau de Feu.* 1910
Watercolour, pencil and gold on paper
Private collection, New York

31 **The Tsarevna.** Costume design for Igor Stravinsky's ballet *L'Oiseau de Feu.* 1910
Watercolour and pencil on paper. 35.5 × 22.1 cm
Museum of Theatre and Music, Leningrad

32 Set design for Nikolai Cherepnin's ballet *Narcisse.* 1911
Watercolour and gouache on paper

33 **The Nymph Echo.** Costume design for Nikolai Cherepnin's ballet *Narcisse.* 1911
Watercolour, gouache, pencil and gold on paper. 39.5 × 26.5 cm
Private collection, New York

34 **Ephebus.** Costume design for Nikolai Cherepnin's ballet *Narcisse.* 1911
Watercolour, pencil and gold on paper
Private collection

35 **Boeotian Girl.** Costume design for Nikolai Cherepnin's ballet *Narcisse.* 1911
Watercolour and pencil on paper. 28.5 × 22 cm
The Stravinsky—Diaghilev Foundation, Venice

36 **Two Boeotian Girls.** Costume designs for Nikolai Cherepnin's ballet *Narcisse.* 1911
Watercolour, gouache, pencil and gold on paper
Private collection

37 **Iskander.** Costume design for Paul Dukas' ballet *La Péri.* 1911
Watercolour, gouache and pencil on paper

38 **The Peri.** Costume design for Paul Dukas' ballet *La Péri.* 1911
Watercolour, gouache and pencil on paper. 47 × 32 cm
Wadsworth Atheneum, Hartford

39 Set design for Act III of Gabriele d'Annunzio's mystery play *Le Martyre de St Sébastien.* 1911
Watercolour and gouache on paper. 62 × 86 cm
Private collection, Paris

40 Set design for Act IV of Gabriele d'Annunzio's mystery play *Le Martyre de St Sébastien.* 1911
Watercolour and gouache on paper

41 **Heralds.** Costume designs for Gabriele d'Annunzio's mystery play *Le Martyre de St Sébastien.* 1911
Watercolour, gouache, silver, gold and pencil on paper

42 **St Sebastian.** Costume design for Gabriele d'Annunzio's mystery play *Le Martyre de St Sébastien.* 1911
Pencil, watercolour, gouache and gold on paper. 44.5 × 25.5 cm
Private collection

43 **St Sebastian.** Costume design for Gabriele d'Annunzio's mystery play *Le Martyre de St Sébastien.* 1911
Pencil on paper
Private collection

44 Set design for Reynaldo Hahn's ballet *Le Dieu Bleu*. 1912
Watercolour and gouache on paper. 55.8 × 78 cm
Centre Georges Pompidou, Paris

45 **The Blue God.** Costume design for Reynaldo Hahn's ballet
Le Dieu Bleu. 1912
Watercolour, gouache and gold on paper
Private collection

46 **Bayadère with Peacock.** Costume design for Reynaldo Hahn's
ballet *Le Dieu Bleu*. 1912
Watercolour, pencil and silver on paper. 58.2 × 43 cm
Private collection

47 **Bride.** Costume design for Reynaldo Hahn's ballet *Le Dieu Bleu*.
1912
Watercolour, pencil and gold on paper

48 Set design for the ballet *Thamar* to the music of Mily Balakirev.
1912
Watercolour and gouache on paper. 74 × 86 cm
Musée des Arts Décoratifs, Paris

49 **Butterfly.** Costume design for the ballet *Papillons* to the music of
Robert Schumann. 1912
Watercolour on paper. 27 × 20 cm
Private collection

50 **Indian Dance.** Costume design for Marchesa Casati. 1912
Watercolour and gold on paper. 48 × 31 cm
Private collection, Paris

51 Set design for Act II of Maurice Ravel's ballet *Daphnis and Chloë*.
1912
Watercolour and gouache on paper. 74 × 103.5 cm
Musée des Arts Décoratifs, Paris

52 Set design for Act II of Maurice Ravel's ballet *Daphnis and Chloë*.
1912
Watercolour and paper. 94 × 122 cm
Musée des Arts Décoratifs, Paris

53 Set design for Oscar Wilde's play *Salomé*. 1912
Watercolour on paper. 45.9 × 62.5 cm
Ashmolean Museum, Oxford

54 Set design for Act II of Emile Verhaeren's play *Helen of Sparta*.
1912
Watercolour on paper. 55 × 57 cm
Musée des Arts Décoratifs, Paris

55 Set design for Acts I and III of Emile Verhaeren's play *Helen of
Sparta*. 1912
Watercolour and gouache on paper. 55.5 × 57 cm
Galleria del Levante, Milan

56 **Helen.** Costume design for Emile Verhaeren's play *Helen of
Sparta*. 1912
Watercolour, pencil and silver on paper. 27.5 × 21 cm
Private collection

57 **Pollux.** Costume design for Emile Verhaeren's play *Helen of
Sparta*. 1912
Watercolour and pencil on paper. 28 × 20.8 cm
Ashmolean Museum, Oxford

58 **Nymph.** Costume design for Claude Debussy's ballet *L'Après-
midi d'un Faune*. 1912
Watercolour, pencil and gold on paper
Private collection

59 Set design for Claude Debussy's ballet *L'Après-midi d'un Faune*.
1912
Gouache on paper. 75 × 105 cm
Centre Georges Pompidou, Paris

60 **Faun.** Costume design for Claude Debussy's ballet *L'Après-midi
d'un Faune*. 1912
Gouache, watercolour and gold on paper mounted on cardboard.
39.9 × 27.2 cm
Wadsworth Atheneum, Hartford

61 **Nymph.** Costume design for Claude Debussy's ballet *L'Après-
midi d'un Faune*. 1912
Watercolour, gouache, pencil and gold on paper. 27 × 23.5 cm
Private collection

62 Set design for the ballet *Les Orientales* to the music of Mikhail
Ippolitov-Ivanov and Modest Mussorgsky. 1913
Gouache, watercolour, silver and India ink on paper.
46.1 × 60.1 cm
Private collection

63 Set design for Act I of Gabriele d'Annunzio's mystery play *La
Pisanella*. 1913
Pencil on paper

64 **Page.** Costume design for the 'Aladdin' divertissement (part of the
ballet *The Sleeping Beauty* produced by Anna Pavlova's
company). 1916
Watercolour, gouache, pencil and silver on paper

65 **The Firebird.** Costume design for Igor Stravinsky's ballet
L'Oiseau de Feu. 1913
Watercolour, gouache and gold on paper. 68.5 × 49 cm
Museum of Modern Art, New York

66 **The Tsarevich Ivan.** Costume design for Igor Stravinsky's ballet
L'Oiseau de Feu. 1913
Watercolour and gouache on paper
Private collection

67 **Potiphar's Wife.** Costume design for Richard Strauss' mime-
drama *La Légende de Joseph*. 1914
Watercolour, pencil and gold on paper
Private collection

68 **Potiphar.** Costume design for Richard Strauss' mime-drama
La Légende de Joseph. 1914
Watercolour, pencil and gold on paper. 31.2 × 22.8 cm
Private collection

69 **Guest.** Costume design for Richard Strauss' mime-drama
La Légende de Joseph. 1914
Watercolour, pencil and gold on paper. 31.2 × 22.8 cm
The Russian Museum, Leningrad

70 **Nurse.** Costume design for Gabriele d'Annunzio's tragedy
Phèdre. 1917
Watercolour, gouache and gold on paper

71 **The Green Devil.** Costume design for Nikolai Rimsky-Korsakov's
opera *Sadko*. 1917
Watercolour, gouache and gold on paper

72 Set design for the mime performance *Les Femmes de Bonne Humeur* after Carlo Goldoni's comedy. 1917
Watercolour on paper

73 **Constance.** Costume design for the mime performance *Les Femmes de Bonne Humeur* after Carlo Goldoni's comedy. 1917
Watercolour on paper

74 **Battista.** Costume design for the mime performance *Les Femmes de Bonne Humeur* after Carlo Goldoni's comedy. 1917
Watercolour on paper
Evergreen House Foundation, Baltimore

75 **Doll.** Costume design for the ballet *La Boutique Fantasque* to the music of Gioacchino Rossini. 1919
Watercolour and gouache on paper
Private collection

76 **Englishman.** Costume design for the ballet *La Boutique Fantasque* to the music of Gioacchino Rossini. 1919
Watercolour and gouache on paper
Private collection

77 Set design for the Prologue to Piotr Tchaikovsky's ballet *The Sleeping Beauty*. 1921
Watercolour, gouache and gold on paper
Evergreen House Foundation, Baltimore

78 **Moor Guardsman.** Costume design for Piotr Tchaikovsky's ballet *The Sleeping Beauty*. 1921
Watercolour, gouache and silver on paper. 44.5 × 29 cm
Galleria del Levante, Milan

79 **Countess.** Costume design for Piotr Tchaikovsky's ballet *The Sleeping Beauty*. 1921
Watercolour, gouache and gold on paper

80 **Prince Charming.** Costume design for Piotr Tchaikovsky's ballet *The Sleeping Beauty*. 1921
Watercolour on paper. 29.3 × 19 cm
Galleria del Levante, Milan

81 **Page to the fairy of the Singing Birds.** Costume design for Piotr Tchaikovsky's ballet *The Sleeping Beauty*. 1921
Watercolour, gouache, pencil, gold and silver on paper.
29 × 22 cm
Galleria del Levante, Milan

82 **Wolf.** Costume design for Piotr Tchaikovsky's ballet *The Sleeping Beauty*. 1921
Watercolour, pencil, gouache, gold and silver on paper.
48.5 × 33 cm
Galleria del Levante, Milan

83 **Russian Peasant Woman.** 1922
Watercolour on paper

84 Design for a lady's dress. 1910s
Watercolour, gouache, pencil and gold on paper. 26.4 × 22.4 cm
The Tretyakov Gallery, Moscow

85 Design for a 'Decadence' dress. 1910s
Watercolour, pen and India ink on paper mounted on cardboard.
28.5 × 21.5 cm
The Bakhrushin Theatre Museum, Moscow

86 Design for a lady's dress. 1912
Watercolour on paper
Private collection

87 **Eagle.** Colophon for the *Mir iskusstva* [*World of Art*] journal. 1898
Pen and India ink on paper

88 Colophon for the journal *Novy put* [*New Path*]. 1902
Pen, brush and India ink on paper

89 Headpiece for the article 'The Stars' by Vasily Rozanov (*World of Art*, 1901, No. 7)
Pen and India ink on paper. 23.2 × 19.8 cm
The Tretyakov Gallery, Moscow

90 Headpiece for Konstantin Balmont's poem 'Predestination' (*World of Art*, 1901, No. 5)
Pen, brush and India ink on paper

91 Headpiece for Konstantin Balmont's poem 'Night' (*World of Art*, 1901, No. 5)
Pen and India ink on paper

92 Headpiece for Konstantin Balmont's poem 'I'm the refinement of the Russian speech' (*World of Art*, 1901, No. 5)
Pen, brush and India ink on paper. 15.3 × 14.5 cm
Private collection, Paris

93 **Vision of Antiquity.** 1906
Pen and India ink on paper. 16.1 × 17.9 cm
The Russian Museum, Leningrad

94 Cover to the programme for the ballet *Le Cœur de la Marquise* to the music of G. Guiraud. 1902
Watercolour heightened with white, gold and graphite on paper.
28.5 × 21.3 cm
Museum of Theatre and Music, Leningrad

95 Headpiece for the historical essay *Royal Hunting in Medieval Russia in the Late Seventeenth and Eighteenth Centuries* by Nikolai Kutepov (St Petersburg, 1902, vol. 3, chapter 3)
Pen and India ink on paper. 22.5 × 28.6 cm
The Russian Museum, Leningrad

96 Border for the journal *Khudozhestvennye sokrovishcha Rossii* [*Art Treasures of Russia*], 1901, No. 7
Pen and India ink and pencil on paper. 31.2 × 23.8 cm
The Russian Museum, Leningrad

97 Cover for the *World of Art* journal. 1902
Pen and India ink on paper

98 The 1902 Exhibition of Historical Portraits. Half-title (*World of Art*, 1902, No. 4)
Pen, brush and India ink on paper

99 Headpiece for the essay 'Paestum' by Vasily Rozanov (*World of Art*, 1902, No. 2)
Pen and India ink on paper

100 Tailpiece for the essay 'Paestum' by Vasily Rozanov (*World of Art*, 1902, No. 2)
Pen and India ink on paper

101 Headpiece to a photograph of the boudoir designed by Bakst (*World of Art*, 1903, Nos. 5/6)
Pen and India ink on paper

102 **Rodin.** Headpiece (*World of Art*, 1902, Nos. 9/10)
Pen and India ink on paper. 7.8 × 22.3 cm
The Tretyakov Gallery, Moscow

103 Cover for *Russian Bookplates* by Vasily Vereshchagin
(St Petersburg, 1902)
Pen, brush and India ink on paper

104 Arkhangelskoye. Frontispiece (*World of Art*, 1904, No. 2)
Pen and India ink on paper

105 Cover to the programme for Piotr Tchaikovsky's ballet *Swan Lake*.
1904
Pen and India ink on paper. 25 × 16.5 cm
The Tretyakov Gallery, Moscow

106 Cover for *The Russian Museum of Emperor Alexander III* by
Alexander Benois (1906, Moscow)
Pen and India ink on paper

107 **Tolling Bells.** Frontispiece for the journal *Zolotoye runo*
[*The Golden Fleece*], 1906, No. 3
Pen, brush and India ink on paper

108 Vignette for the poem 'Octaves of Old' by Dmitry Merezhkovsky
(*Zolotoye runo*, 1906, Nos. 1–4)
Pen and India ink on paper

109 Frontispiece for *Snow Mask*, a collection of poems by Alexander
Blok (St Petersburg, 1907)
Pen, brush and India ink on paper

110 Cover for the journal *Lebed* [*The Swan*]. 1908
Watercolour and gouache on paper

111 Frontispiece for the journal *Apollon* [*Apollo*]. 1909
Pen and India ink on paper

112 **Zeus the Thunderer.** Cover for the journal *Satiricon* (1908, No. 1)
Pen, brush, India ink and watercolour on paper

113 **Doll Market.** Sketch of a poster. 1899
Pastel on cardboard. 72 × 98 cm
The Russian Museum, Leningrad

114 **In a Lady Artist's Studio.** Sketch of the poster advertising an
exhibition of Russian artists at the Viennese Sezession. 1908
Watercolour, gouache and pencil on paper mounted on
cardboard. 46.8 × 60.2 cm

115 **Girl in Russian Costume.** 1893
Watercolour on paper mounted on cardboard. 39.3 × 30 cm
The Russian Museum, Leningrad

116 **Spaniard.** 1891
Watercolour on paper. 32 × 24.5 cm
The Russian Museum, Leningrad

117 **Young Dahomeyan.** 1895
Watercolour on paper mounted on cardboard. 30.2 × 20.8 cm
The Russian Museum, Leningrad

118 **Head of an Arab.** 1893
Watercolour on paper. 30 × 24 cm
Private collection, Leningrad

119 **Uriel Acosta.** 1892
Watercolour on paper mounted on cardboard. 33.3 × 24.5 cm
The Russian Museum, Leningrad

120 **Portrait of Alexander Alexeyev.** 1894
Watercolour on paper mounted on cardboard. 26.1 × 20.5 cm
The Russian Museum, Leningrad

121 **Portrait of Walter Nouvel.** 1895
Watercolour on paper mounted on cardboard. 57 × 44.2 cm
The Russian Museum, Leningrad

122 **Peasant from Normandy.** 1896
Watercolour and gouache on paper. 17.8 × 14 cm
The Tretyakov Gallery, Moscow

123 **Finnish Fisherman.** 1895
Watercolour on paper mounted on cardboard. 27.5 × 17.8 cm
The Tretyakov Gallery, Moscow

124 **Blacksmith.** 1896
Pastel on cardboard. 65.5 × 51 cm
Picture Gallery, Sèvres

125 **Self-portrait.** 1893
Oil on cardboard. 34 × 21 cm
The Russian Museum, Leningrad

126 **Portrait of the Actress Maria Savina.** 1899
Pencil on paper mounted on cardboard. 30 × 22.6 cm
The Russian Museum, Leningrad

127 **Portrait of Isaac Levitan**
(*World of Art*, 1899, No. 6)
Lithograph. 20 × 15.5 cm
The Russian Museum, Leningrad

128 **Portrait of Philip Maliavin** (*World of Art*, 1899, Nos. 23/24)
Lithograph. 32 × 23 cm
The Russian Museum, Leningrad

129 **Evening in the Neighbourhood of Aïn-Zaïnfour, Sfax.** 1897
Watercolour and gouache on paper mounted on cardboard.
37.5 × 55.3 cm
The Tretyakov Gallery, Moscow

130 **Mountain Lake.** 1899
Oil on canvas. 66 × 103 cm
The Russian Museum, Leningrad

131 **Portrait of Lubov Gritsenko.** 1903
Oil on canvas. 142.5 × 101.5 cm
The Tretyakov Gallery, Moscow

132 **Paris Welcomes Admiral Avelan.** 1900
Oil on canvas. 205 × 305 cm
Central Naval Museum, Leningrad

133 **Boy Crawling on All Fours.** Study for the painting 'Paris
Welcomes Admiral Avelan'. 1896
Charcoal and chalk on paper. 38.7 × 56.4 cm
The Russian Museum, Leningrad

134 **Man Picking Up His Hat from the Ground.** Study for the
painting 'Paris Welcomes Admiral Avelan'. 1885
Charcoal and chalk on paper. 42.6 × 59.1 cm
The Russian Museum, Leningrad

romance ascribed to Longus. Sketch
Watercolour on paper. 33.5 × 50 cm
Metropolitan Museum of Art, New York

167 **Bathers on the Lido.** 1909
Oil on canvas. 18.5 × 26.7 cm
Private collection

168 **Delphi.** 1907
Gouache on paper
Private collection

169 **Chloë Abandoned.** Decorative panel after *Daphnis and Chloë*.
Sketch
Watercolour on paper. 26.5 × 49 cm
Musée des Arts Décoratifs, Paris

170 **Street in Fiesole.** Drawing from the artist's sketchbook. 1915
Pencil on paper

171 **View of Mont Blanc.** Drawing from the artist's sketchbook. 1910s
Pencil on paper

172 **Savoy.** Drawing from the artist's sketchbook. 1910s
Pencil on paper

173 **Sprig of Berries.** Drawing from the artist's sketchbook. 1910s
Pencil on paper

174 **Portrait of Jean Cocteau.** 1911
Pencil on paper. 31 × 20 cm
Private collection, Paris

175 **Portrait of Léonide Massine.** 1914
Pencil on paper. 38.1 × 25.4 cm
Private collection, San Antonio

176 **Portrait of Mme T.** 1918
Pencil on paper

177 **Portrait of Louis Thomas.** 1924
Charcoal and coloured pencils on paper. 40.5 × 31 cm
Galleria del Levante, Milan

178 **Portrait of Virginia Zucchi.** 1917
Pencil on paper. 32.9 × 23.3 cm
Ashmolean Museum, Oxford

179 **Portrait.** 1910s
Pencil on paper

180 **Portrait.** 1910s
Pencil on paper
Private collection, Paris

181 **Portrait of Ida Rubinstein.** 1921
Watercolour, gouache and charcoal on paper mounted on canvas.
128.9 × 68.8 cm
Metropolitan Museum of Art, New York

Select Bibliography
in chronological order

WORKS IN RUSSIAN

B. L'vov (L. Bakst), 'Posmertnaya vystavka kartin Endogurova,
 Yaroshenko i Shishkina' (Posthumous exhibition of pictures by
 Yendogurov, Yaroshenko and Shishkin), *Mir iskusstva*, 1899,
 No. 5

A. Benois, *Istoriya zhivopisi v XIX veke. Russkaya zhivopis'* (History of
 painting in the nineteenth century: Russian painting), Part 2,
 St Petersburg, 1901

L. Bakst, 'Zhenshchina v masterskoj khudozhnika' (Woman in the
 artist's studio), *Peterburgskaya gazeta*, 22 December 1902

A. Benois, *Russkaya shkola zhivopisi* (The Russian school of painting),
 St Petersburg, 1904

L. S. Bakst: reproductions, *Zolotoye runo*, 1906, No. 4

L. S. Bakst, 'Puti klassitsizma v iskusstve' (Classical trends in Art),
 Apollon, 1909, Nos. 2/3

V. Ivanov, 'Drevnij uzhas: po povodu kartiny L. Baksta "Terror
 Antiquus"' (Bakst's 'Terror Antiquus') in *Po zvezdam: stat'i i
 aforizmi* (Among the stars: articles and aphorisms),
 St Petersburg, 1909

Lyubitel' (P. D. Ettinger), 'U L'va Baksta' (Lev Bakst), *Birzhevye
 vedomosti*, 14 October 1909

M. Voloshin, 'Arkhaizm v russkoj zhivopisi: Rerikh, Bogaevskij, Bakst'
 (Archaic features in Russian painting: Roerich, Bogaevsky and
 Bakst), *Apollon*, 1909, No. 1

S. Makovsky, *Stranitsy khudozhestvennoj kritiki* (Pages of art criticism),
 Part 2, St Petersburg, 1909

'Anketa k 50-letiyu A. P. Chekhova' (Questionnaire on the fiftieth
 anniversary of Chekhov's birth), *Odesskie novosti*, 17 January
 1910

L. Bakst, 'Otkrytoe pis'mo I. E. Repinu' (Open letter to Repin),
 Birzhevye vedomosti, 6 March 1910

L. Bakst, Introduction to catalogue *Vystavka rabot uchenits i uchenikov
 L. S. Baksta i M. V. Dobuzhinskogo (shkola Zvantsevoj)*
 (Exhibition of the work of Bakst's and Dobuzhinsky's pupils
 [Zvantseva's school]), St Petersburg, 1910

A. Benois, 'Salon i shkola Baksta' (Bakst's salon and school), *Rech*,
 1 April 1910

A. Rostislavov, '6-ya vystavka *Apollona*' (The sixth *Apollo* exhibition),
 Rech, 25 April 1910

I. Repin, 'V adu u Pifona' (In hell with Python), *Birzhevye vedomosti*,
 15 May 1910

S. Makovsky, 'Vystavka v redaktsii *Apollona*. O shkole Baksta i
 Dobuzhinskogo' (*Apollo* Exhibition. The Bakst and Dobuzhinsky
 school), *Apollon*, 1910, No. 8

L. Bakst, 'Nagota na stsene' (Nudity on stage), *Peterburgskaya gazeta*,
 20 January 1911

A. Lunacharsky, 'Parizhskie pis'ma. Misteriya o muchenichestve sv.
 Sebast'yana' (Letters from Paris. Mystery play: *The Martyrdom
 of St Sebastian*), *Teatr i iskusstvo*, 10 July 1911

A. Benois, 'Novye balety. *Nartsiss*' (New ballets: *Narcisse*), *Rech*, 22 July 1911

V. Y. Svetlov, *Sovremennyj balet* (Contemporary ballet), St Petersburg, 1911

P. Kozhevnikov, 'Elena Spartanskaya' (*Helen of Sparta*), *Stolichnaya molva*, 30 April 1912

V. Svetlov, 'Favn' (*The Faun*), *Peterburgskaya gazeta*, 27 May 1912

A. Lunacharsky, 'Parizhskie pis'ma. Elena Spartanskaya. Baletnaya burya' (Letters from Paris. *Helen of Sparta*. Whirlwind ballet), *Teatr i iskusstvo*, 27 May 1912

E. N-n, 'O dekoratsiyakh i kostyumakh khudozhnika Baksta' (Bakst's designs and costumes), *Svobodnym khudozhestvam*, 1912, IV/V

E. Pan, 'O Elene Spartanskoj' (*Helen of Sparta*), *Studiya*, 1912, No. 30/31

Y. Tugendhold, 'Teatral'ny sezon v Parizhe. Elena Spartanskaya' (This season's theatre in Paris. *Helen of Sparta*), *Studiya*, 1912, No. 34/35

L. Bakst, 'Kostyum zhenshchiny budushchego' (Dress for women in the future) (Interview), *Birzhevye vedomosti*, 20 March 1913

A. Lunacharsky, 'Pizanella' (*La Pisanella*), *Den*, 15 June 1913

L. S. Bakst, 'O sovremennom teatre. Nikto v teatre bol'she ne khochet slushat', a khochet videt'' (L. Bakst, 'Contemporary theatre. No one in the theatre wants to listen any more — they want to see'), *Peterburgskaya gazeta*, 21 January 1914

L. Bakst, 'Moda' (Fashion), *Peterburgskaya gazeta*, 20 February 1914

L. Bakst, 'Ob iskusstve segodnyashnego dnya' (Art today), *Stolitsa i usad'ba*, 1914, No. 8

Lyubitel' (P. D. Ettinger), 'Modnaya znamenitost' Parizha. K priezdu v Peterburg khudozhnika Baksta' (The Parisian celebrity. On Bakst's arrival in Petersburg), *Birzhevye vedomosti*, 20 January 1914

M., 'U L. S. Baksta' (Interview with L. Bakst), *Den*, 29 January 1914

A. Levinson, 'Russkie khudozhniki-dekoratori' (Russian artists and stage designers), *Stolitsa i usad'ba*, 1916, No. 57

A. Levinson, 'Vozvrashchenie Baksta (K vykhodu v svet polnoj monografii ego tvorchestva)' (Bakst returns [To mark the publication of a complete monograph on his work]), *Zhar-ptitsa*, 1922, No. 9

L. Bakst, 'Serov i ya v Gretsii. Dorozhnie zapisi' (With Serov in Greece: Travel notes), Berlin, 1923

B. Ronkin, 'O balete L. Baksta' (Bakst's ballet), *Teatr*, 4 December 1923

M. Kuz'min, 'L. Bakst' (L. Bakst) (obituary), *Krasnaya gazeta*, 31 December 1924, evening edition

D. Chuzhoj, 'L. Bakst' (L. Bakst) (obituary), *Rabochij i teatr*, 12 January 1925

G. Stebnitskij, 'L. Bakst' (L. Bakst) (obituary), *Rabochij i teatr*, 12 January 1925

S. Isakov, 'Lev Bakst' (Lev Bakst) (obituary), *Zhizn' iskusstva*, January 1925, No. 1

Li, 'Leon Bakst' (Leon Bakst) (obituary), *Krasnaya panorama*, 24 January 1925

M. V. Dobuzhinsky, 'O Bakste (iz moikh vospominanij)' (Bakst as I remember him), *Segodnya*, 6 January 1925

D. Aranovich, 'Lev Bakst' (Lev Bakst), *Iskusstvo trudyashchimsya*, 31 March – 5 April 1925, No. 18

I. Zharovskij, 'Posmertnaya vystavka Baksta' (Posthumous exhibition of Bakst's work), *Poslednie novosti*, 19 November 1925

A. Benois, *Vozniknovenie 'Mira iskusstva'* (The beginning of 'The World of Art'), Leningrad, 1928

P. P. Pertsov, *Literaturnye vospominaniya. 1890–1902* (Literary reminiscences. 1890–1902), Moscow, Leningrad, 1933

N. Sokolova, *Mir iskusstva* (The World of Art), Moscow, Leningrad, 1934

F. Y. Syrkina, *Russkoe teatral'no-dekoratsionnoe iskusstvo 2-j poloviny XIX veka. Ocherki* (Russian theatre and stage design in the second half of the nineteenth century. Essays), Moscow, 1956

A. V. Lunacharsky, *O teatre i dramaturgii* (On theatre and play-writing), 2 vols., Moscow, 1958

M. Fokine, *Protiv techeniya. Vospominaniya baletmejstera. Stat'i, pis'ma* (Against the tide. Memoirs of a ballet master. Articles, letters), Leningrad, Moscow, 1962

B. V. Asaf'yev (Igor' Glebov), *Russkaya zhivopis'. Mysli i dumi* (Russian painting. Thoughts and ideas), Leningrad, Moscow, 1966

V. N. Petrov, 'Mir iskusstva' (The World of Art) in *Istoriya russkogo iskusstva* (History of Russian art), vol. 10, Part 1, Moscow, 1968

N. P. Lapshina, 'Mir iskusstva' (The World of Art) in *Russkaya khudozhestvennaya kul'tura kontsa XIX – nachala XX veka (1895–1907)* (Russian art and culture from the end of the nineteenth to the beginning of the twentieth century [1895–1907]), Part 2, Moscow, 1969

M. V. Davydova, 'Teatral'no-dekoratsionnoe iskusstvo' (Theatre and stage design) in *Istoriya russkogo iskusstva* (History of Russian art), vol. 10, Part 2, Moscow, 1969

M. N. Pozharskaya, *Russkoe teatral'no-dekoratsionnoe iskusstvo kontsa XIX – nachala XX veka* (Russian theatre and stage design at the end of the nineteenth and beginning of the twentieth centuries), Moscow, 1970

V. Krasovskaya, *Russkij baletny teatr nachala XX veka. Khoreografy* (Early twentieth-century Russian ballet. Choreographers), Leningrad, 1971

A. Gusarova, *Mir iskusstva* (The World of Art), Leningrad, 1972

I. N. Pruzhan, 'Kartina L. S. Baksta "Drevnij uzhas" ' (Bakst's 'Terror Antiquus') in *Soobshcheniya Gosudarstvennogo Russkogo Muzeya* (Reports of the State Russian Museum), vol. 10, Moscow, 1974

M. V. Davydova, *Ocherki istorii russkogo teatral'no-dekoratsionnogo iskusstva XVIII — nachala XX v.* (Essays on the history of Russian theatre and stage design from the eighteenth to early twentieth century), Moscow, 1974

V. N. Petrov, *Mir iskusstva* (The World of Art), Moscow, 1975

I. N. Pruzhan, *Lev Samojlovich Bakst* (Lev Samoilovich Bakst), Leningrad, 1975

N. Lapshina, *Mir iskusstva. Ocherki istorii i tvorcheskoj praktiki* (The World of Art. Essays on its history and work), Moscow, 1977

N. Borisovskaya, *Lev Bakst* (Lev Bakst), Moscow, 1979

A. Benois, *Moi vospominaniya* (My recollections), in 5 vols., Moscow, 1980

S. V. Golynets, *L. S. Bakst, 1866–1924* (L. S. Bakst, 1866–1924), Leningrad, 1981

Sergej Dyagilev i russkoe iskusstvo. Stat'i, otkrytye pis'ma, interv'yu. Perepiska. Sovremenniki o Dyagileve (Sergei Diaghilev and Russian art. Articles, open letters, interviews. Correspondence. Contemporaries on Diaghilev), edited and with commentaries and articles by I. S. Zil'bershtejn and I. A. Samkov, 2 vols., Moscow, 1982

WORKS IN OTHER LANGUAGES

Léon Bakst, 'Les formes nouvelles du classicisme dans l'art', *La Grande Revue*, juin 1910

Jean-Louis Vaudoyer, 'Variations sur les Ballets Russes', *Revue de Paris*, 15 juillet 1910

Léandre Vaillat, 'Les décors russes', *Art et les Artistes*, août 1910

Jean-Louis Vaudoyer, 'Léon Bakst', *Art et Décoration*, février 1911

J. Peladan, 'Les Arts du théâtre. Un maître du costume et du décor: Léon Bakst', *Art Décoratif*, juin 1911

Huntley Carter, 'L'Art de Léon Bakst', *Le Monde*, décembre 1911

Louis de Basilly, 'A propos d'*Hélène de Sparte*', *Siècle*, 13 mai 1912

Robert Brussel, 'Grande saison de Paris (Châtelet): Ballet Russe: *Thamar*', *Le Figaro*, 22 mai 1912

Louis Schneider, '*Daphnis et Chloé*. La mise en scène et décors', *Comoedia Illustré*, 12 juin 1912

William Ritter, 'Léon Bakst', *Emporium*, vol. 36, Bergamo, décembre 1912

Arsène Alexandre, *L'Art décoratif de Léon Bakst* (essai critique par A. Alexandre, notes sur les ballets par J. Cocteau), Paris, 1913

William Ritter, 'Ballettskizzen von Léon Bakst, Paris', *Deutsche Kunst und Dekoration*, Bd. 31, Darmstadt, 1913

Paul Barchan, 'Léon Bakst', *Kunst und Künstler*, Heft 6, Berlin, 1913

Martin Birnbaum, *Léon Bakst*, New York, 1913

A. Bakshy, *The Path of the Modern Russian Stage and Other Essays*, London, 1913

Annie Meyer, 'The Art of Léon Bakst', *Art and Progress*, vol. 5, Washington, 1914

Ada Rainey, 'Léon Bakst — Brilliant Russian Colorist', *The Century Magazine*, vol. 87, New York, 1914

'Léon Bakst on the Modern Ballet', *New York Tribune*, 5 September 1915

Léon Bakst, *Choréographie et décors des nouveaux ballets russes* [Ballets Russes. Programme], Paris, 1917

Albert Flament, 'Bakst — artificier, décorateur et portraitiste', in: *Renaissance de l'art français*, Paris, 1919

Léon Bakst, 'Tchaikowsky aux Ballets Russes', *Comoedia Illustré*, 9 octobre 1921

W. A. Propert, *The Russian Ballet in Western Europe: 1909–1920*, London, 1921

Léon Bakst, 'Spectacles d'aujourd'hui et *Beggar's Opera* à Londres', *Comoedia Illustré*, 11 janvier 1922

André Levinson, *L'Œuvre de Léon Bakst pour* La Belle au bois dormant, Paris, 1922

André Lewinsohn, *Léon Bakst*, Berlin, 1922

Collection de plus beaux numéros de Comoedia Illustré *et des programmes consacrés aux Ballets et Galas Russes*, Paris, 1922

Léon Bakst. Recent Works, New York, 1922

Jean De Segeux, '*Judith*', *Comoedia Illustré*, 12 octobre 1922

'L'Evolution du décor — Opinion de M. Léon Bakst. Réponse à l'enquête de Raymond Cogniat', *Comoedia Illustré*, 3 septembre 1923

Jean-Louis Vaudoyer, 'Léon Bakst et les Ballets Russes', *Nouvelles Littéraires*, 3 janvier 1923

André Levinson, *The Designs of Léon Bakst for the* Sleeping Princess, London, 1923

André Levinson, *Bakst: The Story of the Artist's Life*, London, 1923

G. C. Siordet, 'Léon Bakst's Designs for Scenery and Costumes', *International Studio*, vol. 76, New York, 1923

Louis Thomas, 'Bakst, Student of the Archaic', *International Studio*, vol. 76, New York, 1923

André Levinson, *Histoire de Léon Bakst*, Paris, 1924

Simon Lissim, 'Léon Bakst, ses décors et costumes de théâtre', *L'Œuvre*, Paris, N° 2 (mars), 1924

'Portrait Group by Léon Bakst, Noted Russian Artist, Exhibited', *The Baltimore Sun*, 26 March 1924

Henry Malherbe, 'Istar', *Le Temps*, 30 juillet 1924

Georges-Michel Michel, 'Léon Bakst, rénovateur du décor', *Paris-Midi*, 29 décembre 1924

Jean-Richard Bloch, 'L'Art de Bakst et les vitraux du Moyen Âge', *Le Figaro*, 31 décembre 1924

A. Boll, 'Léon Bakst', *Revue musicale*, N° 6, 1925

Simon Lissim, 'Léon Bakst', *L'Œuvre*, Paris, hiver, 1924–1925

Simon Lissim, 'Un rénovateur de la décoration théâtrale, Léon Bakst', *La Revue de l'Art ancien et moderne*, Paris, février 1925

Paul Barchan, 'Léon Bakst und das Theater', *Kunst für alle*, Bd. 41, München, 1925

André Warnod, 'L'exposition rétrospective de l'œuvre de L. Bakst', *Comoedia Illustré*, 6 novembre 1925

M.-M. Du Guard, 'Léon Bakst', *L'Art vivant*, 1 décembre 1925

Pierre De Colombier, 'L'exposition Léon Bakst', *L'Œuvre*, N° 98 (janvier), Liège, 1926

J.-E. Blanche, 'Léon Bakst dans le ballet russe', *L'Illustration*, 3 décembre 1927

Léon Bakst. 42 Tafeln und 6 Abbildungen mit einer Einleitung von Carl Einstein, Berlin, 1927

Louis Réau, Denis Roche, V. Svetlov, A. Tessier, *Unedited Works of Bakst*, New York, 1927

Peter Lieven, *The Birth of the Ballets Russes*, London, 1936

Georges-Michel Michel, 'Diaghilev et les peintres', *L'Art vivant*, mai 1939

Cyril W. Beaumont, *The Diaghilev Ballet in London*, London, 1940, 1945, 1951

Alexander Benois, *Reminiscences of the Russian Ballet*, London, 1941, 1945, 1947

Cyril W. Beaumont, 'Ballet Design Past and Present', *The Studio*, London, 1946

S. Lifar, *Histoire du ballet russe*, Paris, 1950

S. L. Grigoriev, *The Diaghilev Ballet: 1909–1929*, London, 1953

The Diaghilev Exhibition from the Edinburgh Festival, 1954. Catalogue (edited by Richard Buckle), London, 1954

R. Lister, *The Muscovite Peacock. A Study of the Art of Léon Bakst*, Cambridge, 1954

Richard Buckle, *In Search of Diaghilev*, London, 1955

Nathalie Gontcharova, Michel Larionov, Pierre Vorms, *Les Ballets Russes de Serge de Diaghilev et la décoration théâtrale*, Belvès, 1955

Arnold Haskell, *Ballet in Color*, New York, 1959

Alexander Benois, *Memoirs*, 2 vols., London, 1964

Denis Bablet, *Le décor de théâtre de 1870 à 1917*, Paris, 1965

Léon Bakst. Painting and Stage Design. Art and the Stage in the Twentieth Century (edited by Henning Rischbieter), New York, 1968

Charles Spencer, *Léon Bakst*, London, 1973

Index

Figures refer to page numbers; figures in italics, to illustrations

On the frontispiece (pages 2 and 3):

Bakst drawing an eagle (for the colophon of the *World of Art* journal) in the
St Petersburg Zoological Museum. 1898

ЛЕВ БАКСТ

Альбом (на английском языке)

Издательство „Аврора". Ленинград. 1987
Изд. № 1647
Printed and bound in Austria